BODY, BREATH & BEING

a new guide to the Alexander Technique

Carolyn Nicholls

D&B PUBLISHING
www.dandbpublishing.com

First published in 2008 by D & B Publishing,
80 Walsingham Road, Hove, E Sussex BN3 4FF

Reprinted 2009

British Library Cataloguing-in-Publication Data
A catalogue record for this book is available from the British Library.

ISBN: 978 1 904468 42 4

All sales enquiries should be directed to:
D & B Publishing, 80 Walsingham Road, Hove, E Sussex BN3 4FF, UK

e-mail: info@dandbpublishing.com
Website: www.dandbpublishing.com

Cover design by Horacio Monteverde.
Text design: SCW Design
Production: Navigator Guides
Printed and bound in India on behalf JFDI Print Services Ltd

"We've all been waiting for a 'good' new book introducing the principles and practice of the Alexander Technique. Carolyn Nicholls has given us a 'great' new book on the subject. Highly recommended for beginners of all levels."

Malcolm Balk
Author: Master the Art of Running

"I have had Alexander lessons throughout my career, found them invaluable and recommended them to countless other singers. Congratulations to Carolyn Nicholls, who has distilled her many years of teaching into this lucid, down to earth and entertaining book; it will work well for newcomers and devotees alike (singers and normal folk!), whether as introduction to or reminder of this marvellous technique."

Dame Emma Kirkby
Soprano

"A fantastic book, great pictures, a very informative practical book. This goes on our reading list for BA and MA students."

Chris Palmer,
Head of Voice and Speech, GSA School of Acting and Musical Theatre

"Carolyn Nicholls' book is much more than a beginner's introduction to the Alexander Technique. Teachers of the Technique will also find this book a useful manual for honing their communication skills and expanding their repertoire of handy hints and ideas. Carolyn's expertise as a teacher shows through in her case studies and examples. Using personable, jargon-free language that is easy to follow, she progressively explains the concepts of the Alexander Technique and their value in our busy world. Her book is a pleasure to read."

Dr Terry Fitzgerald
Head of Training, Sydney Alexander School, Australia

"The author has managed successfully to distil many years' experience teaching and practising the Alexander Technique into this highly readable and well illustrated book. I warmly recommend this accessible volume."

Professor Basant K. Puri.

Dedication

To my wonderful children Alison and Christopher

Acknowledgements

The stories in this book are real stories of real people, who have been generous enough to allow me to use their real names (except for Ellen and Jane, who are real people but prefer to be known just as Ellen and Jane). I would like to thank them all.

Matthew Andrews, who also took many of the photos in the book, Kevin Barber, Sinéad Gillespie, Astrid Holm, Mindy MacArthur, Padmini Menon, Alison Nicholls, who also did the voice recordings for the CD, Mark Nelson, Guy Richardson, Anna Thorell and Jeanie Wood.

Alexander teachers who are also expert in other fields have allowed me to pick their brains for the chapter on movement. They are Malcolm Balk, who advised on running; Ulla Pedersen, who advised on swimming, and Richard and Sally Weis, who advised on horse riding.

Thanks too to students and teachers at The Alexander Technique College (Brighton UK) who happily participated in all sorts of experiments for the book. They are Daniel Goddard, Sherry Loh, Paul Marsh, Jenny Aldridge, Natalia Danielczyn, Emily Heath, Padmini Menon and Diana Miller.

For support, suggestions, encouragement and advice on many aspects of the book I would like to thank Alexander colleagues: Malcolm Balk, Ron Colyer, Astrid Holm, Philip Tucker, and Jeanie Wood.

Tuba courtesy of Rosehill Instruments Ltd., Beaconsfield, Bucks.
Quotations from F. M. Alexander's "Aphorisms" courtesy of Mouritz Ltd. Copyright The Estate of F. M. Alexander 2008.

Photo Credits

Matthew Andrews	Author photo, Alison Nicholls and many others
Carolyn Nicholls	Mark Nelson, Guy Richardson, Anna Thorell, Malcolm Balk Running workshop
George Weis	Richard Weis on Ming
Astrid Holm	Two year old boy in wood, two year old girl in chair
Collins and Brown	Malcolm Balk in 'lunge'

CD Sound credits
Scripts by: Carolyn Nicholls
Read by: Alison Nicholls
Recorded by: Patrick Bartlett

Contents

Foreword

by Ron Colyer B(mus) MSTAT
Head of Training: Alexander ReEducation Centre, Berkshire UK

In January 1979 Carolyn Nicholls and I met for the first time as we hung up our coats at the Constructive Teaching Centre in Holland Park, London. This was where we were to embark on the training which would prepare us to teach the work of F. M. Alexander. Each of us had been taking regular lessons in the Technique for some time, and were now to enjoy the privilege of three year's intensive work with Walter and Dilys Carrington.

Walter Carrington had been Alexander's assistant, and continued the work of training teachers after Alexander's death in 1955 until he himself passed away in August 2005. He was widely respected for his wisdom, and for his unique way of communicating the meaning of Alexander's discoveries in a simple and direct way. Dilys Carrington had developed her own thorough and precise method for teaching the unique hands-on skills which an Alexander teacher needs. Without their example and inspiration neither this book, nor its preface, would have been written.

Now, 29 years later, Carolyn and I each direct a teacher training course and meet regularly to run workshops for postgraduate Alexander teachers. With deep admiration I have watched Carolyn develop her own entirely personal way of talking and writing about the Technique, through constant practice, enquiry and reflection.

Writing about the Technique presents two important challenges. The primary one is that people wishing to learn about the Technique need more than just verbal explanations and so teachers use their hands to convey a more direct understanding. However, where the written word really can score – as this book does – is by intriguing us, and inviting us to explore further. In this context the workshops on the CD are particularly useful and will hopefully encourage the reader to find a teacher to help experience the Technique for themsleves.

As in other disciplines, the Alexander Technique has its own traditionally accepted terms and phrases – which do not convey much without the direct experiences to which they refer. Most of us who have worked with these ideas for many years are still discovering deeper layers of meaning within them.

Thus the second challenge for the writer is to find a vivid, precise and contemporary language with which to bring Alexander's ideas to the modern reader. This is Carolyn's special contribution to our work. What I love about this book is that although she does not fight shy of introducing the classical terminology, she presents it alongside apt, colourful and imaginative analogies to help us find resonance with our individual needs and difficulties.

Whether you are totally new to the Technique, are already having lessons or are even an Alexander teacher or teacher-trainee, you will find in these pages inspiration and food for thought.

Alexander was a man of his time, who identified perennial truths about the human condition. He expressed them in a dense and complex language, which many students of the Technique have found difficult to unravel. The writer of this book is a woman of her time, with a particular gift for bringing those truths alive for us in the 21st century.

Ron Colyer
2008

Introduction

Body, Breath and Being:
A new guide to the Alexander Technique

A powerful technique

Many people are puzzled by the Alexander Technique. Why is it, they wonder, that whether you take lessons because of your bad back, to improve your tennis playing or to speak more clearly, the Alexander teacher will put their hands on you and guide you in and out of a chair, sitting down and standing up again? They will also talk a lot about your neck. Why is it that if you want to improve your violin-playing technique the teacher is likely to tell you to leave your instrument at home, at least for several lessons?

Alexander teachers work in many different environments. You can find Glynn MacDonald working with the Royal Shakespeare Company – using the skills and experiential learning of the Alexander Technique to help actors find physical balance and emotional truth in their performance. Meanwhile other teachers put their skills to work in a chronic pain management clinic. What is the common factor and why is it so powerful?

Clinical trial

One of the key reasons that people seek out Alexander teachers is to deal with back pain. The Alexander Technique has been demonstrated as a highly effective method of dealing with this extremely common ailment. A recent large clinical trial of the role of the Alexander Technique in the management of low back pain (MRC ATEAM trial) demonstrated this conclusively. The trial showed that – compared with normal care – a course of 24 Alexander lessons remained effective in reducing days in pain and improving function over a long-term period (patients were followed up over a year), whereas massage – although effective in the short term – was much less effective in the longer term.

How is it that such results are achieved without physical manipulation or medication of any kind? Perhaps the most pertinent question is: what can the Alexander Technique do for me? The answers are the subject of this book. It is the recognition on Alexander's part of the powerful influence that gravity, and how we deal with it, has on our every act. The observation that how we use ourselves affects how we function as human beings, so even the act of breathing is recognised as an act. It is the understanding of the complex interweaving of body and mind and all that implies. It is about the flexible, adaptable nervous system we have, and our mental life! It is about our bodies, in movement and at rest, and how we think and feel.

The fundamental facts about functional human movement

F. M. Alexander was born in Tasmania, Australia, in 1869. Near his birthplace on Table Mountain there is a plaque, which reads:

> "On a nearby property was born FREDERICK MATTHIAS ALEXANDER 20 Jan 1869 – 10 Oct 1955 FOUNDER OF THE ALEXANDER TECHNIQUE DISCOVERER OF FUNDAMENTAL FACTS ABOUT FUNCTIONAL HUMAN MOVEMENT ONE OF THE '200 PEOPLE WHO MADE AUSTRALIA GREAT'"

What are these 'fundamental facts about functional human movement'? The Alexander Technique is not a therapy nor an exercise system, but an in-depth study of how human reaction, co-ordination and movement play a significant part in all our doings – including our well-being. Basically, it is a skill of balance.

With over one hundred years of practice, the Alexander Technique has helped people manage all sorts of conditions, including back pain, stress, anxiety, ME/CFS, fibromyalgia and asthma. It has enhanced the performance of actors, singers, musicians and athletes. It has inspired artists, writers, composers and philosophers. This huge scope of application is possible because the Alexander Technique addresses the fundamentals of human balance.

It has been my joy and privilege to teach this work and to train other people to teach it for over 25 years. In that time I have met many fascinating people, all with their own story to tell. This book explores the Alexander Technique through the stories of those who have studied it and benefited from it. These range from a photographer with back pain who had 12 lessons to a composer who studied the Alexander Technique for 14 years and uses the principles in his compositions. This book will discuss both the practice and theory of the Technique. It tells the stories of a pregnant woman, a potter with back pain and a tuba player with asthma. Most chapters contain a workshop of practical experiments that anyone can try. These workshops are accompanied by a CD of detailed verbal instructions and advice on each workshop.

The book offers a new view of the way we use our bodies and the consequences not only on our health, but also on our approach to life.

Carolyn Nicholls
Brighton 2008

section: 1

body:
To balance your body, first balance your mind

> "EVERYTHING A PERSON HAS DONE IN THE PAST HAS BEEN DONE IN ACCORDANCE WITH THE MENTAL DIRECTION TO WHICH HE IS ACCUSTOMED."
> F. M. Alexander (1930s)

Our bodies, our selves

IN THIS CHAPTER

▨ Balance – the key to the Alexander Technique

▨ Unlearning habits; the concept of Use

▨ Practising active rest; semi-supine

How I learned to stop slumping and love the Alexander Technique

I had my first series of 30 Alexander lessons in my early 20s. Quite simply my mother nagged me into it. She suffered from ankylosing spondylitis, a painful arthritic condition that mostly affects the spine. Lessons enabled her to continue in her job as a schoolteacher when her doctors had told her she should retire at 50. She couldn't explain what the Alexander Technique was about and when I asked her what she did in her lessons she was rather vague and said it helped her think clearly and that, in turn, helped her back pain. I didn't understand. She told me I should have lessons. "I don't have a bad back," I said. "It's about a lot more than back pain," replied my mother mysteriously.

Then I got ill myself. At the time I was studying for a degree in Fine Arts and living a fairly typical student life which meant late nights, even later mornings, bad food, bad housing and huge amounts of work. In my case this was quite physical as my artistic pieces were all large, so I was always heaving equipment around. I got a kidney infection which didn't respond to antibiotics. Neither did I. I hated taking them as they made me feel even sicker. Somehow I limped towards the end of my course, spending a few days in hospital here and there, having various treatments and investigations. I was preparing for my final exhibition, and the workload was enormous. I remember one doctor commenting on the amount of work I was doing and asking me if I couldn't stop for a while and rest. "You're running on empty," he told me, "You can't expect to get better if you don't slow down a bit."

My mother, with uncharacteristic decisiveness, bought me a course of 30 Alexander lessons, made the first appointment, rang me up and told me I was going. So, I went.

A new direction

That first lesson changed my life. I came away feeling lighter both in body and spirit – somehow the workload didn't seem so great. My legs felt strange – as if they were walking without my assistance. I realised that I usually rushed everywhere with enormous tension, particularly in my legs. I seemed taller, which, as I was already 5'10", tall for a woman, wasn't something I at first welcomed; but I was curious that things looked different from my new perspective. As my lessons continued and I began to understand what was happening, the parallels to what I thought of as my creative processes fascinated me. Ideas about not

fixing your mind on a particular result I found very appealing. I always enjoyed letting my artwork unfold, almost randomly, seemingly without any end point in sight, rather than forcing it to do my will. I had wrestled frequently with this strange concept and found it difficult to explain to tutors who wanted to see my working sketches, which in the end I did after I finished the project. It seemed to them that I was unfocused and possibly not serious about my work, which was very far from being the case. I soon discovered F. M. Alexander's ideas about non-end gaining – where if you focus solely on your goal you are ignoring the path towards it, usually at your peril.

I felt I had connected with something I had been looking for, not just for my physical well being but to help me explore my creativity in a new way. It profoundly changed the way I worked. I was so taken with it that I trained to be an Alexander teacher myself. Soon after I qualified, my mother innocently asked me "So what is the Alexander Technique then – how would you explain it?" My answer was that it was about thinking in a specific and purposeful way, it was about breathing, it was about awareness, it wasn't possible to totally verbalise the experience, but it was about all sorts of things... well, it was about body, breath and being. Ultimately the Alexander Technique is about balance.

Keep your balance

Balance is something we seek in all areas of our lives. We are exhorted to find a work/life balance, told to eat a balanced diet, required to pay attention to our bank balance and hope to have a balanced mind. We admire balance in all areas of our lives. A well-balanced painting is pleasing to the eye; a play or book that has a well-balanced plot engages us. Balance is important and it is a very practical matter. The Alexander Technique offers a practical way to explore balance. If your body is not balanced you will hold yourself and move in a distorted way, which could lead you to suffer from back pain or a myriad of other problems.

Balancing act

Imagine trying to stand a 6" stick of liquorice on its end. It would probably fall over. Perhaps you could split the lower half in two so your liquorice stick had legs – would that make it easier? Add a couple of jellybeans on the ends of the two legs as tiny platforms for balance. Then place a round sweet on the top of the stick. Magically make both your liquorice stick and the surface you are hoping to stand it on magnetic. See if you can balance the stick.

The magnetism will want to lie the liquorice down flat – it's easier that way. But it's not what you want – you want it to be upright. Of course the round sweet on the top will make things more difficult. Perhaps it will help if you bend the stick a bit, put a curve in it, or spread its legs apart a bit. Even if you find a balance, the tiniest movement will make it fall over. Balance is a problem.

Endgaining: Concentrating on getting a result, without thinking about the steps involved

Do you balance like the figure in yellow when you stand?

Balance is essential

If you don't balance – you fall down. Of course, you are not a stick of liquorice, but you have some of the same problems to contend with. Gravity is the magnetic force holding you on to the planet and somehow you have to deal with it. Lose your balance and gravity will claim you – you topple or fall over. Like the liquorice stick you are a long, thin structure balancing over two tiny platforms – your feet. Have a look at your feet. How long are they? No more than a foot long. How long are you? Several times longer and wider than your feet, but still you have to balance over them. All your joints are mobile and wobble, your feet and ankles flex and straighten, as do your knees and hips. You have to make constant adjustments to keep those joints organised so that you don't fall over. Then there's your head – a round, quite heavy object – no doubt full of wonderful things, but weighing about 5kg on average and balancing precariously on the top of your very slender neck. Balance is not just a problem for the liquorice stick – it's a problem for you too.

Everyone manages to balance in some way or other, using their muscles to prop a bit of their body here, relax a bit there. The question is, are you managing it well or could you do it better? Furthermore, does it matter how you do it – so long as you do it?

Yes! It does matter. The way we achieve our unique way of balancing our bodies so we can walk around and do what we want is largely hit and miss, and can contribute to back pain and other problems. If you unknowingly walk around carrying your head on one side, then you will compensate for that misplaced weight somewhere else in your body, maybe by hunching a shoulder or hitching up a hip. Our unconscious search for balance can lead us to distort ourselves in ways that only add to our aches and pains.

As well as being long and thin, with a heavy head to balance on a slender neck, we spend most of our time bending in one way or another. We bend our hips, ankles and knees when we walk and we bend them a lot more when we sit or stand. We pick things up and put them down; we carry things in our hands

with their clever opposable thumbs that make us the envy of sheep and cows. We also rotate as we bend, twisting, turning, making the most of our incredibly mobile structure. The question is, could we do these things better?

Proprioception and kinaesthetic awareness

Our bodies really are quite clever – constantly giving us information about where we are in space. The basic reason for this is so that you can avoid falling over and hurting yourself. The information comes from within us – joints, ligaments and muscles all 'tell' us when they are stretched or altered in any way, alerting us to changes in balance and shifts of weight. Due to the fact that our general awareness levels are low, we are mostly unaware of this feedback, which is known as proprioceptive information. Most people don't even think about their balance unless they are in a challenging situation such as walking on uneven or slippery ground, when suddenly balance becomes an immediate issue and we attempt to compensate for wobbles in our ankles and knees so that we can remain upright. The classic slap-stick sketch of someone slipping on a banana skin – which we find so hilarious as an observer – is the body and mind's attempt to keep in balance and not fall over or – if we must fall over – to land on a nice padded bit of ourselves such as our bottom, rather than our heads. If our general balance is good then the banana skins of life are less likely to floor us. However, if our kinaesthetic awareness – so crucial to our balance – is poor, then we are more likely to find the whole business of balance a challenge; we bump into things, we stumble easily and we think ourselves clumsy. F. M. Alexander's observations about how we process and respond to this sensory information offer different ways of tackling the balance problem. Habit, repetition and an assumption that our bodily information is 'right' can all distort our kinaesthetic sense. If you have the habit of walking with the toes of one foot turned in, it will feel straight to you – your body will tell you that it is 'right'. This apparently simple action will have a ripple effect right up through your whole body's musculature and could be a contributory factor to back pain. Learning the Alexander Technique lets you deal with such

ingrained habits and misleading senses and consciously influences your own balance and movement.

Mark's story

Mark Nelson is 6'3" and he has a very long back and very long legs. He is lightly built and has a slight scoliosis (twist) in his spine. He was told over 30 years ago that if he didn't do something about his back he would suffer a lot of pain in later life. The twist makes it difficult to balance the way his back support works. Mark unconsciously developed compensation problems, which included permanently hunching up his right shoulder and swivelling his pelvis round to the left as he walked. With one leg slightly longer than the other, the pattern of compensation spread though his frame. When he took his jacket off and hung it on the door, his wife said the jacket looked like he was still wearing it, as it adopted the shape of his back. Mark's back began to complain and ache.

Mark said, " I knew I was twisted, but honestly didn't realise how much, it all felt perfectly normal to me. People occasionally commented on my odd way of walking and suggested I put my feet down differently, but I couldn't and had no concept of what they meant."

Not doing, but thinking

When Mark began Alexander lessons he wanted the whole thing explained very precisely and had many questions. Why did he need to lengthen?

Surely he was tall enough already? What did it mean when he was asked, "just to *think*, not to *do*"? How could he tell if he was getting it right or not? Why could he not trust his sense of feeling to tell if he was doing the right things in his lessons?

It's never easy to explain an experience in words. You can no more describe what lengthening your back actually feels like than you can fully explain what cheese tastes like. But you can use imagery and metaphor, and you can describe your experience and compare it with someone else's. And you can gather information about it to help make sense of the experience.

"I wanted answers and had no idea that I was so out of touch with what was going on in my body. If you'd asked me where my legs were, I'd look and see. I had no idea what they felt like or how they moved, or that they were so tense. I lived mostly in my head. In the first lesson I was introduced to semi-supine. My teacher got me to lie on my back on a special teaching table with my knees bent and my head resting on a small pile of books. Then she stood behind me and put her hands on the sides of my head. I know she wasn't pulling, but her hands felt firm and strong and after a little while – without her seeming to do anything else – my back began to unravel. I felt like a telescope opening out. It was an irresistible sensation and went all the way down my back to my pelvis and legs. It was very strange. At the end of the lesson I was aware that there was less pressure in my back, although I hadn't noticed there was any pressure in the first place. Somehow, with the pressure gone, I realised it had been there and could have been contributing to my back pain."

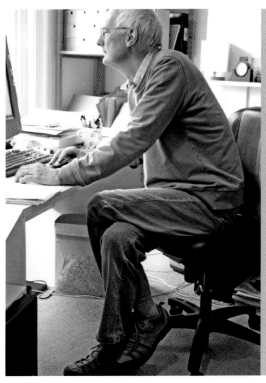

Lengthening (shortening): Unlocking muscle tension and joint compression, thus allowing a natural process of de-contraction of the body to take place. (Using excessive tension that literally drags your body towards the floor, shortening you.)

It's easy to tie yourself in knots if you get too involved in your work

Semi-supine:
Lying on your back with your knees bent, head resting on a small pile of books. This will be explored in great detail in the workshop at the end of Chapter 1.

Sitting in a knot at the computer

Mark often sat with his legs in a considerable knot. He crossed his legs and wrapped his foot round the back of his other ankle. This way of sitting was a habit. He sat like this when drinking a cup of tea at the kitchen table, when working at his computer and even when relaxing in the garden. It was such a strong automatic habit that he didn't realise he did it. The tension in his legs was such that this twisted position felt comfortable – even right. Sitting like this occasionally for a few minutes doesn't matter, but for Mark it was a habit that contributed to his problems. Constantly sitting with uneven weight on his sitting bones meant his pelvis – already tending to be twisted – was encouraged to twist even more. The body tends to learn what we teach it and the more you practise a poor habit like this, the easier it becomes and the more natural it feels. For Mark this seemed like a relaxed position and when he felt tense he went even further, wrapping the whole twisted spiral around the leg of the chair, hooking his ankle behind the chair leg. Consequently his legs were tense in all other activities, too, so that when he walked his legs remained tense and had the effect of pulling his entire body down towards the ground. At the other end of his body, Mark balanced out his legs and pelvis by hunching his shoulders and pulling his neck and head out of shape. Our bodies work as a whole unit, not in separate bits, and we will compensate for tension throughout our whole structure. Mark's compensation included thrusting his head forward on his neck with his back rounded and compressed. It wasn't only when he worked at the computer that he experienced these problems; he used his body in the same way when playing guitar, too, his favourite hobby.

A fundamental problem

After lessons Mark began to realise it didn't matter what he was doing, whether he was playing guitar, sitting at the computer, drinking tea or watching the television. It was a more fundamental problem than getting the right chair, or even learning to sit up straight. It was about him, his body and how he dealt

Use:
Literally how you use your body: well or badly.

with gravity – that ever present force that holds us on to the planet. Learning to relate to gravity in a free and easy way is part of what the Alexander Technique is about. Mark began to reassess his situation. "I had to relearn things, or perhaps unlearn things would be a better description. The way I moved, the way I breathed – it all changed. What I was doing with my head and neck was crucial to keeping myself in a good balance."

Mark practised active rest, in semi-supine position, every day. This is the single most important thing anyone can do to help themselves. It can change the way your body supports you and refreshes discs, muscles and ligaments. When you lie down you are in a different relationship with gravity and your back no longer has to work in the same way as it does to hold you upright. Your legs are not carrying your body weight and so have a chance to change the way they relate to your back. Lying down allows the spongy discs that separate the bones of your spine to soak up fluid. These disc are hydroscopic in nature and can absorb fluid from surrounding body tissues if they are not under pressure. When you are walking around, with your weight going through your spine, there is compression on these discs that squashes them slightly. This pushes fluid out back into the body. The discs are then a little narrower, a little harder, a little less flexible. They don't act as such good shock absorbers when you walk around. When you sleep at night, the discs plump up again, and you will wake up in the morning actually taller than when you went to bed. But why wait till bedtime? Lying down practising active rest is like giving your spine a drink.

The bank account of good Use

Changing the way you use your body is a slow process, and it requires thought. The best way you can improve your Use is to practise active rest, in the semi-supine position – and to do this regularly. You may not notice very much at first, people vary as to what they observe and what seems to change, but those who are persistent will gain benefit. Think of your Use as a bank account in which you deposit time

and thought. When you have built up your account – because you have given your Use time and attention – then you can expect to get some interest. Your general everyday Use starts to improve, even when you are not thinking about it at the time. This only happens because you have put the work in – it isn't a random occurrence. You notice you are pain free, or joints are easier to move, or you have more energy. All these things are the interest paid on your Use account. Notice too when funds get low and you need to deposit more. Small niggles, extra tiredness or stressful feelings again are signs that you need to do some more work on your Use. So practise active rest and keep your bank account of Use in credit.

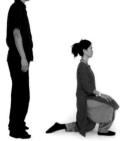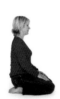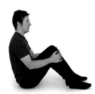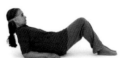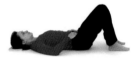

Workshop 1

Active Rest: The art and practice of Semi-supine

Read through the workshop material first to familiarise yourself with the concepts. This will greatly improve your understanding and enjoyment of the audio instructions. Gather together the items you need and when you are ready select Track 1 on the 'Workshops CD'. The CD will talk you through the active rest procedure in detail while you are doing it. It contains directions and thought pathways for you to follow. Listen to it regularly, everyday. There is a lot of information on the CD and you won't absorb it all in one session. Make yourself a promise to practise regularly and commit to it and you will gain enormous benefit. If at any time during your practice you feel discomfort and want to stop, just gently roll on to your side and get up when you are ready. The most important aspect of the active rest practice is to take your time and not rush through it.

You will need

▨ A quiet, warm, draught-free place to lie down, with a firm but not hard surface. A carpeted wooden floor is ideal. Don't lie directly on floorboards, as you do need some padding. Put down a yoga mat or a duvet if you have no carpet. Avoid lying on a concrete floor, even if it is carpeted. Your bed is too soft for this practice, but may be used if you have such severe pain or restricted mobility that you can't get down on the floor. If this is your case please read the section on adapting active rest at the end of the workshop notes. You need:

▨ A small pile of paperback books about 2–4" high.
▨ Loose, comfortable clothes you are happy to lie down in.
▨ 15 minutes uninterrupted time just for you.

Your approach to the procedure

Active rest is much more than simply adopting a position and resting in it for a while. It's a subtle combination of a bodily position that will encourage muscular release and the practice of engaging the mind in a thoughtful process of directing neuromuscular energy in an organised way throughout your whole body. These two aspects make for a dynamic procedure.

So now it's time for a nice lie down. You can get down on the floor following the series of photos above. They show the least stressful way to lie down. Getting on to the floor with care rather than just throwing yourself down will help you get the most out of the activity.

Read through the description of getting on to the floor, but adapt it if you need too. You might like to

Directing
Using your mind to send messages to your body: thinking rather than doing.

have a chair nearby to support you on the way down, or you might find kneeling painful and want to miss it out. A little experimentation will help you find the best way down.

This procedure is an active, thoughtful resting state that can help you change your pattern of co-ordina-tion. It is stress free, can be practised almost anywhere and needs no special equipment or skill. Over a period of time you will come to appreciate the benefits of a quiet mind and an alert body. Having chosen your quiet place, turn off your phone and put the cat out. Place the pile of books on the floor behind you, ready to rest your head on when you lie down.

Lengthening up from the floor

Start by simply standing quietly with your feet a little apart from each other, about a foot, perhaps a little more if you are tall. Allow your arms to be resting by your sides, with your fingers uncurled but not stiffly pointing towards the floor. Having bare feet will help you appreciate the contact of your feet on the floor, but if you are a cold person, keep your socks on. Stand quietly with your head gently balanced on top of your neck. Look straight ahead but don't lock your gaze on anything in particular. Keep your mouth lightly closed and breathe in and out through your nose. Take a moment to appreciate what is under your feet. Is it the carpet, or a mat of some kind? Is it smooth or textured? Appreciate the contact of your feet as they rest on the floor and hold you up. Aim your head up to the ceiling and allow the natural spring in your back to lengthen your body. Don't force this at all; simply ask for it. A good guide is your breath-ing. If you interrupt the gentle rhythm of your breathing then you are more likely to be stiffening up rather than lengthening.

Kneel on one knee

Kneel on one knee, still keeping your body up-right, your head gently balanced on the top of your neck and your arms quietly resting by your sides. Fold your other leg underneath you and sit back on your heels.

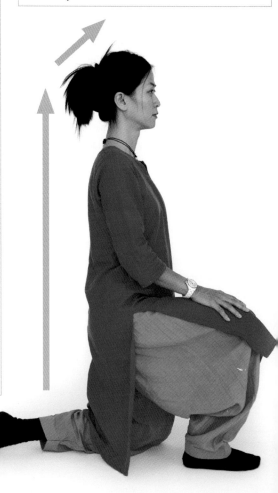

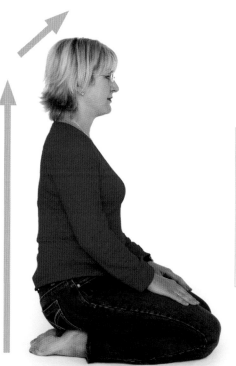

Sit on your heels

Stay there for a moment, allowing the weight of your pelvis to rest on your feet, but still having an idea of the upward spring of your back encouraging you to lengthen. Keep your mouth closed and continue to breathe in and out through your nose. Take your time over this simple movement.

Bring your knees round

Slide your pelvis off your heels to one side so that you can bring your knees round to the front of you with your feet resting on the floor. Place your arms round your knees and take the time to take five gentle breaths before going on to the next part of the procedure. Keep your head balanced and your back long, but be aware in this situation that your back will naturally be a little rounded.

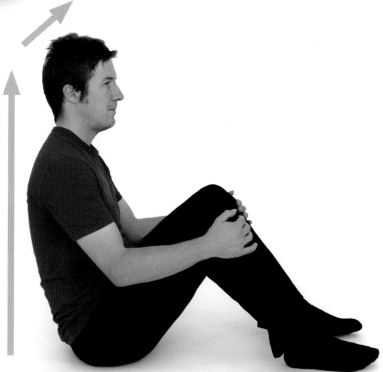

Begin rolling down

Roll halfway down to the floor, allowing your arms to support you. Keep your abdominal muscles released; this is not an exercise! Interruptions to your gentle breathing will let you know if you are making too much effort.

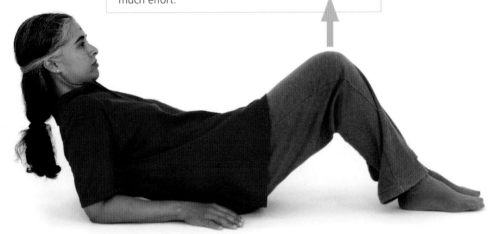

Arrive in semi-supine

Continue to roll down on to the floor, allowing your head to rest on the books behind you. Rest your hands gently on your abdomen and check your position.

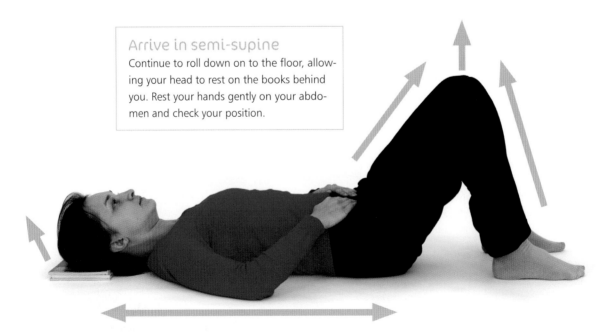

Your head is:

▓ Supported by the books so you can aim it out and slightly up behind you (see the arrow).
The books are paperbacks, not hardbacks, so they have a little give. They are sufficiently high to support you properly. You can experiment with this, 2–4" is a rough guide. If you are very round-shouldered you will need a bigger pile.
If the back of your head is bony, place a small folded towel on top of the books, but avoid using a cushion, it won't support you.

Your neck is:

▓ Free to maintain its natural curve.
▓ Not squashed by the books.

Your shoulder blades are:

▓ Resting on the ground, gently widening apart from each other.

Your arms are:

▓ Semi flexed at the elbow.

Your hands and fingers are:

▓ Resting gently and openly on you.
▓ Not clasped together or interlaced.

Your legs are:

▓ Bent at the knee so your feet are flat on the floor.
▓ Your thighs are 'pointing' to your knees.
▓ Your knees are balanced apart from each other, not touching, 'pointing' up to the ceiling.
▓ Your lower legs are pointing up to your knees.

Your feet are:

▓ About hip width apart from each other.
▓ Reasonably close to your buttocks so your legs are forming nice mountain shapes.
▓ Toes released, not scrunched up. If you feel as if your feet might slip, put a towel underneath them.

Once you are in semi-supine you can begin Track 1, **The Active Rest Procedure,** *on the CD. The track starts with you already in this position so that you can* *take your time getting ready, adapting the procedure to your individual needs. The track contains more details than the text below.*

Now that you're there

Take a little time to quieten down and then simply ask all the muscles of your back to lengthen from your tailbone to the top of your skull. Make sure you don't clench your neck muscles or your jaw while asking for this. Don't try and do it – just ask. Your brain will send messages to your muscles if you allow it to work naturally and do not try and force things. At first you may find this idea very strange and want to feel something happen. Be patient, don't try and feel things out. You will slowly become more aware of your muscular and mental state, but if you try and force things to happen, nothing will.

Lying there will allow the discs in between your vertebrae to plump up a little by absorbing fluid from surrounding body tissues. This happens because you are in a different relationship with gravity when you lie down. Lengthening muscles can gently release long held tensions and start to reorganise how your back is co-ordinated and supported. Breathing can quieten and deepen. You are not deliberately aiming to relax, but you will find yourself feeling calmer, taller and better balanced.

Stay there for about 10–15 minutes and then gently get up and walk off calmly into the rest of your day Keep practising daily and, over a period of time, you will reap benefits.

▓ Keep your eyes open, they are organs of balance telling your brain where you are.
▓ Don't give up if you don't notice anything at first.
▓ Don't listen to music at the same time; use the CD track or allow yourself the luxury of silence.

After some practice

When you are more familiar with this practice, you can give yourself more directions for releasing

excessive and hidden tension. You may wish to work independently of the CD. Experiment with the following order.

▥ Ask your neck to be free, **so that**

▥ Your head can move gently away from your shoulders (no sneaky pushing please!), **so that**

▥ Your entire back can lengthen and widen, **so that**

▥ Your legs can release out of your pelvis, **and**

▥ Your thighs can lengthen out of your hips and your knees can point to the ceiling, **and**

▥ Your arms can release out of your back and neck, **and**

▥ You can lengthen from the tips of your toes to the crown of your head.

Getting up

You will find the time you can lie down usefully will increase. Aim for 10–15 minutes each time, but stay longer if you are still able to release. You can't overdose on active rest and many people do it twice or even three times a day, according to their activities. When you are ready to get up, you want to carry the benefits of lengthening muscles into the rest of your day so it's worth taking care about getting up, just as you did when lying down. Follow the photos and instructions, but adapt to your own circumstances.

Roll on to your side. As you do so, avoid lifting your head so you can allow your neck muscles to remain free from over tightening. Keep your breathing calm and gentle, in and out, through your nose. Pause here for a while, still keeping your lengthening thoughts going.

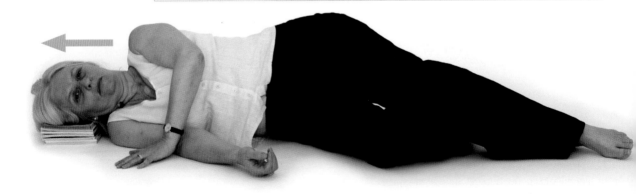

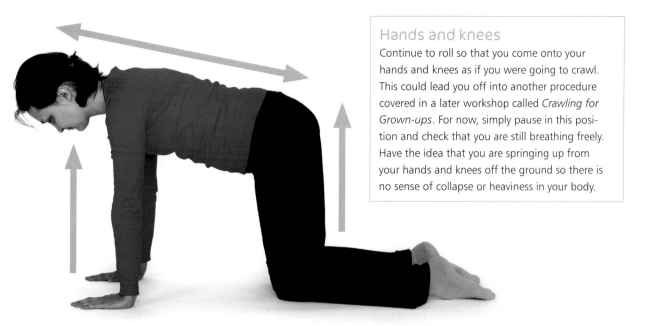

Hands and knees

Continue to roll so that you come onto your hands and knees as if you were going to crawl. This could lead you off into another procedure covered in a later workshop called *Crawling for Grown-ups*. For now, simply pause in this position and check that you are still breathing freely. Have the idea that you are springing up from your hands and knees off the ground so there is no sense of collapse or heaviness in your body.

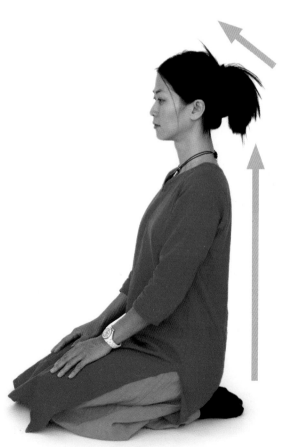

Sit back on your heels

Gently rock back so that you are sitting on your heels again and let your pelvis rest on your feet. As before, just take time to allow yourself to absorb this new position. Your back is now upright again, as it will be when you are walking, and it is helpful to maintain the sense of the back as a spring to help you support yourself easily when walking around.

Let your head lead your movement as you kneel upright. This simply unfolds your hip joints so that the long bones and muscles of your thighs are more or less in the relationship with your back that you need for upright posture and walking.

23

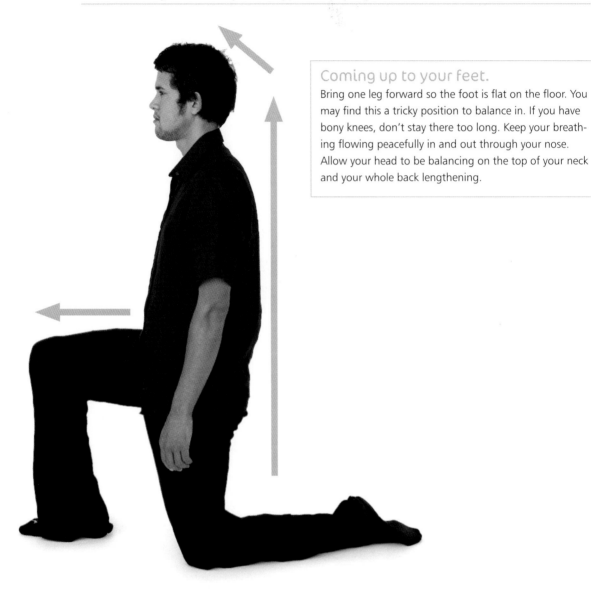

Coming up to your feet.

Bring one leg forward so the foot is flat on the floor. You may find this a tricky position to balance in. If you have bony knees, don't stay there too long. Keep your breathing flowing peacefully in and out through your nose. Allow your head to be balancing on the top of your neck and your whole back lengthening.

Adapting active rest

If you have considerable pain and the idea of lying on the floor seems too much, then start simple by exploring this procedure lying on top of your bed. This isn't ideal as the bed is too soft to promote the changes you want, but you can get familiar with the thought processes that are vital to active rest and in time you can transfer to the floor.

If you wish to start out on your bed, replace your pillows with a couple of telephone directories to rest your head on. This will help your neck muscles begin the release process.

These directions work with the most important relationship of your body. That is, the relationship of your head to your neck and back. When we hold tension in ourselves, we disturb this relationship and then every-

Standing

Gently lean forward so your own weight stimulates the movement of your body up on to your feet. Stand upright and again enjoy the contact of your feet on the ground. When you are ready, walk off calmly into your day.

thing becomes effortful. Sometimes we know why we are in pain, sometimes it's not easy to understand why pain is there. Whatever the reason, you can do a lot to help yourself by practising this and other Alexander Technique ideas. Learning to release excessive, usually unrecognised tension and, most importantly, having an upward direction in your body, allows your whole system a chance to rebalance itself. Give it a go!

Active rest is beneficial for

 Learning to relieve and prevent pain.
 Freeing your body and your breathing.
 Improving posture, balance and co-ordination.
 Reducing stress.
 Managing your energy better.
 Getting your mind and body talking to each other.

> "The best and safest thing is
> to keep a balance in your life,
> acknowledge the great powers
> around us and in us. If you can do
> that, and live that way, you are
> really a wise man."
>
> **Euripides**
> Greek tragic dramatist (484 –406 BC)

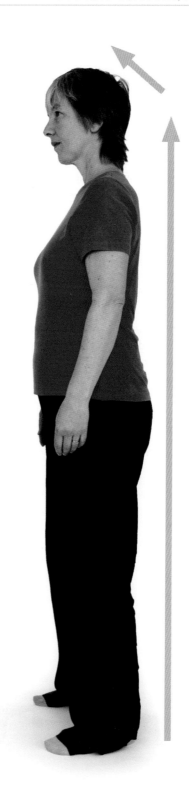

5 good reasons to lie down

A chance to stop and do nothing. In our end-gaining society, success is often measured in terms of what we have, or what we have achieved. The first question we ask a new acquaintance is not "What do you enjoy?" but "What do you do?" We measure almost every-thing, from our children's educational achievements to the size of our houses and we make judgements about these measurements. And the way we get these things is to work hard. We rush to work, we rush to the gym, and our lives are a constant movement from one place to the other. We rarely have 'time to stop and stare' as the poet suggests. Lying down genuinely gives us a chance to stop and do nothing.

Staying present

When you first practise active rest, you are liable to find your mind wandering. You may even feel bored. Nothing is happening so why should you stay there? Once you begin to focus gently on the technique of simply lying there and directing, you will find that every time is different and every practice brings new insights into your balance. In other words, you learn to enjoy staying present.

Quietening down

The process of active rest allows the nervous system to quieten down. It is a low stimulus activity and op-portunities for mind and body to achieve a different harmony from the usual jangled muddle with which

we operate. Breathing tends to deepen and quieten and blood pressure will lower too.

Lengthening muscles

Learning to allow muscles to undo under gravity's gentle persuasion and with the encouragement of your own directed thoughts makes for lengthened muscles. Muscles that are long tend to be more elastic in quality. That's what you want, best quality elastic muscles to support you at rest and in activity.

Cumulative experience

Active rest is a skill. You can get better at lying down! It doesn't have instant measurable rewards but over a period of time the effects are cumulative. The more you lie down and engage in the mental discipline of quietening and lengthening, the easier it is to do so. The pathways you set up every time you practisce become easier to follow. Lying down in this way be-comes refreshing and energising.

End of workshop 1

SUMMARY OF CHAPTER 1

- Balance involves both your mind and body
- Changing postural habits can change how your body works
- How to get the most out of lying down

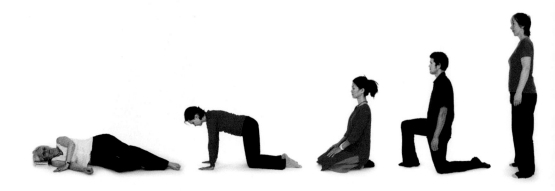

CHAPTER: 2

"THERE IS NO SUCH THING
AS A RIGHT POSITION, BUT
THERE IS SUCH A THING AS
A RIGHT DIRECTION."
F. M. Alexander (1930s)

Postural myths and legends

IN THIS CHAPTER

- Posture and its relation to Use
- Shortening and lengthening
- Exploring the concept of walking

What exactly is posture?

Posture is not a cloak that we sometimes wear and at other times shake off. We may think – or more likely have been told – that our posture is not very good. Perhaps we slump a little and are round shouldered, or we think we should learn to sit properly at our desks. How often have you been told, or told yourself, or told your children to "sit up straight"?

We live in a very image and body conscious society and most of us feel apologetic about our posture. This is often because we feel self conscious about how we look and how others see us. We tend to judge our posture, and that of others, on how it appears from the outside. What do we see in the mirror? Or reflected in the shop window? Or on the CCTV camera that we catch a horrified glimpse of? We see the outside shape of ourselves and usually we are not happy with it. But our concept of body awareness from this perspective is deeply flawed. We think we are aware of our bodies but we see them as an object. In a society obsessed with how things look, we tend

to pay homage to the outside view and have little idea of what goes on inside. We overvalue judgements concerned with appearance and undervalue judgements concerned with sensory awareness, and our internal world.

Not outside, but inside

Posture is not just about the outside of you – it dramatically affects the inside of you too. Poor posture can have significantly adverse effects on your health and well-being. It can contribute to all sorts of muscular difficulties – our bad backs and stiff necks are often posture related.

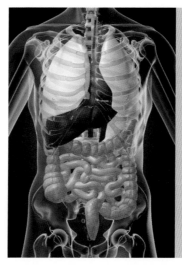

Organs can be squashed by poor posture

Our digestion, circulation and breathing are all affected by our chosen posture. The way our bodies work is directly affected by what we do to ourselves as we carry our bodies about the daily grind. If we carry ourselves with a lot of tension and effort then we create pressure on internal organs as well as wear and tear on joints and ligaments that simply doesn't need to be there.

The fix-it approach

We make attempts to improve our posture and – in order to do so – employ a variety of external aids. Sometimes this is equipment we add on to our own body, such as a shoulder brace designed to hold the shoulders back, or a body belt to support the lumbar spine because we've forgotten how to do it ourselves. Many of us wear insoles to lift the arches of the foot, or shoes that roll the foot while we walk. We buy the perfect bag, designed to cause as little problem to our back as possible. We decide to get fit and do a work out – but with little thought as to how, or what we are trying to achieve.

Not content with adding things to ourselves we alter our environment too. The perfect mattress, the support pillow, the perfect chair – perhaps a kneeling chair, the correct angle for the monitor screen, the wrist support, the ergonomic keypad, the ergonomic mouse. Type 'ergonomic' into any search engine and you will be presented with an endless list of objects designed to change your posture or your workstation.

Unfortunately these things are of little value if we continue to use ourselves in a tense and effortful way. It's not the environment that needs to change – it's us.

Not posture, but Use

Alexander teachers don't tend to talk about posture – we talk about Use. This concept recognises a complex inner harmony of mind and muscle. It acknowledges the ability we have to adapt to our environment and situation, our flexible nature and our ability to organise ourselves well. Good Use shows itself when we can go about our tasks in an effortless, balanced manner. Poor Use has us pulling bits of ourselves apart from each other, exerting excessive effort where none is needed. Poor Use sees us gripping our neck muscles and hunching our shoulders round our ears just to write a cheque. Use is about how we organise ourselves – not just for special activities such as playing a musical instrument but also for ordinary activities such as breathing, walking, doing the washing up and generally dealing with the constant pull of gravity on us.

Not what you do – it's the way you do it that counts

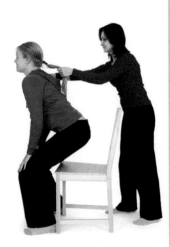

You wouldn't let someone else do this to you, why do it to yourself?

A helping hand?

Imagine yourself sitting in a chair. Just as you are about to stand up, someone grabs hold of the hair at the back of your head and pulls it – dragging your head back. At the same time that someone leans heavily on your shoulders pushing you downwards. It's a struggle to get up battling these external forces. You brace yourself, attempting to move upwards in space, but the other person is pushing you down-wards. If you are strong and expend a lot of effort you probably will manage to stand up – but it's not an easy way to move. But what if you were doing this to yourself – pulling your own head back and crushing your own body down? What if it wasn't only when you decided to stand up that you did this, but subtly all the time?

Nobody sets out to misuse themselves in this way deliberately and wouldn't do so if they fully realised what was happening. But habits – such as pulling your head back – can creep up on you slowly so you don't notice yourself doing them. You may strongly believe you don't do it – but you probably do and it isn't helpful.

Attitude and Use

The way you Use yourself is influenced by many differ-ent factors. Habit is one – we tend to do things the way we've always done them. Those 'things' include how we move about, how we walk, how we talk and how we support ourselves in gravity. Other things influence us too – our mental and emotional state all have an influence. When we wear special clothes for an event such as a wedding, we hold ourselves dif-ferently – we want to be elegant and tend to adopt a more upright carriage of our body. Ceremonial clothes have an effect on us too. No-one expects to see a king or queen slumping in their throne. If you were a king and you habitually pulled your head back your crown would probably fall off. Our language acknowledges this interplay of mental and physical states; we talk of 'a fine upstanding man', or of being 'level headed', phrases that suggest both a physical and a moral perspective of the person concerned.

Ceremonial headdress re-quires good balance, demonstrated by the elegant poise of the head on the neck

Everyday Use

Kings put away their crowns and the bride doesn't wear her wedding dress every day. The special situa-tion is short and temporary – so what happens to the idea of Use afterwards? What about when you are cleaning your teeth, or simply walking the dog: will you hold yourself in the same way? The most likely answer is no. Everyone can attain what appears to be a good posture for a period of time. The emotions of the event carry you with it but afterwards habits reassert themselves. If your habit is one of shortening yourself then that is what you will return to. The most likely reason is simple. You don't feel yourself shorten-ing – it is your normal, usual state. It is familiar, even comfortable. You are unlikely to question it until something prompts you to do so. This might be back or neck pain, or the desire to change the way you play the saxophone. You might have suffered an injury or an illness and be aware that everything is not quite right. You may have been told your 'posture' is poor. Whatever the prompt – and whether it comes from the inside (because you experience pain or difficulty) or the outside (because you are told you are tense or have round shoulders) – your situation is the same. What do you do with this prompt? How do you re-spond to a situation when you can't see the way out?

Matthew Andrews, documentary photographer

Matthew Andrews is a Brighton-based freelance photographer. He does a lot of work for the Brighton Festival and covers other local and national events. His work means he is constantly carrying a lot of very heavy equipment around and he is usually in a hurry. He took some of the photos for this book. When not rushing around from venue to venue, Matthew is glued to his computer – sorting through his work, getting the images how he wants them, writing the occasional book. Being freelance, his work schedule is completely unpredictable. Midday could find him still in his dressing gown answering emails. However in May – during the Brighton festival – you won't see Matthew for dust. He is also a hands-on father of three young children. All this takes its toll and Matthew had back pain.

Matthew went to an osteopath and got considerable relief, but the osteopath told him his posture wasn't good and he'd be constantly coming back for more treatment unless he did something about it.

The usual response to such a prompt is to stand up straight, or decide to embark on an exercise regime – go to the gym and get fit. However Matthew's osteopath told him to have Alexander lessons – so he did.

Knowing that you have poor posture and are therefore holding yourself wrongly, and knowing what to do about it are two entirely different things. Matthew knew he was tense – particularly in his shoulders and neck – but didn't know what this was doing to him, apart from the obvious effect of making him tense. Nor did he know how to stop it.

The first lessons were revealing. I asked Matthew to mimic what he did taking photographs. As he lifted the imaginary camera up to his face, he pulled his head back and fixed his whole upper body rigid, poking his neck forward into the camera. When I saw him taking photos for real this pattern of Use was even more pro-

nounced. Matthew photographs a lot of performance work where people are leaping about, not standing still. This is different from a studio situation where shots can be set up with the camera happily resting on a tripod. Matthew is his own tripod – supporting his heavy camera – constantly bobbing up and down, twisting and turning as his subjects twist and turn, so he can get what he wants. Physically it's quite an athletic occupation, but unlike most athletic activities, Matthew doesn't warm up for his workout. After the photo shoot, it's back home to work on the computer. Like many freelance people, Matthew is always on the move, but never really moving. He brings the same pattern of Use to taking photographs as he does to sitting at the computer or sitting on the bus. With a long back to support, he can no longer get away with poor Use.

Heat of the moment

Matthew stood little chance of directly changing the way he supported his body during a photo shoot. The demands are swift and constant and the job intense. It isn't the place to make change. Matthew began to realise that he not only used a lot of tension when he was working but also that it didn't stop when he wasn't working. He was still stiffening his neck and hunching his shoulders just to drink a cup of coffee. This awareness can be depressing in its implications, but it also points the way towards change. Matthew enjoyed lying in semi-supine, finding it enabled him to lengthen out in a very new way, and sometimes made him feel quite different. Releasing tension you don't know you've got is always a revelation.

The value of taking time

Taking the time to make changes when you have the chance to do so, such as lying in the semi-supine position practising active rest, really pays dividends. Matthew found himself sitting upright easily without having to constantly nag himself. When he did slump, instead of counteracting it by pulling himself up, he recognised he had in fact pulled himself down and letting go of that pulling down allowed him to lengthen up.

Lengthening is our natural response to good old gravity; it will happen if we understand it and learn to let

it happen, and that's what Matthew learned to do. In addition to practising active rest and improving his general level of awareness, Matthew practised a semi-flexed position with his ankles, knees and hips bent and his torso leaning forwards. In the Alexander world this has become known as monkey (see Workshop 3 at the end of the next chapter).

Now that he has tools to help manage his back pain, things are improving. Mathew still rushes around, but he also takes time to lie down and allow himself to lengthen. He doesn't compress himself so much during his day either. All of this takes the pressure off his lower back, allowing the natural spring to work again.

When it all goes horribly wrong

When our Use – and consequently our posture – is not in a good state the same pattern seems to emerge in everybody. Our upright structure balanced over our two small feet works well when things are harmoniously balanced, but when things go wrong our balance is disturbed. In particular, tension and poor Use interferes with the balance of our head as it sits on our neck and the balance of our head and neck relationship to the rest of our back. The way we use

the interplay of our head, neck and back profoundly affects the rest of our body. It is central to our balance and co-ordination. When things go wrong we tend to stiffen our neck and pull our head back, causing us to shorten all the way down our back. The knock-on effect is that we will tend to tighten our legs and our arms – dragging both sets of limbs into our bodies. We shrink into ourselves.

This shortening or pulling down can be gross and easily visible or it can be subtle – sometimes so subtle that we fool ourselves into thinking we are holding ourselves up when in fact we are stiffening, shortening and pulling ourselves down, the exact opposite of our intention and our perception.

Why not feel your way to a better posture? One of the problems we face when we set out to change how we balance and move in the world is our sense of kinaesthetic awareness. Mostly we rely on how something feels to tell us if it is right or wrong. But if your sense of right and wrong is itself faulty then you can't rely on it. Getting over this particular stumbling block is an interesting challenge. Instead of relying immediately on sensory feedback

Pulling (up or down): Over contracting muscles causes compression in your spine and through your body, you literally pull yourself towards the ground with tension.

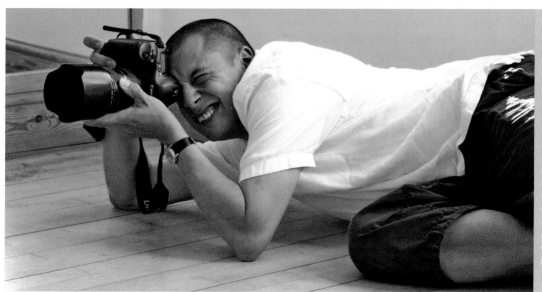

Matthew has to get to where his subject is, and use his body as a tripod. It's easy to do this with excessive tension

to tell you if you are right or wrong, you need to adopt a different attitude. When you give yourself the directions to release your neck and send your head forward and up and let your back lengthen and widen, you are both side-stepping the 'feeling' trap and at the same time improving your sensory reliability. The more you adopt an attitude of direction to encourage your body to lengthen the more you will recalibrate what is 'right' in your balance. This is an indirect approach to the problem but it gives the best results. As you improve your ability to 'direct', so your Use improves and so your awareness improves. You can still get surprises. As things unravel in your body and deeper layers of twists and distortions reveal themselves you may find yourself back in the strange territory of faulty sensory perception. So your guide here is not the feeling of things but the consideration of things. Asking for lengthening in your stature is the key to change.

The constant problem

The pattern of pulling our head back – and all that goes with it – isn't there just in movement, it's embedded in our reactions. It's in our stillness – even in our sleeping. Changing it has less to do with relaxation and more to do with revelation. When you begin to notice you are stiffening your neck and pulling your head back your first response is likely to be an attempt to relax your muscles. After all relaxation is good, isn't it? But relaxation doesn't address the chronic shortening, and without that being resolved, your pattern of Use will remain the same, or get worse.

Close-up on poor Use

Misuse is not something a person sets out to do deliberately. Most people have little idea of their Use and little idea they can influence it for good or ill. Whether you habitually hunch your shoulders and poke your neck forward, or have a sway back or knock-knees, the overall effect on you is the same – you shorten. Your whole body is pulled down towards the ground and you are probably pulled in on yourself too or, as F. M. Alexander would say, you have shortened and narrowed in overall stature. This tendency to shorten of-

ten first reveals itself in an Alexander lesson – perhaps in a movement. You will find in the course of a lesson your teacher is quite likely to have you sitting on a firm chair, or perhaps on a stool, and then moving to standing up. Although standing up and sitting down is something you do many times a day, it is a complex movement requiring a considerable co-ordination of all your various parts. It's also a very revealing movement because, with your teachers' hands on you, you are most likely to notice that you really do stiffen your neck and pull your head back and down – almost as if you were a tortoise withdrawing into your shell.

Stiffening your neck

Where do you think your neck starts and how do you think about it? Most people have a picture of the back of their neck usually starting just below their ears and ending at collar level. But your neck has a front and an inside too. Your vocal organs and swallowing mechanisms are all in your neck area. A stiff neck can do a lot more than give you aching muscles and difficulty turning your head – it can interfere with your speaking and singing voice and disrupt the smooth flow of neurological information between your body and brain. Muscles run from behind the ears over the sides of your neck down on to your collar bones; other

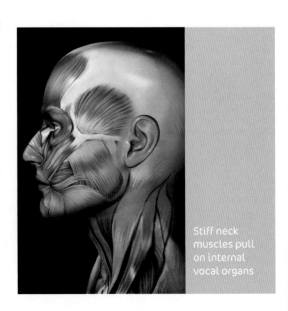

Stiff neck muscles pull on internal vocal organs

The pulling down conspiracy

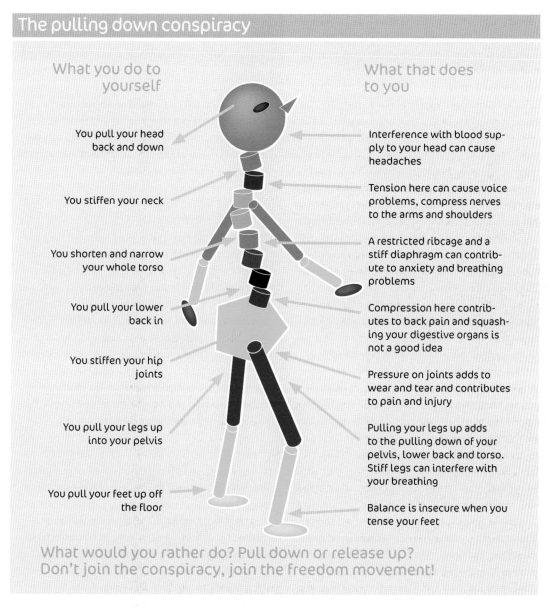

What you do to yourself

You pull your head back and down

You stiffen your neck

You shorten and narrow your whole torso

You pull your lower back in

You stiffen your hip joints

You pull your legs up into your pelvis

You pull your feet up off the floor

What that does to you

Interference with blood supply to your head can cause headaches

Tension here can cause voice problems, compress nerves to the arms and shoulders

A restricted ribcage and a stiff diaphragm can contribute to anxiety and breathing problems

Compression here contributes to back pain and squashing your digestive organs is not a good idea

Pressure on joints adds to wear and tear and contributes to pain and injury

Pulling your legs up adds to the pulling down of your pelvis, lower back and torso. Stiff legs can interfere with your breathing

Balance is insecure when you tense your feet

What would you rather do? Pull down or release up?
Don't join the conspiracy, join the freedom movement!

muscles run from the back of your skull all the way down to the middle of your back, draping over your shoulders as they go. They meet and blend in with yet more muscles running on down your back and legs. In the living, breathing human, it's more useful to think of muscles as part of a suit that covers your bones rather than focusing on individual muscles or even muscle groups. Your neck is like the first number in a combination lock. Keep your neck free and you have a good chance of unlocking bodily tension.

Pulling your head back and down

Because we are a fluid-filled being everything we do affects not only one part of ourselves but all of us. When you lift a foot your clever brain sees to it that other muscles throughout your body adjust to support you

– making sure the lifted foot doesn't pull your ribcage down on top of it or unbalance you. When your neck is in a state of constant tension, it will have an effect on your whole body. The most obvious manifestation will be some kind of pull on your head. This is likely to pull it backwards and certainly likely to pull your head down into your shoulders. Your head contains, apart from all those wonderful thoughts in your brain, organs of balance. Your eyes and ears both contribute to your balance. Your eyes take constant measurements of horizontal and vertical surfaces, telling you where you are. If your head is permanently tilted back, then your eyes will adopt a habitual position in relation to your head where they can easily see the horizon. That is where you will believe the horizon to be – because you can see it. But what if you're wrong? Many Alexander pupils find themselves quite disorientated when their neck releases and changes the way the world looks. Slipping into their cars, they have to adjust the rear view mirror because the angle is wrong now that they have changed. Your ears contain a delicate sensing mechanism that responds to gravity. Even swimming underwater, you know where 'up' is and you know if you are swimming on your back or your front. When we pull our head back, we interfere with the fine workings of our balance.

Shortening and narrowing your back

Every joint, every tendon and every muscle can give you information about where it, (and therefore you) is in space. Somehow we have to recognise this information and make use of it. When we shorten everything and tighten up, we deaden the sensations coming to us from joints and don't notice where they are or what we are doing with them. Are you sure you know where your shoulder blades end? When was the last time you thought about your tailbone? Many people walk round in a mental daze, unaware they are pulling their knees together as they walk or crushing their own spines.

Our spine is a wonderful flexible springy structure, with delicate vertebrae in the neck and larger heavier vertebrae in the lower back. In between each vertebra is a shock-absorbing disc which pads the spine and protects the spinal cord from damage. Downward pressure distorts us and makes a less effective spring.

When we narrow our backs we mostly do so in the lower back, pulling it forward and consequently poking our belly out. This has the additional effect of dragging our lower ribs down and in, so they are squashed on top of the pelvis instead of being free to float as we breathe in and out.

Pulling your legs up and your knees together

The wave of shortening carries on past your back and into your legs and feet. It disturbs the sense of your feet of the ground underneath you. This makes balance even more difficult and is likely to make you tighten up even further. You'll notice this in unusual situations such as walking down an icy path, but you are less likely to notice it as a habit that stays with you in normal circumstances. Pulling your legs up makes your hip joints stiff and drags the top rim of your pelvis forward. If you are pregnant, this makes less space for your growing baby and, even if you are not, the space for your digestive system and other organs is compromised.

Why not just stand up straight?

When we realise that we are in a state of compressive tension and we want to organise ourselves to move freely and easily about our world, why doesn't it work just to stand up straight? Why not do exercises to tighten up slack muscles or learn to hold your shoulders back so you don't slouch?

The answers are a matter of practical reality. You can indeed pull yourself up, straighten your shoulders and adopt an apparently upright posture. Unfortunately for you this is most likely to cause extra difficulties rather than address the original problem. First of all such an approach requires effort and it's impossible to sustain that kind of effort for more than a few minutes at a time – mostly because you will make that effort by piling another layer of tension on top of the underlying tension pattern you are hoping to change. Secondly, as you are

not addressing the real problem – what you are doing to yourself – you are just paddling round the outside of the problem, not addressing the fundamental issues.

What next then?

Recognising that you have a part to play in your own Use and movement brings you to an understanding that it boils down to two elements – you and gravity. What gravity does to you – and what you do under its influence – are the determining factors in your Use. So forget ideas of what is good posture. There is only the best posture for you at this moment in your life, that lets you do what you want and need to do. That is what you should pay attention to.

Workshop 2

A spring in your step: Walking without stress

Two experiments

This workshop is in two parts. Part 1 explores the action of walking in some detail. For Part 1, a full-length mirror would be useful, or a friend, to tell you what you are actually doing as opposed to what you think you are doing. Part 2 offers more general directions for walking outside.

Do part 1

At home or somewhere inside where you can take your time.

Do part 2

Anywhere! Try it at home walking up the stairs, try it in the street, on the way to the shops, or walking the dog. Whenever you walk, think first.

Your approach to the procedure

All the workshops are concerned with playing with ideas rather than telling you exactly what to do. They are observation experiments. We all have our quirky ways of doing things, but whatever our ways are, if they cause us to shorten ourselves, we need to rethink them.

In the first workshop, exploring active rest, you began an invaluable practice that offers you a chance to observe and improve your co-ordination. In active rest, you learn to become more aware of habits you may not have noticed, such as shortening your whole body, or holding your breath. You learn how to give yourself time to stop these harmful habits, so that you can create new ones. You learn how to direct messages from your mind, to your muscles, telling yourself what you want your body to do.

These messages are important ways of promoting a freer and easier use of your whole body. Without involving your mind, nothing much will change. The directions apply to any situation, not just lying down.

In active rest you are less tempted to try and put things right directly. When you are upright the temptation is greater, but the same calm approach is needed when it comes to putting what you have learnt into daily practice.

Part 1 Start simple

Start your experiment just standing on your two feet, lengthening up from your feet to your head, asking your back to widen. Ask yourself if your weight is even on your feet or are you standing more on one side than the other? If you do have a strongly ingrained habit of standing more on one leg than the other you are not likely to notice it at first.

Sway

Play about by letting your self sway forwards a little over your feet, then back, then to either side. This is a small movment, just a little, enough so you notice it. Then bring yourself back to where you think your centre of balance is, with your weight even over both feet and gently dropping through your ankles. Is it a different place now?

Lift a heel

Walking involves bending all the joints of your legs, your ankles, knees and hips, but often we are stiff in

one of the joints, sometimes we are stiff in all three sets of joints, so a little experiment with your joints will help highlight any problems.

You are going to raise one heel off the ground so that foot rests on the ball. Don't take your foot off the ground. Start with whichever foot you like, you will probably choose your dominant foot.

As you do this, the other side of your body will automatically begin to tone up more in preparation for you lifting that foot to take a step. The question is, how do you respond to that preparation? Do you:
■ Stiffen your neck, pull your head back and grip your chest?
■ Lose your sense of 'up'?
■ Let the hip on the lifted heel side drop down towards the floor?
■ Or hitch it up towards your ribs?
 What happens to your knee when you bend it? Does it track inwards towards your other knee? You can check this in your mirror or ask a friend to watch you. All of these little habits can add up to make walking stiff and effortful. Take some time to think through what you don't want and play with the heel lifting again.

Both heels

Play with lifting the other heel and take the same detailed approach to that action too. When you are ready, play with lifting the heels alternately, one after the other and check out the following.
■ Is there a lot of side-to-side swaying going on as you lift your heels? If so, you have probably lost your sense of upward direction.
■ Are you pulling the heels up or letting them rise? There is a big difference.
■ Are you compressing your hip joint each time your leg bends?
■ Are you still breathing or have you forgotten?
■ Are your ankles stiff as they move?
■ What are your knees doing?
As before, all of these habits will do you no favours; they are things you want to inhibit, to prevent. So let them go by focusing on some directions.

■ Let your body lengthen up as you move.
■ Keep your neck free and your head going up.
■ Let your back lengthen and widen.
■ Direct your knee to go forwards, away from your hip joints as they bend, and away from each other so they don't pull towards each other.
■ Direct your heels to go down towards the floor, even when you are lifting them up; this will help you avoid dragging your legs up into your pelvis. This seems a very odd thing to do but remember direction is an intention, not an action.

Part 2

Having worked with how your legs and back respond in a walking movement let that information stay with you as you walk around your daily life. You can't give yourself all those directions all the time; you wouldn't get out of the door! But the work you do re-educates your nervous system so you are less likely to fall into the old tightening habits. The most useful direction you can give yourself is to ask your neck to be free. This is a short-hand message to your nervous system to start the process of unravelling unwanted tension and let your body lengthen and widen. The more you ask your neck to free, the more often you give that 'whole body' message to yourself.

When you next catch yourself rushing along, head down, neck locked, intent only on getting to your destination, don't stop walking, but do ask yourself to free your neck and let your head direct up. You'll be surprised how effective it is.

SUMMARY OF CHAPTER 2

■ Your posture affects how you move, and vice-versa
■ Don't pull down, release up!
■ Walking well with less effort

CHAPTER: 3

> "EVERYONE IS ALWAYS TEACHING ONE WHAT TO DO, LEAVING US STILL DOING THE THINGS WE SHOULDN'T DO."
> F. M. Alexander (1930s)

Gravity, gravity, gravity

HOW YOU DEAL WITH GRAVITY DEEPLY AFFECTS THE WAY YOU ARE

IN THIS CHAPTER

- How we interact with gravity
- Inhibition and primary control
- A new method of thinking

Same old, same old

We interact with the world through our muscles. We communicate through our muscles. When you talk you must activate jaw and tongue – using muscles to do so. When you think, you are awake and are using muscles to stop yourself falling over and much else besides. The question is – do you use your muscles well or not?

The tendency we have to misuse ourselves by shortening and pulling down is a powerful habit. It is a response in us that is there all the time, waiting to be triggered by some kind of stimulus. The stimulus could be almost anything, from our desire to get somewhere in a hurry or an attempt to do something like stand up. It might be something we want to do, or something someone else demands of us.

It's not just when you walk around or play your violin that you are likely to pull your head back; it's not just nervousness or anxiety that causes you to stiffen up; the tendency is so ingrained that it's more than a simple movement problem – it's our basic response to the pull of gravity, it's a habit.

Habit can be comforting – we like familiar activities and routine. Freedom from routine is a little scary and often we avoid changes – even good changes – because the familiar is what we know and what makes us feel safe. Habits can become so automatic that we no longer register them or their effects. In the days when more of us smoked than now, lighting a cigarette was something so habitual that people could easily finish a packet without knowing they'd done so till it was empty. Chocoholics will recognise the same tendency for chocolate to mysteriously disappear.

Start to choose

Becoming aware of your responses to everything around you creates an opportunity to change your pulling down habits. This awareness is not so easily come by and often starts when your Alexander teacher points out that you really are stiffening your neck. You are likely not to believe it, or to feel it, which does make responding problematic. Once you have an inkling of what is happening you can take steps to avoid it. Every time you refuse to stiffen your neck and pull your head back, you make it easier not to do so the next time and you break a link in your chain of habit. Likewise, every time you stiffen up, you reinforce that habit. So decide what you want and make your choice.

Choosing your response

**Your choice
You choose**

The challenge
Something happens – the phone rings, the dog barks, or you decide to move. What's your response? You could...

Respond automatically, the way you always do, without thinking. What happens then?

Take time to think about your reaction, choose not to respond in the same old way. What would that do for you?

You stiffen your neck. You pull your head back. You shorten your back. You narrow your back. You clench your shoulders.

You rush to answer the phone. You shout at the dog, who doesn't listen because you're always shouting at it. You move stiffly.

You decide not to stiffen your neck, or pull your head back, or shorten your back. Not an easy decision!

You're not tense as you answer the phone. You speak to the dog rather than shouting, distract its attention. You move differently.

ARRGG!! By responding in this way, which is what you always do, you make it easier to keep responding in the same way. You reinforce the pathways of response so they are unthinking. You have trained yourself to be like this! It feels normal, but unfortunately it might be exactly what you need to avoid! All that tension throws you off balance and is a waste of precious energy.

AAHH! You have taken a step to break the chain of habit. By doing this you gradually change the way you respond to situations, even situations such as 'posture', which most of us don't think of as a situation at all! But 'posture' is something we do and something we could do better! Learning to stop the rush to react gives you breathing space to think.

**Your choice
You choose**

Make a friend of gravity

How can you choose to break the pulling down habit? Once you learn that it's not so much any movement you make or don't make – it's how you respond to anything that comes your way – you begin to see that it's not just a physical situation you

are dealing with, it's a mental one too. Your mind reacts so quickly to circumstances that your body is off and running before you know it. Understanding this lets you break the cycle by deciding to stop the automatic runaway train response. Think of it as saying, 'No thanks – not today' to your nervous system, or perhaps, 'well, just a minute, let me think about that'.

Creating this thinking space between any stimulus you experience and your reaction to it gives you a chance to choose. By choosing to break the pulling down habit, you make it possible to respond positively to gravity, allowing it to lengthen you rather than shorten you. You could of course decide you want to carry on with your old nasty pulling down habits. It is, after all, a choice. F. M. Alexander called this pause 'inhibition' and told people that they must first inhibit their tendency to react to stimuli if they were to have a chance of changing how they used themselves.

> "Inhibition is the most wonderful thing. In that moment between stimulus and response is a complete and total freedom, a sublime opportunity to change the world, or do nothing at all. It is not an empty space, but a place of infinite possibility. The more I see it, the more I value it."

> Guy Richardson (Composer)

The stimulating effect of gravity

Thanks to the space programme, we know quite a bit about the effect of gravity – and indeed zero gravity – on human beings. Take gravity away and people have enormous difficulty straightening their limbs. Instead, all joints come to rest at a mid-way position in their range of motion so that elbows and knees are flexed, fingers curled and the spine rounded forward. We are used to seeing floating astronauts in this position as an iconic image of the 1960s.

Back on terra firma, if we examine the relationship between gravity and conscious thought we can see that this makes for an upright attitude in man. It's not enough to stop pulling down – although it is a vital first understanding. There's more. You need to understand how a lengthened free body behaves and then wish for it.

We need gravity to help lengthen us

Primary movement

When F. M. Alexander first began teaching his work, he talked about a primary movement. This was an upward movement of the whole body, relative to itself. It didn't mean stretching or putting your arms up. It meant having a tendency in your entire self to be moving upwards instead of moving down. In particular, Alexander was referring to the head, the neck and the back as leading this movement, but he included an understanding that it wasn't helpful to tighten the legs and feet either. Later he refined this concept and called it the primary control. This reflected his understanding that when the central core of us – our head, neck, back, and legs – are working in an integrated way, then the rest of us will work well too. Looking after your primary control is the most important and useful thing you can do for yourself. It may be your hip that causes you grief, but attending directly to that area alone will only give limited benefit. Attending to what you are doing with your head, neck and back – and ensuring your feet and ankles are free from tension – will have a more profound effect on your whole structure – and help your hip too.

Fluid
forward
motion

From the top down and the bottom up

Alexander's observation about the head, neck and back and legs gives us an insight into useful co-ordination. We want to lengthen throughout ourselves from the head down through to the feet and from the feet up through to the head. This is true not just of humans, but of other animals too. Mammals exhibit this coordination in many of their movement patterns. When a dog leaps into water his entire body flows forward with the leap – the head leading the outstretched body and limbs, the tail following for balance. This co-ordination gives the dog appropriate strength and energy for the forward leap. It is not relaxed or limp but full of focused muscular intention. This labrador has no room for a stiff neck in this activity.

Turning

Turning either slowly or at speed reveals the same principle at work. Four-legged mammals with forward-facing eyes, such as dogs and cats or side-facing eyes, such as horses or elephants, all exhibit a fluid motion from end to end of their bodies. The tiger – changing his direction and walking in a lazy curve – turns his head to look where he is going and his long

body follows him. His legs respond to the movement of his back to place his feet underneath him on his chosen route and his tail balances the path of his body. Domestic cats walk in the same way and when they roll in the dust in the next door neighbour's garden – while you stand there futilely calling, "here kitty" – it is the head that initiates that luxurious rolling movement and the tail that balances it out. Each species of animal has a different conformation from other species – a horse's neck is quite different from a dog's neck, a giraffe looks radically different from a mouse. However, what they have in common with each other, and with us, is a head, neck and back that they must organise if they are to move freely about their business. Animals tend to move in a way that gets them from where they are to where they want to be. They don't look one way with their head and move another way with their body. That is a human trait – looking over your shoulder whilet walking in the opposite direction. You can do it because of both your structure – with your very flexible neck and easily turned head – and because your human consciousness allows you to adopt almost any movement pattern you want. Whether you should or not is a different issue.

Tiger changing direction, head leading, tail comes last

Movement at speed

When a horse changes direction while moving at speed it has much to co-ordinate. When it is galloping only one foot is on the ground at any moment. That foot must be placed to allow the next foot to come down in the right place and this process is ongoing. Each foot must take the horse further round the curve of its movement, all without falling over. The horse must angle its body towards the way it wants to turn, leaning over into the curve. It must bend and flex its neck and body. It must keep its legs underneath its body so as not to injure itself or fall. This horse is doing all this on snow-covered ground. Sometimes it does all this with a saddle, a rider on its back and a metal bit in its mouth.

This is instinctive in the horse and it moves by allowing its head to lead and its body to follow. The complete co-ordination package of tail balancing and feet contacting the ground allows for easy movement in the horse. An experienced rider – finding herself in difficult terrain – will literally give her horse its 'head', knowing that it will be more successful at picking its way across rocks and bad surfaces than she will be if she attempts to guide it.

In the early days of horse-drawn carriages – when selfish fashion dictated that horses should hold their head up unnaturally high – a bearing rein strapped a horse's head into a position where its strength was compromised. The strap caused the horse to stiffen its neck and literally pulled its head back. Going uphill in such a manner was a tremendous strain, leading to many horses' health breaking down as they became broken-winded. This unnatural practice didn't allow the horse an opportunity to co-ordinate itself successfully. In the animal kingdom, baring the throat by pulling the head back is a position of submission, not strength. My dog does it when the cat, who rules the household with iron paw, gets too close for comfort. The message it sends is, "I give in, you've got me, I can't move now." It's a literal message, you can't move easily with your head pulled back.

Horse balancing as it turns at speed

The happiness of lengthening

Lengthening is a natural state, and it doesn't mean standing up rigidly straight. Your muscles clad your skeleton like a well-fitting suit – a muscles suit. You can be lengthening your muscle suit even if you are curled up in a little ball. It's not about adopting a particular position – it's about adopting an attitude of mind that lets your body flow upwards from the ground in any situation. If you want to bend and twist yourself into wonderful yoga postures, you can do so with release, length and flow. If you want to sit and play your cello – without bodily and mental tension holding your performance in check – you can keep a length through your back and arms and flow into your instrument so your cello becomes part of you and your bow an extension of your arm. If you want to engage in dynamic activity, such as horse riding, you need a way to harness tone and energy in your body. When you read this, the language sounds theoretical – but this is a practical matter. A tight, short muscle suit will not flow and will not let do what you want to do or do anything to the best of your ability. However, a lengthened, released muscle suit will let you do far

An upright lengthened meer cat is on the lookout

cat can flow through my hands like water and jump effortlessly onto the garden wall. However, neither of them can stand on their hind legs, walk along and use their front paws to bring food to their mouths. I, on the other hand, can wander round the house eating an apple, turning my head to look where I'm going and twiddle a pencil with my other hand. Even with only two feet to connect me to the ground I can constantly make the necessary adjustments in my body that I need to prevent me falling over. My whole brain and being has plasticity – an ability to adapt and change according to my circumstances. I can orchestrate my movements and reactions to my environment from moment to moment without effort. Keeping my neck free is one useful component in allowing my flexible nature to work for me. The point is – I want to be free to move where I choose to move – not to be held in any idealistic position or restricted from movement by my own tension.

more than you thought possible. A lengthened body is quietly alert. You can observe this quality in the animal world too.

The look-out of the meer cat clan raises itself up to its full length with its head balancing on the top of its neck. It is both relaxed and alert, watching for trouble.

What does a free neck mean?

In humans, our head balance is a delicate, somewhat flimsy affair. Our skull rocks on two very small contact points with our first neck vertebrae – which is a very small bone in comparisonwith the size of our head. Our whole neck column is wonderfully flexible – allowing us an extraordinary degree of twisting and turning in all manner of ways. Keeping it free is a task requiring constant reorganisation and adjustment. I want enough tension in my neck to stop my head simply falling in a heap on to my chest, or lolling over on to my shoulder, but I don't want so much tension that I lock up my muscles and make movement difficult. My dog – with her four feet on the ground – can turn her head and look over her shoulder as easily as I can. My

Without excessive tension in your neck – if you ask for it – your head will tend to move upwards in relation to your neck. As your head is heavier in front than at the back, there is a forward element to the movement too. F. M. Alexander describes this accurately as "sending the head forward and up". The subtle movement of the head forward and up has a toning effect of the muscles of your back, stimulating a lengthening throughout your back.

A well-balanced head

Allowing your head to be freely poised on top of your neck is a bodily attitude sometimes seen in classical painting and sculpture. It goes with a sense of calmness of temperament and a balanced attitude of mind. The face is free of tension with eyes and mouth quietly reflecting an inner poise. The statue depicts a clear link between state of mind and state of body. From an Alexander perspective the statue shows good Use of the head and neck. The sense of poise and balance continues throughout the whole body.

Length and openness

This statue of Mary, mother of Jesus, shows her lengthening up from her feet, with her head poised on the top of her spine. Clearly her head isn't pulled back as her chin is not poking forward. Her neck is long, so is unlikely to be stiff. Her shoulders and chest are open, with her shoulder girdle resting on her rib-cage. Her arms are lengthening out of her shoulders and her hands are open, displaying the palms, free from tension. Her body weight is evenly distributed between both feet and her whole appearance is one of ease and openness of body and mind.

Compare Our Lady with the businesswoman (see next page) who pulls her back in and clasps her hands together because they are tense, and the businessman facing her who exhibits tension in his legs and shoulders, which creates a rigid look to his head and neck.

The head of Jesus is poised on his neck, gently nodding forward

A new direction

Good Use is a question of practical balance. It is being able to use yourself in such a way that all the habits that pull you down and interfere with your freedom of movement are denied their usual pathways through your body. More than that, it is the setting up in yourself of new pathways of direction that will help you respond positively to gravity – allowing it to stimulate you to lengthen rather than surrender to shortening. In a course of Alexander lessons, you would be introduced to this idea that you can influence your Use positively by directing your muscles to do what you want. So what is it that you want? What are these mysterious directions and how do you give them?

What you don't want and what you do want

Spiral thinking

At the heart of the matter is this – you want to choose how you respond to things, because if you don't choose, you respond in an unthinking, habitual way. This will include you doing things to yourself that are not helpful such as stiffening your neck, pulling your head back and shortening your back. The effect of this

can be unpleasant and even painful, causing problems with your breathing, circulation and digestion. It will also make your movements stiffer and effortful without that effort being rewarded. So, if you are to change the way you respond, you first have to stop responding. You have to deny yourself the habit of stiffening and shortening. Instead you choose to give

An open posture

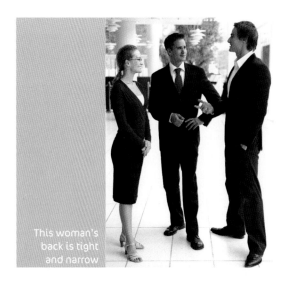

This woman's back is tight and narrow

merge. When F. M. Alexander gave advice to his pupils about how to give their directions he told them to give them, "one after the other all at the same time".

Initially this seems impossible, it seems like a jumble of thoughts on which you can't quite focus. This is because the type of thinking you want has qualities not normally associated with thought. You are using your mind to create a field of awareness that includes your reactions, your previous knowledge of your habits and a new template of desired behaviour. You are filtering this through all your senses, including senses to which you don't normally pay attention such as balance and proprioception (internal messages from joints and muscles telling you where they are – sometimes called our sixth sense).

The diagram opposite illustrates something of this process. Start in the middle, with your thoughts, your conscious awareness and your ability to choose and think clearly. From there you could move out in a number of directions as indicated by the inner circle of dark blue arrows. This pathway suggests an inhibition journey, starting with the red circle of inhibition. Each aspect of your thinking and experience feeds back into the central awareness, refining and consolidating your ability to think more and more clearly. You can move round the path from the circle of inhibition to the circle of direction, which allows you to give yourself new thoughts and directions. Giving new directions is a bit like housework, its wonderful when you've finished and have a shiny clean house, but somehow the dust creeps back in and you find you have to do it again. Our old habits are like the house dust – they creep up unnoticed. So, every now and then, you need to check out your thinking. Your attention shifts from your centre, out to your limbs, your inhibition and direction processes and shifts back again to your centre. What at first seems complex and unobtainable becomes much simpler and is a skill that improves with time and patient practice – mostly in active rest but also in any activity you can dream up. It contains a simple message – expand! It also contains all the elements you need to consider if you are indeed to expand.

yourself new thoughts to work with; new directions for your body to make sense of. You ask your neck to be free from tension so that your head can go forwards and upwards and your back lengthen and widen, your knees can release out of your hips and your arms release out of your shoulders.

To do all this you have to contend with the power of your habits and your lack of reliable sensory awareness about your situation. If you have the habit of tilting your head to one side it will feel straight to you, but it isn't and only when someone points it out to you will you notice. You will most likely respond to this new information by attempting to straighten your head out and you will make that attempt by doing the very things you want to change, such as stiffening your neck. And there you are, back at square one. However, there is a way out...

Don't think in a straight line

When it comes to increasing your understanding of how you function and move, linear thinking will not get you anywhere. It's never a simple step 1, step 2, step 3 process. What is needed is an ability to think differently and be able to string thoughts together until they

Inhibition and direction trail

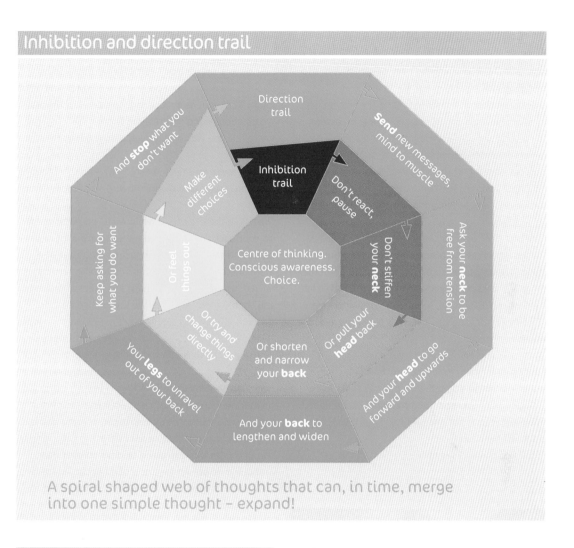

Direction trail

And **stop** what you don't want

Make different choices

Inhibition trail

Send new messages, mind to muscle

Don't react, pause

Keep asking for what you do want

Or feel things out

Centre of thinking. Conscious awareness. Choice.

Don't stiffen your **neck**

Ask your **neck** to be free from tension

Or try and change things directly

Or shorten and narrow your **back**

Or pull your **head** back

And your **head** to go forward and upwards

Your **legs** to unravel out of your back

And your **back** to lengthen and widen

A spiral shaped web of thoughts that can, in time, merge into one simple thought – expand!

A unified field of attention

Any new skill that has a degree of complexity is acquired gradually though experience. Learning to consciously monitor your reactions and lengthen is like learning to drive a car or perhaps to play chess. The task has so many variables, so many unpredictable possibilities and so many things to attend to at once. Nearly everyone masters the skill of driving to such an extent that they can hold a conversation, listen to music and still get home safely. Experienced chess players can not only envisage the entire chessboard at a glance, but also anticipate whole sequences of possible movements both by themselves and their opponent, almost without conscious thought. It's as if they fly over the board and have a bird's eye view not only of what is happening, but also of what could happen. This kind of skill is built up from experience, increased awareness and ability to process information in a non-linear fashion.

Just as no one expects to be a grandmaster after a few games of chess, or drive a car after a few lessons, no one should expect to change their relationship to gravity without giving the matter considerable time and thought.

Anna Thorell, ceramicist

Anna decided to have Alexander lessons because she was suffering from crippling back pain that was interfering with all aspects of her life. Working with clay is heavy work and Anna was finding she was limited in what she could do. During the course of lessons, she recognised similar thought processes and ideas in the Alexander Technique that she used in dealing with her own work. The following paragraphs contain my observations of her Use patterns and extracts of conversations between Anna and me during lessons.

"I've had back pain for some years now," said Anna. "When I stand at the bus stop waiting for a bus to my studio it's sometimes so bad that I have to go home." While she talks to me Anna is smiling, she waves her hands around and I can see that her shoulders are stiff simply from the way her arms fail to move as she waves her hands.

I ask Anna to stand in front of my teaching chair and put my left hand up on the base of her neck. As I expected her neck feels like it has been concertinaed down for years. I put my right hand lightly on the crown of her head.
"Shall I sit down?" she asks.

Anna wedging clay; it's heavy work

"Yes, do," I say, realising that even a short amount of time standing still is difficult for her. Keeping my hand on her neck I say to her, "Part of what this work is about is learning to use ourselves in a better way. You might think of it as a more appropriate way. The way we go about our daily lives, the way we walk, or sit, we will do the way we've always done things."

"I don't know what you mean," says Anna, "I thought you were going to show me how to sit properly."

"Just sit in the chair for a while whilst I put my hands on your back. You have told me you have a lot of back pain and that you have bad posture. You have also mentioned that you are tense. These things are connected, and together they have the effect of making you shrink, making you, as we say, pull down."

"Here is your neck," I say, "under my hand. And of course your head is above it and the rest of your back is below it. What I'd like you to do is think about your neck. Talk to it if you like. And what I want you to talk to your neck about is not being so tense – ask it to release some tension. You see, because your head is above your neck, if your neck muscles are very, very stiff and tight they are going to drag on your head and pull it down. And we don't want that – it leads to all sorts of problems. The reason I want you to ask your neck to release – to undo some of the tension – is so that this drag on your head can stop and it can go up a bit.

"Here's my other hand on the top of your head and so you can literally think your head up into my hand."

Anna is keen to do what I ask and starts to stretch her neck out and raise her eyebrows. "Is this right?" she asks.

"The thing about release is that it is a letting go process, an allowing process, so you have to ask your neck to do it for you. Rather as if you were asking a good friend for a favour."

"Oh," says Anna, and well she might. But, bit by bit she is responding to my hands and quite suddenly her neck undoes and her head goes up.

"Oh! That feels really odd, what did you do?"

"I didn't do anything. I encouraged your neck to release, as we've been saying."

Standing in front of my teaching chair Anna clasps her hands in front of her.

"Just let your hands rest at your sides," I say.

"But it feels so much more comfortable like this."

"Possibly it does. But it is excessive tension that makes you seek the familiar stance and if we're going to change that, then you can't take too much notice of what things feel like. It's not necessarily how they are. It might feel comfortable to stand with your hands clasped, but you're actually reinforcing the tension patterns in your arms and back."

"It feels to me as if you are pushing your hand into my neck when I sit down," says Anna. "Do you want me to put my head in a different place?"

"No. I want you to stop pulling it back in the first place. If you put it in what you think is the right place, the right position, you are simply adding yet another layer of tension on to the layers that are already there. And it does no good, you've got to get to the basic problem."

"My pots are a bit like that sometimes – well not my pots, my ceramic sculptures. If I've not got what I want it's often better to chuck the whole thing in the bin than to try adding extra bits on. I do hope you don't want to chuck me in the bin. Sometimes, when I want to make something different in clay, and I don't know what I want to do, I sort of play with the clay. I try not to think about it, I make some kind of mental switch in my head, because if I don't, I find I just

produce the same piece of work over and over again. It's alright doing variations, but when it goes too far, it's just stale."

"That's right!" I say, "So what we need to do is take a fresh look at the way you get out of a chair."

After a few lessons Anna says, "I have been doing a bit of semi-supine, I can't stay there very long and I'm sure I do it all wrong, I'm all the wrong shape somehow."

"I wouldn't worry about that, Anna. Alexander always said that his technique was about the individual, not a set of fixed rules. It's not about being straight. Walter Carrington, who trained me, often told us a nice story about Alexander and his best pupil. When F. M. Alexander taught in rooms in Ashley Place in London, there was a waiting room for pupils. One day, F. M. told a few of the training course students that his best pupil was in the waiting room. So they trooped along to take a discreet look. But they came back disappointed. There was no one there they said, except an old lady who was very twisted.

"She", said F. M. "is my best pupil!"

"What he was referring to wasn't her structure, but

Working a potter's wheel demands co-ordination

her ability to inhibit and direct, to make the best possible use of herself. Straightness is not a reliable judgment of good or poor Use."

Anna pondered. "We have jam like that," she says finally.

"Jam?" I reply, totally baffled.

"Yes, a Swedish jam made from some berries that you only find in particular areas of Sweden. They are a yellowy orange. But when you pick them and cook them, they change to a muddy brown. It doesn't look good, but it tastes wonderful. We eat it hot with ice cream."

Now that I have given Anna some lessons, I have some idea of her Use. The concertina-like compression of her neck is obvious, but it is only part of the picture. She uses her hands and arms a great deal – when she throws clay and does her ceramic work. Her arms are very contracted, and pulled up so that her shoulders are not only rounded, but also raised.

Her lower back is pulled in, is tight and seems very weak. Her legs are drawn up into her torso, just as her arms are drawn into her back. Her joints are very stiff. She says she feels like the tin man in The Wizard of Oz, and I can see what she means. She is noticing that she pulls herself down.

"I think I understand now how I pulled myself down wiping my feet on the door mat. But in my family, we were brought up to be very clean in the house. We take our shoes off in the house. I found it very odd that in England people keep their outdoor shoes on when they come inside. It's so dirty isn't it? Where we lived, in the country, you nearly always got muddy when you went out, so you would take your shoes off when you came in.

"I suppose it's different nowadays, and perhaps it's different in the city. But you see, because I keep my shoes on when I come into a house, I make sure there is nothing on their soles. So I wipe my feet very thor-

oughly. But I used to do it very heavily, I can see that now," Anna laughs. "You'll have to teach me how to wipe my feet."

"You don't have to learn to do everything separately," I reply. "The idea is to improve your Use so that whatever you do, you use less tension and effort. Next time you want to wipe your feet, ask your neck to release and send your head up as you do it."

Anna is quiet for a while and I continue to work on her. Taking her shoulder, I slip one hand up high under her armpit and put the other over her scapular. Directing my hands into her I am aware that she is pulling down much less through her middle, and her diaphragm is not so tight. This in turn enables her shoulders to release and widen. Her shoulder releases under my hand and eases away from her neck.

"You know, when you work on me, I feel as if I've been drinking champagne. It's wonderful. I really like it. I can't get the effect so strongly when I'm on my own, but a bit of it. Why is that?"

"You are learning a skill and, like any skill, you'll always get more when a teacher is guiding you. The more you practise it, the better you'll get at it, till you can direct easily for yourself. It just takes time, that's all."

Anna giggles, "My neck feels like ET's, all elongated. It's a bit odd isn't it? You don't stretch my neck out or anything and yet, when I've had my lesson, I feel as if my neck has stretched but somehow from the inside. I had some physiotherapy some time ago, and she actually pulled on my neck and twisted it from one side to the other. She said she was mobilising it. But it felt like agony to me and I always felt as if I was fighting her. It doesn't feel like that with you, it's a lot easier."

"Good," I reply. "That's because the way we use our hands as Alexander teachers is quite different to the way other therapists use theirs. We pay attention to our own Use so we can to help you to improve yours."

"The other day, when I was throwing clay," says Anna, "I suddenly felt myself pulling my head back. So I thought about releasing my neck and sending my head up. I've not felt it before – up to that point it did all seem rather vague. I tried to explain what I was doing to Sally, who shares my studio, and I couldn't express it at all. I told her that I was releasing my neck and sending my head up and she just looked completely blank and asked why. I tried to explain that it helped my arms but I think she just thinks I'm a bit strange. I'm realising that it's so difficult to explain, because you can't feel it until you feel it can you?"

Now that things have improved, Anna does more walking, applying her directions as she does so.

"I've been thinking about it quite a lot when we are walking. When I start to get tired, I realise I start to pull down more. So, I think instead about sending my head up and it makes a real difference. Of course we take frequent breaks. We are not the sort of walkers who just want to get as many miles done as possible. We like to admire the view so it's easy when we stop, to think about directing."

Anna has continued to have lessons and is making steady progress. She now feels she has a positive way of working with her back problems. She is great fun to teach because she asks such clear questions and relates to the ideas in different ways.

Workshop 3

Flexion without tears: monkey with your hands on the wall

Read through the workshop material first to familiarise yourself with the concepts. This will greatly improve your understanding and enjoyment of the audio instructions. When you are ready, select Track 2 on the 'Workshops CD'. The CD will talk you through the monkey procedure in detail while you are doing it. It contains directions and thought pathways for you

to follow. The idea of this procedure is to give you a chance to use yourself in a more springy way whilst being upright. There are many different ways you could practise monkeys; this variation gives your arms a chance to act as weight-bearing limbs without having to resort to press-ups.

You will need

■ A small area of wall without any furniture in the way that you can put your hands on with your palms flat on the surface. A door is suitable for this too.
■ Thinking space.
■ Time.

Your approach to the procedure

Like active rest, monkey is much more than simply adopting a position and staying there. Think of it as an experiment in observing the subtle combination of your bodily position and the practice of engaging your mind in a thoughtful process of directing neuromuscular energy in an organised way throughout your whole body.

Begin by standing facing the wall or door, about two foot away from it. You need enough room to be able to bend your hips and let your upper body incline towards the wall without bumping your head on it. Don't rush standing, the more you think 'I want to get on with this' the more likely you are to surreptitiously pull yourself towards the wall and tighten your shoulders and chest as you do so. Take the time to stand and allow yourself to lengthen from your feet up to your head via your nice free neck and from your head down to your feet via your nice free back and legs. Appreciate the weight of you on your feet and let your body spring up from the ground.

Ask the joints of your legs, that is your ankle joints, your knee joints and your hip joints, to unlock, so as to be ready to move. At the same time, don't move

them without giving yourself this mental instruction. You are preparing to move, not actually moving. Keep in mind your overall desire to go up, to lengthen and not to shorten.

Head direction

In your mind's eye, picture a big red dot on the wall in front of you, about three feet above your own height. You can aim your head towards this dot. Use it as a reminder that you wish to avoid pulling your head away from the dot rather than straining towards it. It is a prompt to direct your thoughts rather than a bull's eye you must accurately hit.

Still keeping your 'lengthening' thoughts going, allow your ankles, knees and hips to flex, letting your whole torso lean forward from your hip joints, so you are folding up a little like an anglepoise lamp. Make sure that you don't let your neck and head dip down and droop forward as you lean forward; keep aiming up towards your magic red dot on the wall. Don't go too low; probably lowering your overall height by 9 inches or so will be enough.

Hands and arms

Having got 'there' give yourself time to repeat your directions and continue to inhibit the strong desire to let your neck stiffen and your head pull back, or your legs to tighten up and pull your feet away from the supporting floor. Instead, ask your neck to be free, your head to go forward and up towards the red dot, your back to lengthen and widen and your knees to direct out over your toes. This means your thighs must let go of clutching on to your hips and lengthen. Let your feet stay resting on the floor with your heels gently dropping into the floor. Take time to set up this cycle of directing in yourself. With practice it will all blend into one direction – up!

You are now going to place your hands, one at a time, on the wall in front of you at shoulder height. If you do this unthinkingly, you will tighten your arms and neck in order to bring your hands up, so don't do that! Instead, picture your arm being supported by and emerging out of your lower back; don't worry how that might work anatomically, it doesn't matter. What is important is that you allow your lengthening and widening back to keep lengthening and widening to support your arm.

Let your finger tips lead your hand up and simply place your palm on the wall. Don't be tempted to do this in ultra slow motion, you will probably stiffen up if you do. But don't rush it either, give yourself time to keep thinking while you are moving.

Before you bring the other hand up, go through your directions again.

Let the neck be free to let the head go forward and up

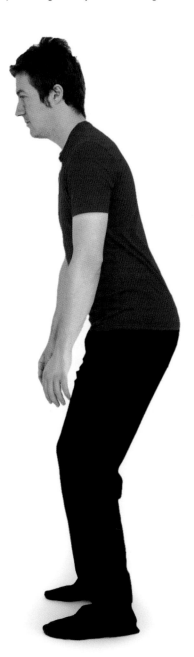
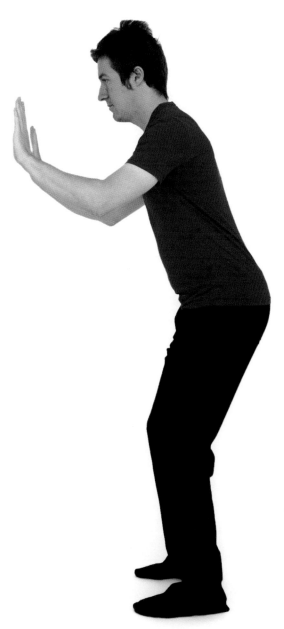

And the back lengthen and widen
And the knees go forward from the hips and away from each other.

Now bring the other hand up. Place your hands ap-proximately shoulder width apart. You don't want to lean heavily on them, but you want your arms and hands to rest gently on the wall. Keep the magic red dot in your mind and allow yourself to continue to direct up.

Stay there for a minute or so. If you have weak arms or RSI problems this will be very good for you to do, but make sure you don't stay there too long. Take your hands off the wall one at a time, repeating your directions.

Allow yourself to straighten up from your flexed posi-tion taking care that you don't simply pull yourself around as you do so.

Free joints and a length-ened back

Reconnect with the balance over your feet when you are fully upright. You can do this as often as you like (perhaps not in public!).

After some practice

When you have experimented with this procedure for a while and are aware of all the pitfalls you can play with gently sliding your hands higher up the wall. If you follow the same pattern of maintaining direc-tion you will gradually get a greater sense of opening across your shoulders and chest.

Application

If you love to ski, or are thinking of taking it up, this procedure will be very helpful. Keeping your neck free when speeding down hill is a lot easier if you have thought about it before you get to the snow. You can use this co-ordination to do many ordinary tasks such as washing up or cleaning your teeth. You can also use it to complement active rest, as a way of improving your own use. Flexing your hips, knees and ankles freely is a vital part of your general mobility; you need it in all sorts of situations – such as walking up and down stairs, or simply walking, sitting in a chair, putting your shoes and socks on, moving about the house or maybe jumping off a bench! It's part of your Use pattern and part of your general co-ordination.

SUMMARY OF CHAPTER 3

▓ Make the most of gravity

▓ Reactions and co-ordination are linked

▓ The way you organise your thinking affects the quality of your movements

CHAPTER: 4

Back pain, ME and Fibromyalgia

IN THIS CHAPTER

▨ The origins of back pain in poor Use

▨ The rhythm of inhibition and direction

▨ Inhibition as the key to good Use

A skill

When you learn the Alexander Technique you are studying a skill of balance and release. Like any other skill, you can get better at it if you think about it and practise it. A good teacher can help you along that path, and always take you to the next step. This is a very different approach from being a patient – even if the discipline you are embracing is an alternative or complimentary discipline, you are still a patient.

This different mind set is very liberating, particularly if you are in pain and want to be able to do something to help yourself, or if you are coping with a long term condition such as myalgic encephalomyelitis (ME) or fibromyalgia.

The three significant skills you learn are:

1. How to release compression in joints, muscles and soft tissue.

2. How to breathe more freely.

3. How to expend only the required amount of energy needed to keep you upright and moving around. Many people with back pain unwittingly make their situation worse by pulling down on their own bodies, adding to the compression on an already unhappy back. If you are low on energy, micro-managing your energy is the best approach.

Checklist for back pain

Back pain is a huge problem in the UK as well as many other countries. Some estimates put the cost of back pain as high as 2% of the Gross National Product. That's a lot of money, but it's also a lot of pain. Over the years I have been teaching the Alexander Technique, I estimate that half my clients come because of some kind of pain, low energy or both. It could be back or neck pain, pain from injuries that have been slow to recover, pain from work situations such as computer use or pain that is there just because it's there. Singers, actors, performers of various kinds, composers, artists and people who want to use their bodies better make up the other half.

People with back pain do other things than just have back problems. They too are musicians, photographers, actors, dancers, parents, rock climbers and so on. Many

people seeking Alexander lessons to help with a pain problem are delighted to find it helps them approach everything differently and has an effect on other aspects of their lives.

If you have a back problem and you would like to try the Alexander Technique, there are a few questions to consider.

1. Do you know why you have back pain?
So many things can cause back pain, from infections to injuries. If your pain is sudden, or acute, then do consult your doctor. Alexander teachers do not diagnose your problem medically, or do any kind of test or examination, so if in doubt, see your GP.

2. Do you think your pain is work or lifestyle related?
If you sit all day at a computer it can contribute to back pain. Sports activities such as running – if done badly – can make pain more likely. Alexander Technique lessons can help you improve your Use in these situations.

3. How long have you had the pain?
If your pain has lasted longer than a month, or you have episodes of back pain, then you can consider it a chronic problem. The chances are your own Use is exasperating the situation and Alexander lessons will help you.

Self-awareness for good back care
Thousands of people worldwide have used the Alexander Technique to solve back problems and to re-educate themselves about back care issues.

Our back is a huge part of ourselves. It is a complex structure comprising bones, discs, muscles, fascia, tendons, nerves, the spinal cord and blood supply. Our back is subject to huge distortions and pressures from our daily activities.

Tension that we are unaware of can be the cause, or a contributing factor, for many back problems. In other words we can unwittingly be adding to our own

problems. It is not enough simply to 'relax', as the word is commonly understood. Relaxation is a desirable thing and good for us but we need more than that. Tension is not just about tight muscles – it's about adopting the right level of muscle tone for the task undertaken and the right co-ordination of effort. Getting the balance right in respect of tension depends on how you use yourself. You do need appropriate tone for whatever activity you are doing, but you never need excessive tension. If you are taking part in a tug of war, then the amount of appropriate tone you need will be considerable and you will be making a lot of effort. But you don't need that amount of effort to clean your teeth. Most people unwittingly go through their day carrying a huge amount of tension just to walk and talk – far more than they need. They don't realise this because it has become an ingrained habit. Just as a smoker lights up without being aware of it, people become accustomed to a certain level of tension and maintain it even though it is damaging. Because our back is such a complex and sensitive part of ourselves, if we misuse it, we will suffer the consequences.

Re-educate your back
The Alexander Technique re-educates the awareness of what we are doing with our whole selves and so we learn to make choices about how we move and undertake activities. In this way we greatly reduce the stress load on our entire system, including our backs. We learn, literally, to look after ourselves. Friends and family often say, "look after yourself" to loved ones – the Alexander Technique offers a practical way of doing exactly that.

Back pain tends to be felt in one local area either low back, mid back or upper back. But the misuse contributing to the pain is not likely to be just a local problem, it's more likely to be global, involving all of you. This is because what you are doing with your body in one area will have an effect on other areas too. A common experience of low back pain is that it shifts to the upper back at a later stage. Even if it is obvious what is causing the pain – such as a disc problem or a specific injury – compensation patterns are likely to

put extra demand on other parts of your back and cause pain there too. Instead of chasing the problem up and down your back, it's more helpful to consider the whole back and that means thinking about your neck, head and legs too.

Tone your whole back

Think of your back muscles like a rumpled bed sheet and the most rumpled bit is in the middle of the sheet, where you experience pain. You could smooth the rumpled bit out directly with your hands, but you'd find the rumple just moves somewhere else. If, on the other hand, you tuck the sheet in under the head of the mattress and tuck the other end under the foot of the mattress, gently tugging as you go, then the sheet will smooth out. You'll want to tuck the sheet in properly on either side of the bed too, to keep it smooth and flat. It's not that you want your back to be completely smooth and flat but, like the sheet, you want to stimulate an appropriate stretch or tone in yourself that is likely to allow your back to reorganise. Sending your head forward and up and your feet down is the body equivalent of tucking the bed sheet in top and bottom; widening your back is like tucking the sheet in on either side. Don't forget that a mattress, like you, has a depth to it and part of your widening process is from your front to your back, not just side to side. Think in all three dimensions.

Low back pain

Lower back pain is the most commonly reported pain. A good question to ask yourself is, "What stops me lengthening?" Lengthening and widening can only happen when all of you is working reasonably well. Sometimes it's useful to consider what you might be doing that prevents you from lengthening and widening and deal with that interference. If you predominately have low back pain, it is likely that you have stiff hip joints and are actively pulling your legs up into your pelvis. This will reveal itself in sitting, where you will be pulling your whole upper body forwards at your hips. This has the effect of pulling you down and you inevitably compensate by stiffening your neck too. In an Alexander lesson your teacher might use their

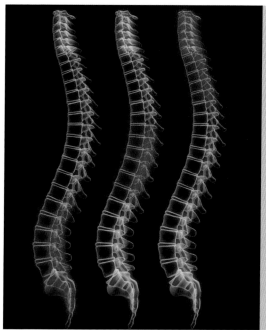

Your pain may feel local, but your misuse is global!

hands to lengthen you and take you back in the chair, so your upper back is in a different relationship to your legs than it normally is. The hip joints are the mediators between the legs and back, affecting both when they are tight. If you are used to the tension in your hips, this release will feel as if you are going to fall over backwards, even if you are simply upright. Ultimately you have to recalibrate the levels of tension needed in your hips joints to let you be properly upright, and that means recalibrating the whole of you. You will also have to recalibrate your sense of what you are actually doing as opposed to what you think you are doing. If your tight hip joints have pulled your body forward in a sitting position, this will feel upright to you – but it isn't upright and your sense of feeling is leading you astray. This is very confusing as we generally prefer to rely on how something feels to get a sense of it. The 'sense' that we are 'feeling' comes from within us – it's our proprioceptive sense which is dulled or out of kilter with reality. Awareness improves as we practise lengthening and widening and develop a better understanding of what we are doing.

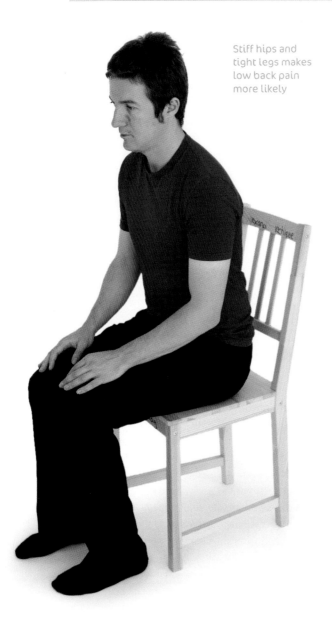

Stiff hips and tight legs makes low back pain more likely

combination of inflexibility in the ribs and compression in the neck can then contribute to mid back pain. Again the real message is to do with lengthening. A persistent message to the ends of your body to move away from each other (head away from feet, feet away from head) will stimulate a lengthening that will include the mid back.

Upper back pain

The rounded shoulders that can develop in computer users or people who spend a lot of time sitting can contribute to upper back pain. When your back isn't lengthening, then you tend to slip into a semi-slump with your ribs being pulled down and your shoulder girdle pulling forward so that the fronts of your shoulders are narrowed towards each other. This also encourages you to drop the column of your neck and put strain on both upper back and neck muscles. It's a common position people adopt when they don't think about their Use. If you cross your arms a lot when you are standing this can be a sign of tension in your upper back that you unconsciously seek to relieve.

Whiplash

The damage to soft tissue caused by a whiplash injury can be extensive and take considerable time to heal properly. Our necks are not designed to move in this way at such speed. The most common reaction to a whiplash is for the muscles to go into spasm and start to twist and distort the neck column. This holding pattern then becomes part of the person's Use and causes further problems. Old whiplash injuries do respond very well to Alexander lessons, as there is an opportunity to undo acquired holding patterns that are no longer needed.

Mid back pain

The misuse pattern most often associated with mid back pain can be quite complex and is usually influenced by what you are doing in your back both above and below the area that is causing you pain. If your breathing pattern is poor and shallow then your ribs can become very fixed in your mid back area. The

Letting go

Undoing tension that you have used to hold yourself up can be a challenge in many ways. Somehow, despite ourselves, we have a belief that we need the tension and without it we will fall apart. This is partly because our awareness of what we are doing to ourselves has got so out of kilter, that our distortion and tension feels normal and right. This is the case even when it's

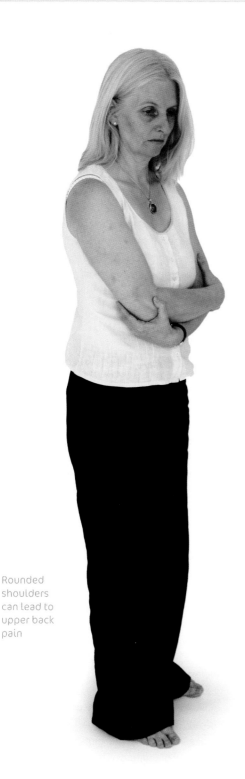

Rounded shoulders can lead to upper back pain

obvious it's not alright and occurs partly because fear creeps in and we are reluctant to 'let go' in case it hurts even more. This is where active rest can be so useful for people in pain. The more pain you have the more reluctant you are to risk doing anything unfamiliar. But active rest is an easy, neutral position that is unthreatening so letting go becomes a possibility. Experiencing release in this situation builds confidence that release is possible in other situations, such as being upright, or sitting.

Mindy's story

Mindy McArthur is a nurse, working in intensive care. She has experienced episodes of back pain over a period of years, and in the past it has always 'gone away'. Recently her back became very painful and stayed that way. Her mobility was severely compromised and she could walk only very slowly, with her knees bent in an effort to protect her back. She was in constant pain and was signed off from work. She couldn't get her shoes on or do the normal things of life. She was taking the highest dose she could of anti-inflammatory drugs and didn't want to continue with them but without them she couldn't sleep or do much at all. Mindy had heard about the Alexander Technique from a friend and decided to give it a try. This is Mindy's story

My happy place

"The first thing that happened for me was my pain levels lowered after lessons and I was able to cut right back on my pain killers and then stop taking them. I had a focus to help me relieve pain by doing lots of semi-supine. It was much better than relying on medication – I felt empowered to help myself because I could do something useful. Semi-supine became my 'happy place'. I liked the fact that there was no pressure to get better. I was given no time frame and no date. That was both a little scary because, of course, I wanted to know when ... when ... when ... but I soon realised that it gave me freedom to be where I was, not to rush towards a cure. It gave me a whole new philosophy of life. I felt I had been given tools and I could dip into my AT utility belt when I needed to.

Therapeutic touch

"I found the Alexander touch very therapeutic. Being in that level of pain was very shocking and the gentle touch helped guide me through that darkness towards some sense of control. If you can see one small step ahead, you can accept there is another step after that. At first part of me was quite sceptical – particularly when I was advised not to do anything else, such as back exercises, for the first few weeks of my lessons. Carolyn explained to me that I needed to sort out my Use and improve my awareness before doing anything else. This really changed my attitude to endgaining. At first it seemed like an effort to direct, now it seems like an effort not to! My awareness has improved and the whole experience actually made me grow up and take appropriate action to look after myself properly. It's not wishy-washy, it's very practical, even if it is very hard to explain it to someone who's never experienced it. It all makes such good sense to me. I liked being able to read about it, finding out that there was an academic side to it all.

Chronic pain and guilt

"Coping with chronic pain is not easy. I felt guilty that I was letting down my colleagues at work. I thought other people had expectations of me, of when I'd be 'better', that in fact they didn't have. Whenever I went for an assessment I struggled with the guilt and almost felt that I had to be unwell to justify all the time I was taking off work. This set me back and made me feel downhearted until I saw the pattern and realised it was once more an endgaining attitude I was taking and not only was it not helping me, it was making me worse. It was a very difficult juggling act. In fact my employers were great and gave me time and space and didn't pressurise me, and through lessons I learned not to pressurise myself.

A new attitude to work

"I am going back to nursing, but with a completely different attitude. I am going to see what kind of work will really suit me, so I'm not end-gaining about it. I feel I have learned how to stop back pain becoming an issue and when to stop and take a good look at how I'm doing things. I also feel I have the freedom to let myself not do silly things like lift a heavy weight, whereas before I would have done it at my own expense if I felt it might help someone else."

Mindy continues: "I felt quite disconnected from my body previously, which isn't a surprise really, I didn't want my body to be the way it was. I wanted to be well, not always tired and in pain. Using inhibition and direction really increased my awareness and enabled me to be in touch with my body after years of trying to escape it. I was so excited when I discovered direction. It actually worked for me and seemed such a simple thing. It's different from positive thinking – it's a very practical skill. I have always been a very positive person but felt I didn't have the tools to put that positivity into practice. Now I do."

ME/CFS

Over a number of years I have taught people with ME and fibromyalgia in my private practice and I have trained a few Alexander teachers with this condition. I have seen the technique offer great benefit to sufferers. Most of the people I have taught were also using other approaches to help their condition – such as homeopathy, naturopathy or acupuncture – as they found they needed a variety of ways to support themselves. Physically the Alexander Technique enabled people to approach movement and activities in a different way. ME is an extremely complex condition. As yet there is no cure and diagnosis is by default when other causes of the symptoms have been eliminated. It is a fluctuating condition and sufferers tend to go through dips where they are extremely unwell and sometimes bed bound. Now classified as a neurological condition by the World Health Organization, most treatment takes the form of management techniques and coping mechanisms. The condition affects all social classes and age groups and is not a modern illness. The illness feeds upon itself in that the exhaustion means people are unable to move about much and this in itself leads to muscle wastage, reduced respiratory capacity, stiff joints, more lethargy and a general level of unfitness. This of course makes

recovery even more of a struggle because it is so difficult to tell if you should walk those extra few yards to stand a chance of increasing fitness or if that little extra will tip you back into a dip. Improving awareness with the Alexander Technique offers a more reliable measure of appropriate activity.

Lymph circulation

Even in a condition of considerable fatigue, end-gaining can be a hidden problem. The natural desire to get up and move around, to try and get better at all costs or in some way to try harder, can all lead to making a difficult situation worse. The things people have to cope with when they have ME vary from person to person, but the most common reasons they seek Alexander lessons is for fatigue and muscle pain. If your situation is such that your low energy prevents you from moving around very much then muscle tissue becomes sluggish. This happens as there is not much opportunity for the waste end products of muscle metabolism to be removed naturally from your muscles. If you are unable to move very much then circulation is compromised, particularly circulation to your lower legs, feet and toes and your arms and hands. Normal daily activities of being upright and walking around stimulates both circulation and lymph drainage. Lymph is a fluid that circulates the body removing debris such as bacteria and abnormal cells. It also carries white blood cells with their disease-fighting capabilities back into the blood stream. Although the lymphatic system filters fluid produced by the blood stream, it has no central pump to chase it around your body; it circulates as a result of muscle movement. If you are unable to move much, this system is compromised. Muscles then become stiffer and tender. Learning how to direct muscles to lengthen can help release unrecognised tension and allow for better circulation of both blood and lymph.

Non end-gaining

Not trying to make things happen or striving directly for an end result allows you the chance to think differently. Non end-gaining simply means not getting

ahead of yourself and going too quickly towards your goal. When you do that, your striving only creates more muscle tension. This approach applies to simple activities such as lifting your arm, as well as larger, more complex, considerations such as "I am going to try harder today". It is a subtle skill as it doesn't mean simply giving up on a goal, but rather taking a different approach towards it and – most importantly – knowing where you are starting from. When you take this approach you can inhibit both excessive physical tension, which even exhausted muscles make, and the kind of mental striving that occurs when we experience brain fog or mental exhaustion.

Applying the Alexander Technique to pacing activities

Several of my ME and fibromyalgia clients use a rebounder (a mini trampoline) to improve circulation and encourage lymph drainage. Applying non end-gaining to this activity really helps. One pupil found she was often too fatigued to stand on the rebounder so she sat on it instead, giving her Alexander directions of asking her neck to be free, her head to go forwards and up and her back to lengthen. At the same time she gently moved up and down just a little – just so the bed of the rebounder was flexing, no more. She did this for just 30 seconds. Gradually she built up the time, by just 10 extra seconds every two or three days. Then she was able to get up on to her feet and do her flexing when she was upright. Finally she began to bounce a little. She found she could tell if she was beginning to overdo it because she would forget her directions and start getting too involved in the bouncing. Her increased awareness of her body and her self that she learned in her lessons enabled her to monitor herself more accurately. She had tried pacing and graded exercise in the past and had always relapsed. This she found extremely frustrating – each relapse felt as if it took her further away from recovery. By applying inhibition and direction to her decision-making about movement, and about how much movement, and when to stop, she felt she had found a missing piece of the puzzle.

Reactions

The tangle of problems that most people with ME are dealing with is complex. As well as physical symptoms of muscle pain – and sometimes muscle spasms and tics – there is exhaustion on both a physical and mental level and inevitable emotions that go with the situation. Some people experience anxiety, are overwhelmed with feelings of guilt at needing so much help from others or mourn the loss of their previous lives. For teenagers, seeing their peer group moving ahead without them is particularly traumatic. Whatever the reason, or the feeling, there will always be a component of muscle stiffening that is to a certain extent predictable. The stiffening will include a shortening of the whole muscle suit and, in particular, a stiffening of the neck. Alexander's discovery about this universal misuse pattern is extremely helpful in this case because one way or another you can be sure you are shortening. His further discovery that you can prevent this from happening by release and direction – and that this is a mental decision that has a physical consequence – is of great help to people in pain or with low energy. If you are having a challenging ME day, you can give your directions, knowing that it will help break the cycle of exhaustion you experience. It also allows you to 'be where you are'. The awareness you gain helps you be more mindful of your self and your situation; it enables you to engage with new pathways of thought and to inhibit old thought pathways that no longer serve you. Inhibition in particular is a chance to observe and choose reactions, where previously reactions just took place and swamped your nervous system. Inhibition can help quieten the chatter from an over stimulated system.

When to have lessons

Because ME is such a variable condition, it may not always be possible to get to a teacher for lessons. My basic guideline is simple: if you are well enough to get in a taxi and get to a teacher and can sit for a period of time, then you are probably well enough to benefit from lessons. The learning process will give you energy by releasing tension, but you need a certain amount of energy to fuel that process. For those whose ME is severe and who can't get to lessons, experimenting with the adaptation of semi-supine in the workshop at the end of Chapter 1, and the breathing experiment in Chapter 5 will help. You can also listen to Workshop 4 on the CD, which is designed for people with very low energy or very high pain levels.

The common factor

Whether you are suffering from back pain or ME, improving your Use could help you. This can be done with the help of an Alexander teacher, but there are things you can do for yourself, such as active rest and other procedures covered in the workshops at the end of the chapters. The twin skills of inhibition and direction are the keys to improving your own Use and helping your back pain or your low energy.

A natural function of the nervous system

Unconscious inhibition is a natural part of the nervous system and works in part to allow us to have the superb motor control we take for granted. For you to pick up a small bead, you must inhibit large grasping movements of your hand and refine the action of your hand so that you can use your fingers delicately. You can naturally inhibit the large movements of your hand simply because you want to, you don't have to think about it. A baby can't do this – the full grasp of a baby's hand round a new parent's finger that is so endearing is because the baby's nervous system is new and immature and can't inhibit the large movement. That's why first toys and rattles are better if they are soft so that when babies accidentally hit themselves on the head with their rattle it's not serious. As the baby's nervous system matures they can inhibit the large uncontrolled movement of their arm that made them hit themselves at an earlier stage of development. There are many levels of inhibition operating in the nervous system, most of which we will never have to concern ourselves with nor have access to. But we can, if we wish, use the skill of inhibition in a conscious way, by making a choice about our actions and reactions.

Inhibition and direction

If you want to change the way you are, you will have to stop doing some of the things you do unconsciously. You will have to inhibit. When you consider inhibition on its own, you are looking at the way you respond to any kind of stimulus. That stimulus could be pain – such as your backache or fatigue, in which case it's a stimulus that arises internally – or it could be some kind of a demand on you, such as answering the phone, which of course arises from outside you. It could be a self-initiated stimulus, such as your decision or desire to stand up or walk into the kitchen, or it could be initiated by someone else asking you come into the kitchen or to stand up.

Stimuli come in a number of ways and can trigger emotional responses as well as physical reactions. If you are asked to go to the kitchen to get something for someone else and you don't want to, then the stimulus of being asked will trigger a reaction of resentment on your part. It's worth noting that it wasn't the stimulus that triggered the resentment, it was your response to the stimulus. This understanding is crucial to behavioural change of any sort – without it you feel constantly at the mercy of events and circumstances or other people's moods and demands.

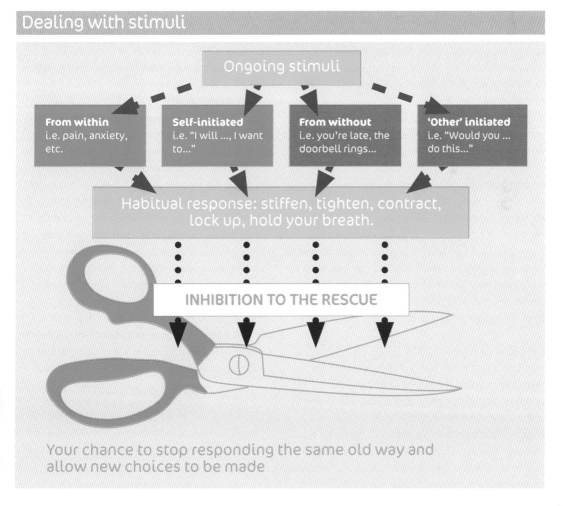

Dealing with stimuli

Ongoing stimuli

From within
i.e. pain, anxiety, etc.

Self-initiated
i.e. "I will ..., I want to..."

From without
i.e. you're late, the doorbell rings...

'Other' initiated
i.e. "Would you ... do this..."

Habitual response: stiffen, tighten, contract, lock up, hold your breath.

INHIBITION TO THE RESCUE

Your chance to stop responding the same old way and allow new choices to be made

Mind the gap

Inhibition is an opportunity to cut into that constant stimulus/response cycle – to create a gap, a little space where something can change. The genius of Alexander was his discovery about the nature of reaction. It doesn't matter what type of stimulus you receive – external, internal, self-initiated or initiated by circumstance – your reaction will include physical tension in the form of stiffening your neck, pulling your head back, shortening and narrowing your back and holding your breath. Regardless of your emotional response, these physical manifestations will be present and that is something you can address. If the stimulus is a strong emotional one, then inhibiting the physical tension allows you to consider the emotions more calmly.

Inhibition is a mental choice that has a physical consequence. It is making a decision not to react in the old habitual way, not to stiffen your neck, not to pull your head back, not to shorten your back or hold your breath. It's a decision made in the strange territory between thought and action, a territory that continues to move and change the more you explore it.

Inhibition allows a different response to stimuli to happen. It's like clearing the path so you can see where you are going. It allows you to direct your actions and your responses. In physical terms it allows you to direct your neck to free and your head to go forward and up and your back to lengthen and widen and your breathing to be free and easy. The best bit is understanding that the directions are your natural response to gravity and are what will happen when you do stop the stiffening.

Rhythm

Inhibition and direction form a rhythm and both are needed to complete the rhythm. It's like breathing – you breathe in and you breathe out; you can't just do one or the other. Like breathing, the stimuli of life are ever present. If you are sitting in a chair and you decide to stand up, that idea is constantly made and remade in your nervous system. The stimuli are constantly firing and you are constantly reacting to them. So it's not enough

to change your mind about stiffening your neck before you stand up and then forget about it and just stand up – you need to do more than that. But you don't need to get into the equivalent of kangaroo hopping down the road like a learner driver, so that you inhibit, direct, inhibit, direct and so on. That just makes you jumpy. Think once again about breathing. It's something people do rather badly, but you can't decide to stop breathing (for longer than a second or so) while you work it out – you've got to work it out while you're doing it. You can't 'freeze frame' one single stimulus and decide to inhibit it, you've got to inhibit on the hoof!

Instead of thinking of this as an impossible task, think of it as having many opportunities to inhibit and direct, something you can do anywhere, any time and from which you will receive benefit. Every time you make the choice not to stiffen up, but to let yourself expand, you are practising the twin skills of inhibition and direction.

What stimulus?

Sometimes it isn't possible to identify any particular stimulus or alternatively we may fail to notice them completely and, instead, notice the response. This is a very common situation. It is fruitless to try and work out what the stimulus was – this simply adds to the tension cycle. The response then becomes something on to which we embroider a story, trying to explain it, entrenching it more deeply into us. Instead, notice the response – your shrinking body, your stiff neck, your held breath – and don't try to work out why you are like this. Accept that stimuli have happened and are still happening and find that inhibition gap that lets you begin to unlock your self. That's inhibition too – you don't have to identify a stimulus in order to inhibit your response.

How does misuse start?

There are many factors that affect your Use. One of the strongest influences is the people you spend time with, such as your family. The way your Uncle

Cute or damaging? This is not a good way to sit, or a good focus for attention

Leave the technology at home. This is not a good way to sit either!

Eddie walks might be the way you walk too. The postural patterns of your family come out sooner or later, unless you do something about it. Early influences are important. Its easy to acquire poor postural habits and very hard to get rid of them. The younger you start on the road to poor Use, the harder it is to change things. Injuries can become part of our Use problems. If you break a wrist you will do everything with your 'good' hand until your injury heals. Inevitably as you restrict the movement of the injured wrist, you also restrict the movement of that whole arm, and that shoulder, and that side of your neck, and so on. You compensate not just by using your other hand, but also by subtle postural twists and adaptations. Sometimes, even when the injury has recovered, you fail to let go of the compensation patterns. This then becomes part of your Use pattern. Familiar activities, such as sitting at a computer, also contribute to our Use. Perhaps your job or your hobby involves repetitive actions. All of these things build up, creating your individual Use profile.

The Final Straw

It's not always possible to notice what finally tips your misuse into a critical state where you are in pain or having other difficulties and – like trying to identify the single stimulus that you want to inhibit – looking for the final straw doesn't help. Years of misuse can make you more vulnerable to that final injury that seems to come out of the blue. "I just bent down and something twanged," is often what people identify as the cause of a back problem. At that moment, their back goes into spasm and causes intense and obvious pain, which has to be dealt with in one way or another. It is likely that poor Use over a period of time is a major contributory factor and good Use, also over a period of time, is the best road to recovery. Good Use is drug free, has no unpleasant side effects and is something you can do for yourself.

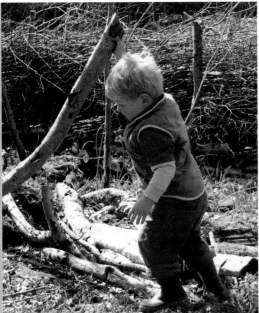

Good Use lets you naturally balance your body with your environment

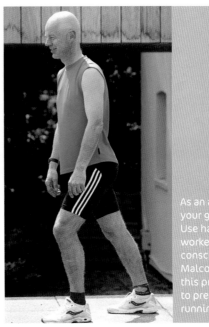

As an adult, your good Use has to be worked for consciously. Malcolm uses this procedure to prepare for running

The road to good Use

When you are young, good Use comes about naturally when you are involved in activities that move your body around. In his curiosity about the log and how heavy it is, this two-year old boy easily balances his body and the log in a harmonious relationship. His back is lengthened and his head is well balanced on his neck as a continuation of his spine. His legs are freely bent and his feet well connected to the ground. He is able to lift the log because he is using an integrated stretch throughout his whole body. Compare his Use to the young boy 'playing' on the laptop in the earlier picture and ask yourself which child is more likely to develop posture related pain in later life. Both children are involved with their activities, interacting with their environment and using their bodies accordingly. But the choice of environments, usually made by a parent, significantly influences development of the Use of a young body.

Conscious good Use

As an adult you are lucky if you have kept the natural good Use of young childhood. For most of us the journey of life has challenged posture, Use and breathing and our adaptations may have been less than helpful. Using the Alexander Technique you can make choices about your Use. Alexander teacher and running coach Malcolm Balk makes use of a similar body position to the two-year-old boy. Like the youngster, Malcolm is maintaining length throughout his back, his neck is free so that his head is freely balanced on top of his neck and is a continuation of his spine. His legs are lengthening out of his back and his feet resting properly on the ground. The difference between Malcolm and the two year old is that Malcolm does this consciously, giving himself the directions to lengthen and widen and seeing to it that he inhibits unhelpful tensions that would pull him down and shorten and narrow his back. Malcolm wants to run freely so he needs good Use; the two year old wants to lift an enticing log, he needs good Use too.

Choose good Use

We have to make our choices. We can work on our Use and keep ourselves flexible in our joints, free in our breathing and able to cope with problems of pain and exhaustion. Alternatively, we can leave it all to chance and let our Use simply deteriorate. Improving your Use improves

your balance, your mood, and your ability to cope with whatever is pressing upon you. It is a tool that has many applications and can be practised in many situations. Whether you want to run marathons, like Malcolm, or deal with your back pain, like Mindy, understanding good Use offers you choice where previously you had none.

Workshop 4

Release and relax

This workshop is a gentle talk through of directions. It is only on the CD and is designed for people with a lot of pain or with low energy. Select Track 3, get yourself in a comfortable situation and enjoy the talk. It will take you on a journey of releasing muscles and allowing length to return to

your body. You can also listen to the workshop at the end of Chapter 5, "The calmness of breath".

SUMMARY

All of your body is involved in back pain.
It is important to stop tension and encourage expansion in your muscles.
It is as important to know what you don't want as it is to know what you do want.

SUMMARY OF CHAPTER 4

- Why all of your body is involved in back pain
- Why stopping tension and encouraging expansion in your muscles works
- Why it's as important to know what you don't want as it is to know what you do want

section: 2

breath:
While I have
breath in my body

CHAPTER: 5

"THIS ISN'T BREATHING; IT'S LIFTING YOUR CHEST AND COLLAPSING."

F. M. Alexander (1930s)

Breathing; you can help it

IN THIS CHAPTER

- Breathing as a key compenent of Use
- The mechanics of breathing
- How the Alexander Technique can help sufferers of asthma

The subtle art of respiration

This chapter is about breathing – the simplicity and the complexity of it. We all breathe, from first breath to last gasp. We breathe in and out, in and out. Breathing defines us and we, as individuals, define our breathing. When we really fully understand it, breathing is a powerful tool for our lives.

In a few seconds, you will see a large full stop appear on the page. When you see it, breathe out and then hold your breath for a couple of seconds.

Make sure your lips are closed and gently breathe in through your nose.

Now just read on, breathing normally. Normally, that is, for you. Your breathing pattern will be individual to you. As you read slowly to the end of this section, simply notice your own breathing. Are you breathing in, or out? Is your mouth closed or slightly open? Is your tongue clamped against the roof of your mouth, or lying quietly in your lower jaw?

How do you feel?

Are you breathless, do you want to take in a nice big top up breath?

As you read about breathing, what is it doing to your breathing?

Now stop, and go back to the top of the page and read this section again.

Was anything different? Has being asked just to think about your breathing affected you in any way?

Use and breathing are one

The moment you were born, two demands were made on you at the same time. First of all you had to breathe for yourself and secondly you were thrust into the world of gravity and its constant influence on your muscles. From that moment the way your developing nervous system dealt with those intertwined needs shaped your breathing and your muscular co-ordination. A baby's bones and muscles are soft and the

process of developing the skills needed to stand up and walk is mainly one of exercising body muscles and the respiratory system at the same time. All the lovely little coo-ings and smiles and wriggles that your baby makes engage him in communication with those around him and prepare him for walking and talking. All the encouragement you give him to make sounds, crawl around and begin the journey to uprightness and walking and talking is usually mastered within the first two years of life. After that it is soon replaced by "sit down and be quiet!"

The act of breathing

Breathing is a most complex activity. It is something of which we can deliberately take total control, or it can – and will – continue without any attention from us at all, such as when we are asleep. It exists in the borderline country between consciousness and unconsciousness.

Many people breathe badly, partially holding their breath, often breathing in a very shallow and spasmodic manner. When the breath is held in any way, then the ribcage is either fixed or – instead of gently expanding sideways as the breath comes in – is heaved up and down in one rigid block. This affects the flexibility of the spine and causes the back to be narrowed. In this way the arms are then robbed of their support and a cycle of tension builds up. Often poor breathing goes with a fixed jaw, clenched teeth and, inevitably, a rigid neck and pulled back head.

Most of the time we are unaware of our breathing and even our best-intentioned efforts to improve it usually result in interference rather than anything else. Breathing is intricately and inextricably bound up with our Use. As we are, so we breathe. It both reflects and is affected by our passing thoughts and emotions. It responds to our physical efforts, our states of arousal, our wellness or our unwellness. There is nothing – absolutely nothing – that does not influence or register its effect in our breathing in some way or other. From the sharply drawn gasp of surprise or anger, to the gently exhaled sigh of contentment, breathing defines our lives.

Breathing – particularly its quality – in turn affects the many complex rhythms that go to make up a human being. It affects the blood chemistry directly in terms of oxygen/carbon dioxide levels in the blood. This, in turn, has an influence and effect on the circulatory system. Cardiac specialists recognise poor breathing as a contributory factor to heart disease.

Breathing affects mood and psychological states as well as being affected by them. We are often told, "Take a few deep breaths and you'll feel better." It's true – you probably will. Poor, shallow breathing, or held breathing results in lowered levels of oxygen in the blood and a general imbalance of blood gasses which can contribute towards states of chronic tiredness and other problems.

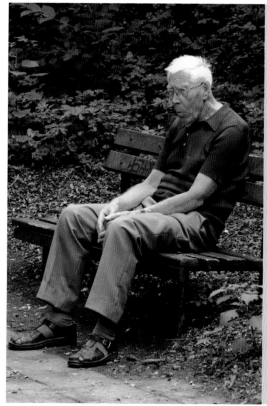

Poor breathing, poor Use and a poor psychological state go together and reveal themselves in your body

Storing and moving energy

Breathing is a very powerful process and its potential as a tool for transformation has been recognised for centuries by Eastern disciplines. In these the breath is seen as an element in storing vital life energy such as Chi or Prana. Practices such as Tai Chi, and Qui-chong are based on a combination of movement, breathing and contemplation that enhances body mind and sprit. The breathing is fully integrated with movement.

In the West breathing is used in various therapies both physical and psychological. Many meditative techniques use the breath or the breathing process as a bridge to greater consciousness or awareness.

It is entirely appropriate that breathing should be such an effective and effecting process. After all, no breath, no life.

Natural rhythm

The most common thing we do with our breathing is interfere with its natural rhythm, and the very fact that we can, if we wish, take such complete control of it can mitigate against us if we do not fully understand what we are doing. If breathing is perceived as a separate activity, something that we 'do', then gross interference is inevitable.

If, however, breathing is recognised as an integral part of our Use, our response to gravity, then we have far more clues as to what we can avoid that causes interference, such as stiffening the neck.

Quiet respiration

As you breath in, your diaphragm flattens down in your body and your lungs fill – or partially fill – with oxygenated air. Lung tissue itself is elastic in nature – it can stretch and shrink according to circumstances. Your ribcage should expand, just a little, to accommodate the descending diaphragm. If the ribs are fixed, then the diaphragm will have to push soft squishy stuff – such as your digestive organs – out of the way instead If you breathe like this, then your chest is liable to be rather collapsed and pulled down. This will lead to the elastic nature of your lungs being compromised. Another common misuse is lifting the chest up by moving the ribcage in a swinging motion, so that the lower back pulls forward on the in breath. In this way the chest moves as one solid lump.

Respiration with slight demand

When you speak, you put a demand on your respiratory activity and will often do so badly, interfering with the freedom of movement of the ribs and diaphragm. Some people hold their breath when listening to others, waiting for their chance to butt in quickly. Other slight demands on respiration are walking, moving around and so on.

Greater demand

One of the points of oxygenated blood is that it

Tai Chi combines fluid movement with regular breathing

enables your muscles to use energy to move. So, the more you move, the more oxygen you want and the quicker you want it. If you start to run, or to climb a long flight of stairs, then your muscles need more energy, more fuel and you need to increase breathing to deliver the goods. So you will breathe more quickly, more deeply and more of your muscles will involve themselves in this process. Your chest will move more and your shoulders will become involved – moving up and down to help your rib cage along the way. Strong emotions affect our breathing too. Anger, fear, rage, all make an extra demand for oxygen in preparation for whatever our next move might be.

In terms of Use – the greater the demand, the greater the potential for misuse. So, if in quiet respiration you hold your ribs or press down on your diaphragm even a small amount, then in a more demanding breathing situation your misuse will escalate and interfere with your functioning. The way you breathe when you're not doing anything in particular, and certainly not thinking about it, is the most significant breathing that you do. It is your breathing pattern. People's breathing is very individual, and related most directly to their manner of Use. If you think about sitting next to someone you know well, you'll realise you know them as much by the small noises they make when they breathe as by their looks.

Your breathing defines you

In Conan Doyle's The Red Headed League, Dr Watson describes the tension he felt in one of Holmes's artfully arranged traps. Holmes, Watson and two companions are concealed, in pitch black, in the cellar of a bank waiting to catch the villains who have designs on the bank's stock of French gold. Watson says: "...my hearing was so acute that I could not only hear the gentle breathing of my companions, but I could distinguish the deeper, heavier in-breath of the bulky Jones from the thin sighing note of the bank director."
Although this is fiction, it is very well observed fiction.

The best way to improve your breathing is to improve your Use. As your whole Use improves, so your

breathing will improve, and such things as breath control for speaking, singing and even running will also improve, probably without direct attention.

Interfering with breathing

The function of respiration is obviously a most vital one. F. M. Alexander's explorations that led to his discoveries of what we now know as the Alexander Technique were partly prompted by friends telling him that, when he was reciting, his breathing was audible and he could be heard (as they put it) 'gasping' and 'sucking in air'. When Alexander was discovering the source of his problems he realised that breathing played an important role in voice production.

The noisy breathing worried him even more than his throat trouble, which was then in its early stages. He thought he was free of the habit that many reciters, actors and fell into; that of nosily sucking in air when he breathed in whilst reciting. He sought the advice of both doctors and voice trainers to help remedy this fault, but despite their teaching his problem got worse. The noisy in-breath became even noisier and the throat problem got worse so that his hoarseness reoccurred more frequently than ever.

Over time, Alexander solved his problem so successfully that other people sought his advice and he was known initially as The Breathing Man and renowned for his superb breath control.

The Use is the breathing and the breathing is the Use

Just as your first moments in life were concerned with muscles and breath, so the Use of yourself and your breathing are continually interlinked. This diagram shows the outline of the diaphragm muscle inside your body. It is shaped rather like a large umbrella or mushroom and is attached to your lowest ribs at the back and sides and your costal arch at the front. It has tail-like tendons – the equivalent of the mushroom stalk or the umbrella handle – attaching it to the inside of the vertebrae of your lower back. It is a very strong muscle with other tendons running through it, from your costal arch at the front of your ribcage through to the centre of the muscle itself. When you breathe in tendons contract, so the diaphragm flattens and spreads sideways and downwards in your chest. This flattening performs two jobs. First of all it moves the ribs in different ways, allowing the breastbone to rise up a little and the lower ribs to flare out, making room for the diaphragm to descend and flatten in the first place. So, as it moves, it makes room to move. That is, of course, unless you are so stiff and rigid that you make the movement difficult for yourself. If your ribs won't move to let your diaphragm down easily then it will simply squash what is underneath it. These are the digestive organs – and they don't appreciate being squashed.

The other feature of the downward movement is that it allows expansion of the lungs and the intake of nice fresh air to rejuvenate your body with oxygen. You can't directly feel your diaphragm. You can only feel the effects of its movement. If you are breathing well, without interference, your in-breath will expand and slightly lift your chest out sideways. It feels as if your diaphragm should be moving upwards, but actually, it's moving downwards. This causes a great deal of confusion as the sensation of inflation doesn't match with the reality of a downward movement, but that is how it is. When you breathe out, the diaphragm rises again, coming back to a dome-like shape. So it's moving upwards. Once again the sensation is quite misleading, your ribs are coming back together, towards each other and this motion can be interpreted as the diaphragm going down, but it's not, it's going up. At least – it's trying to. If you are contracting and pulling your body down as you breath out – particularly if you are trying to squeeze an extra bit of breath out perhaps for one more swimming stroke or to get to the end of a phrase you're singing – then you are fighting the natural free movement of the diaphragm. It wants to go up, and you are going down. What that tends to mean is that you will have to forcibly lift your whole chest up to make the next in-breath possible. If you continue to breathe in this way as a habit then, over time, your diaphragm becomes stiff and your ribs stop bothering to expand gently and instead move in a sullen lump.

Not just the diaphragm

Your ribs attach to your spine at the back. They make small joints with the spine and there should be some movement at those points. If you have shortened your spine by compression, you make it less likely that the ribs can move easily at this small joint. Ribs, by the nature of their shape, move like levers, or bucket handles. A small movement at the hinge of a bucket handle results in a large move-

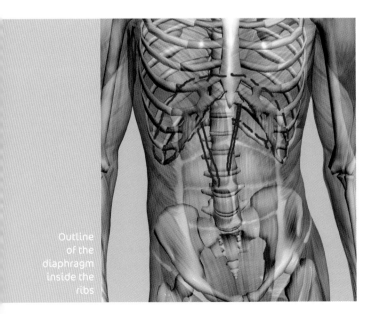

Outline of the diaphragm inside the ribs

ment of the handle itself. If the hinge of your bucket handle seizes up, the handle will be stiff and you will naturally do what you can to free up the hinge and let the handle move. The same is true of your ribs. What could you do at the hinge of your ribs and spine? You could make sure you weren't compressing downwards. What you are doing with your back profoundly affects how your ribs work. If you have a lengthened and widened back, then your ribcage is flexible and springy and, most importantly, it provides a good platform for your shoulder girdle to rest on. Your shoulder girdle doesn't have the stability of your pelvic girdle. It is designed for maximum flexibility and has very little rigid structure to prevent movement. The only bony attachment of the whole shoulder girdle is where your collarbones meet your breastbone at the top of your chest. Your shoulder blades, which make up the back half of your shoulder girdle, simply float in a sea of muscles. If they didn't you couldn't brush your hair or put your arm right across your body and up over your head. But the muscles that your shoulder blades swim around in attach to your ribs and on down into your back so, once again, if you have habitually tight shoulders you make it difficult to move the ribs and stiff ribs result in difficult breathing.

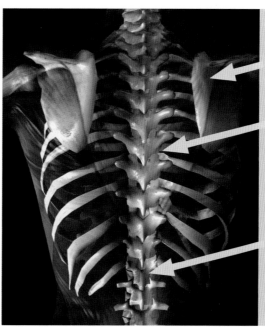

the shoulder blades float in a sea of muscles

ribs articulate with your spine

diaphragm attaches on the other side of these vertebrae

Mouth and nose

Try the following experiment. Open your mouth and take in a deep breath, filling your lungs. Then let it out. Now close your mouth and take a deep breath in through your nose. What was the difference?

Try it again. This time have one hand resting on your stomach and one on the side of your ribs. Notice which bits of you move more when you breathe in through your mouth and which bits move more when you breathe in through your nose.

Basically it's much easier to take in air through your mouth. For a start, it's a bigger channel so a lot more air can get in quickly. You may have noticed that the mouth breath was much quicker and, the second time you did it, you probably noticed more movement under the hand on your stomach and less movement under the hand on your ribs.

Your mouth takes air into your lungs if you want, but it also takes food and liquid into your stomach. You divert the food and drink to your stomach when you swallow by closing the entrance to your windpipe. On the odd occasion when you are not paying attention as you swallow, liquid can seep into your lungs and you will immediately cough it up – it's not supposed to be there.

Breathe through your nose

There are two simple things you can do to improve your breathing. The first is to lengthen your back so your ribs and diaphragm can move and the second is to shut your mouth!

Have you ever looked at your nostrils? Are they like little slits at the end of your nose, or are they wide and easily moving when you breathe? Do you breathe in and out through your nose or your mouth?

If your nostrils are like little slits, the chances are you are largely a mouth breather. Habitual mouth breathing makes your respiratory system lazy. It's much easier to take in a breath in through your mouth than through your nose. Your ribs don't have to bother to move very much if you always breathe through your mouth. Your nose is lined with fine hairs to trap dirt and act as a filter, your mouth isn't. Your nose has a very good blood supply close to the surface, which makes the nasal lining warm, so air is warmed to body temperature by the time it hits your lungs. Your mouth doesn't do that, so in wintry weather very cold air hits your lungs and they don't like it. If your nose isn't used, it gets clogged up so stuffy sinuses are likely. There is a direct connection between a stiff, tight neck and fixed ribs – often as the result of years of poor breathing habits. As you begin to let go of some of the tension in your neck, and keep your mouth closed as you breathe, your ribs will start to creak back into life.

At first this can make you feel a little panicky, feeling that you might not get enough air in through your nose, but if you persevere you will find the panic diminish as your ribs move and plenty of air comes into your body.

Extra air

When you need extra air, such as when running or doing other exercise, then quite naturally you will take it in through your mouth. When this is the case your shoulders will help move your ribs in and out more rapidly so the air gets to you quickly. But this is not the thing to do in quiet respiration when you are watching the television. If you want to change the habit of mouth breathing you will have to learn to close your mouth consciously. Constantly breathing through your mouth is likely to contribute to a sore throat as unfiltered air hits the back of your mouth, drying out the mucus lining of the mouth and making you thirsty. One further point is that mouth breathing is an extremely unattractive habit.

Anxiety and breathing

Breathing is directly affected by our emotional state and we often hold our breath or breathe quickly and shallowly when we are agitated. Fortunately, it can work the other way too. If you learn to regulate your breathing by improving your Use you can calm your anxiety and reduce the feeling of panic. It's just as important to breathe out as it is to breathe in and often anxiety is exacerbated by a feeling that you want to breathe in when you already have too much oxygen in your system and are in need of carbon dioxide. Learning to allow your ribs to come back together can help with hyperventilation syndrome, which is linked to panic attacks and anxiety.

Asthma

Asthma is one of the most common breathing diseases. Over 5 million people in the UK suffer from it. Symptoms include shortness of breath, a tight feeling in the chest and a build up of phlegm in the lungs blocking the airways. There is often the feeling that you can't get enough air and want to keep breathing in to get more. Use can be a significant factor in asthma, with your shoulders migrating up round your ears and your ribs becoming welded together and moving in a solid lump instead of having a ripple movement through the ribcage. Many asthma sufferers have found the Alexander Technique extremely helpful. Improving Use reduces the panic often induced by shortness of breath and enables a sense of control of symptoms.

Jeanie's Story

Jeanie Wood is an unusual woman. She has asthma and fibromyalgia. But she doesn't suffer from them – she manages them. It's different. Jeanie plays the tuba, is a highly skilled editor and an Alexander Technique teacher. This is Jeanie's story.

"I had asthma from childhood, it was so severe I spent long periods – months at a time – in hospital. As a result my education was very disrupted and I learned

to take things at a different pace to other people. I was always reading and I loved music, I studied both piano and violin. Even aged eight I found playing the violin made my arms ache to the point of pain. And I was always out of breath when I arrived for my lessons. Because of my asthma I left the pollution of Scunthorpe, a steelworks town, and went to a boarding school in the country where it was all pretty tough and I couldn't keep up with anyone at anything. I certainly couldn't play games and I had pneumonia so often I came to think of it as a permanent state.

"Well, I survived. I passed enough 'O' and 'A' levels to go to university and eventually became the first woman to work on the Home News desk of The Times. I worked there for more than 20 years, ending up as Night Chief Sub-Editor. I loved the work. My asthma was fairly well controlled and I didn't mind working nights (useful when you have a young family). I started at 7pm and finished around 3am, but often stayed longer if big news was breaking. Back home I slept during the day, but it was not a good quality of sleep and over a long period this regime began to undermine my health.

"Although my asthma wasn't too bad I had a few chest infections. I also had two children and after the birth of my second child I had a bad case of mumps. The mumps seemed to trigger a downward health spiral, possibly including fibromyalgia. I began to get really bad muscle pain – first of all in my neck, then shoulders and then arms and hands. Doctors diagnosed RSI, the editors' curse, but then I also started to get painful legs so they started scratching their heads.

"These painful episodes continued for the next 15 or so years and I struggled on because, not only was I the main breadwinner, but I really did enjoy the challenge of my work. Things got worse and I saw rheumatologists and neurologists, but nothing they did helped with the muscular-skeletal problems. I tried physiotherapy and acupuncture amongst other approaches but they didn't help either. The pains in my arms and shoulders were so severe that I couldn't pick

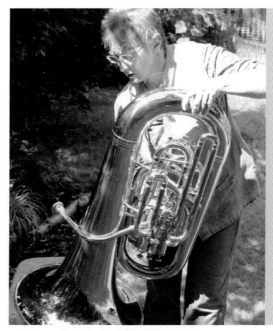

Jeanie's tuba is not much smaller than she is

up my daughter, lift a kettle or even open a door. In the year before I left The Times I had constant chest infections, escalating asthma episodes and ended up being hospitalised on two occasions. I realised that if I carried on like this I wouldn't be around to see my children grow up – so something had to change in my life – and that something turned out to be me.

The tuba as an instrument of change

"Although music was my soul food, I didn't feel I had found the right instrument in piano or violin, but then in my mid-40s I woke up one morning and decided I wanted to play brass, in particular the tuba. Everyone laughed at that idea because of my small stature and my asthma but I found a teacher and started playing. Immediately I absolutely loved it and still do. (The musical moral of this story is don't settle for the instrument you have been given.) My husband plays the trumpet so we often play in bands together and it's a big part of our lives. My first tuba teacher kept mentioning the Alexander Technique to me – telling me I should have lessons – but I had tried so many things I wasn't listening. He persisted in his recom-

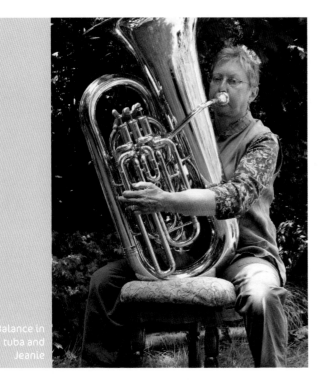

Balance in tuba and Jeanie

mendations and finally I decided to look for a teacher. The Times/BUPA agreed to pay for most of my lessons as I was by that time not in a good state of health and occasionally had to take time off.

My first Alexander lesson

"My nearest teacher was Frankie Stringer in Windsor and I booked my first lesson with no idea of what to expect and off I went. I found the lesson really confusing and wasn't sure what was going on, but on the way home I suddenly had a feeling of absolute relief – a blindingly brilliant moment when I realised I had no pain. I felt light, in balance and somewhere in my body I felt that a very deep rhythm had changed. I was driving home when this happened and I pulled over into a lay-by as the feeling was so strong I wanted to give it space. I felt really happy and thought 'this is it, here's a way to conquer the pain and get on with living'.

"I carried on having lessons. I certainly didn't always have such lucid moments but over the next four years I realised that the situation I had created in my life

wasn't healthy and was damaging me, so I started making escape plans. Pain levels decreased swiftly after a lesson but I didn't have enough knowledge or skill to maintain that and felt I needed to make major changes in my life if I wanted to be pain free. I decided that good health and the chance to dream about a fulfilling future were the most important things in life so I took early retirement from The Times on the grounds of ill health at the age of 48. I gave myself a year after leaving the paper to recover before starting Alexander Technique teacher training. I really wanted to do it for my own benefit and my family's future. But I was worried that it would be very difficult for me as I had never been any good at physical skills. When I went to visit the Alexander training school, the Director gave me a lesson and said, amongst other things, 'This will be the best thing for you, the best health insurance you could have.' So I started training and although it was probably the most challenging thing I have ever attempted I absolutely loved it. When I began I was so pulled down through dreadful posture that I was smaller than anyone else on the course, but at the end I had blossomed and was inches taller – up to my full height of 5'2½".

Benefits

"There is no doubt in my mind that improving my Use has made an enormous difference to me. I am no longer regularly in pain, I sail a boat with my husband at weekends, I play the tuba, I edit books and I teach Alexander Technique. My asthma is stable, although new improved medication has helped there too. One thing the Alexander Technique taught me was the skill to find the best way to tackle problems, whatever they are. Tuba playing helps my asthma, too, as it really exercises my lungs.

Tuba technique

"The tuba imposes huge postural problems, particularly for a short person like me. The sheer size and weight are problems even before you get it out of the case. You have to think about your Use the whole time. Even going into the room where I keep it can make me pull down in anticipation if I don't think positively about it. Playing it has been a kind of

one-woman Alexander Technique assault course. But application of the Alexander Technique has eventually allowed me to play with physical comfort and enormous enjoyment. Keeping my arms released is one challenge – it's a huge stretch (for me) round the instrument to the fourth valve. This can easily make you pull your shoulder girdle out of shape and your head back. When your fingers finally get to the valves, you need to be very dexterous and light, but at the same time maintain strong muscle control. There is a fractional delay in the note emerging from the tuba so you always have to be slightly anticipating the beat. The tuba is very much part of the rhythm section and a main driver of the band/orchestra so you have to get this anticipation just right or things fall apart big time.

"Blowing the tuba, managing and controlling the breath for volume and phrasing puts a great demand on my breathing, particularly when playing pedal [very low] notes. Because the tuba range is at the bottom end of any ensemble it forms the foundation note of chords and supports the melody and other lines above it. Therefore phrasing is very important and this takes great volumes of breath, so you cannot hang back being asthmatic and wheezing. Another postural challenge is marching. The tuba weighs about 21lbs so marching and playing at the same time is quite a challenge. My balance has improved so much, thanks to the Alexander Technique, that I can still march with my tuba in comfort whilst many younger colleagues with smaller instruments have given up marching because of back pain or other postural problems.

The brass section

"A common sight when you are sitting in a band is seeing the whole brass section breathe in as one person, shoulders up and elbows sticking out sideways. The conductor raises his baton and the brass section raise their shoulders. This isn't helpful – it makes your upper chest rigid, which makes breathing even harder. I try to make sure I don't do this. In rest bars I reconnect with my sitting bones and get my back lengthening. I devised a clever gadget I call my 'surgical support' – actually it's a piece of wood, which I have padded with a bit of foam and covered with a plastic bag. I can put it on any seat we are offered when we go out to play. Often we get plastic bucket seats, which are not only uncomfortable but for me, being short, make it impossible to organise my tuba properly. My homemade 'surgical support' not only lets me feel my sitting bones, it gives me an extended platform on which to rest the base of the tuba. It's all a question of working out a way of playing your instrument that doesn't damage you and allows you to perform to your greatest potential.

"Without the Alexander Technique I couldn't comfortably have achieved the level of enjoyment that I have playing and wouldn't still be in love with my tuba. When I am playing now I am happily in balance with my instrument."

Workshop 5

The calmness of breath

Read through the workshop material first to familiarise yourself with the concepts. This will greatly improve your understanding and enjoyment of the audio instructions. When you are ready, select Track 4 on the 'Workshops CD'. The CD will talk you through the breathing procedure in detail while you are doing it. It contains directions and thought pathways for you to follow. The idea of this procedure is to give you a chance to experience breathing as part of your natural use of your body. You can do this procedure anywhere anytime and once you are familiar with it, you can dispense with the audio instructions if you wish.

You will need

▓ Somewhere you can either rest in the semi-supine position, or a chair. You can try this experiment in a number of different ways.
▓ Thinking space.
▓ Time.

Your approach to the procedure

Anything that quietens your breathing down will help you to feel calmer. Think of this as an experiment in allowing your mind and your intention to integrate breathing and postural support.

Try it out first of all in semi-supine. If you have problems getting on to the floor, adapt semi-supine to lying on your bed (see Workshop 1).

Then experiment with putting your feet up on the wall, still lying in semi-supine with your knees bent and your lower legs horizontal, so the soles of your feet are flat on the wall. If you wish you can support your lower legs on some cushions.

Try it out sitting in a chair with both feet flat on the floor.

Get organised

Whichever position you decide to start with, take some time to settle and get your thinking going. Ask your body to lengthen and widen (see previous workshops). You are going to use your directing skills and imagination skills together. Directing forms the background to your imagination, so keep gently reminding yourself to keep your neck free and allow yourself to lengthen and widen throughout the experiment.

Imaginary journey

Imagine you can breathe in through the soles of your feet! Let the whole surface of the undersides of your feet breath as if they were huge nostrils. Take a breath in through these nostrils in your feet and draw the

Taking time to breathe through your feet

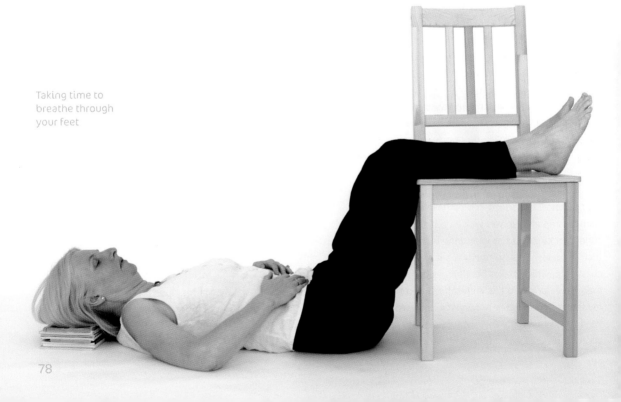

breath gently up your lower legs to your knees. Make sure your breath covers your shins and calves as well as being 'inside' your legs. When it gets there, gently let it out, allowing it to flow down your legs and out of your feet. Keep your mouth closed so the breath goes out through your nose.

Keep your mouth closed and take another breath in through your feet and draw it up your legs, past your knees, right up into your hips. As you do so let the oxygen flood into the muscles of your thighs and around the bones. Let this breath flow out gently down your thighs, past your knees and ankles and out through the soles of your feet and the tips of your toes.

Still with your mouth closed, allow another breath in through your feet. Draw it gently up the same way as before and this time continue to allow it to spread up your body through your pelvis and your abdomen, right into your chest and back. Let it flood all your organs with oxygen. Gently allow the breath to leave the way it came in, flowing it with your mind down your chest, into your pelvis, through your thighs, down your calves and out of your feet.

Mouth closed, take another breath in, through your toes and feet, up past your calves and shins, through your knees and on up your thighs, through your pelvis and abdomen and on up your back and into your chest and throat. Allow it to flow right into your throat and mouth and then open your mouth just a little and let the breath out through your mouth and lips with a gentle slow sigh.

You have just completed one cycle of calming breath.

Take your time and practise, adding as much detail as you can. Notice where your breath flows.

What you are doing is taking a series of breaths, each a little deeper than the last, but you are not heaving them in and out, you are allowing your body to expand to let the breath in and out as you wish.

Your ribs and back will move more freely and flexibly. Remember to keep the idea of lengthening as you do this.

After some practice

Once you have mastered the basic idea, try it out in different situations and then try it walking round your room.

If you feel at all dizzy then it's likely you are dragging breath in rather than letting it in. Take a break and come back to it another time.

Application

You can do this anywhere anytime and no one will notice! It will help you to release any build up of tension in your body, calm you down and let you breathe more freely. It will encourage your ribs to move more elastically and your back to support you throughout the breathing cycle. You can do it as often as you like. Many of my younger students have done this while sitting at their desks in examinations. When they find they are nervous and panicking a bit, they take a few moments to use the calming breath; they find it clears their minds and calms them down. Other clients have used this technique in business meetings, particularly when things are getting a little heated. It can help you centre yourself and not be distracted by a tense atmosphere.

SUMMARY OF CHAPTER 5

- The way you breath and the way you use your body affect each other
- You can't breathe freely if you are shortening your muscles
- Learning to lengthen can help relieve your asthma

CHAPTER: 6

"INSPIRE ME WITH BREATH."

Uninterrupted breath

IN THIS CHAPTER

- The challenge of public speaking
- Your back and your voice
- Breathing and speaking for actors and ordinary people

Ellen's story

When Ellen phoned me for lessons she told me she'd just been promoted at work. This meant she had to give presentations to senior managers about product lines she was recommending to the chain of stores for which she worked. "I get so nervous when speaking," she told me, "My voice goes up high and sounds strangled. I find I'm gasping for breath and I sometimes feel faint. My nerves are really getting on top of me."

During her first lesson I noticed that Ellen's normal breathing pattern was very poor. She took small shallow breaths and then big catch up breaths. She also yawned a lot, for which she apologised, saying she wasn't really tired. She didn't know it was her body's way of getting oxygen. So we started slowly, with Ellen lying in semi-supine and beginning to pay attention to her neck and back. She soon realised her back muscles were rigid and her neck very stiff. I pointed out to her the link between stiff muscles, poor breathing and her problems with her voice and nerves, but at first she couldn't see the connection. She left her first lesson rather

frustrated as she'd hoped to cure her voice problem in one go. She came for more lessons and gradually noticed that her tension levels were falling and this made her breathing calmer, more regular and, in turn, she was able to steady her nerves and speak more freely.

Ellen had a big presentation coming up and we prepared for it during her lessons. First she learnt to stand without bracing her entire body, paying a lot of attention to her neck muscles as she did so. Then I got her to start her presentation and, at the end of each sentence, I asked her to close her mouth and stop speaking. This was to allow the air to come back in through her nostrils rather than her mouth and to give herself the direction to release her neck muscles again before she began the next sentence. Ellen found this very difficult. She felt she would lose people's attention if she closed her mouth and stopped speaking. It seemed to her that the silence between sentences was very long. I assured her that it wasn't and people needed a bit of time to hear what you were saying. Ellen agreed to try it out.

The next lesson Ellen came in beaming; she had been congratulated on her presentation and told she came across as clear and confident.

Voice and speech

F. M. Alexander was himself an actor and his technique is widely used in speech and drama academies

worldwide. His own voice problems started him on the road of discovery about how his own Use affected not just his voice, but all the functions of his body, including circulation, breathing and digestion. When he first suffered from hoarseness after recitals he thought it was purely a voice problem that could be solved by voice training or exercises. He knew that his breathing was poor – he gasped in air noisily on the in-breath, which was a particularly distressing habit. He could see that when he began to speak he stiffened his neck and pulled his head back because of the neck tension, and he saw how that depressed his larynx and basically squashed his vocal mechanism. That was a useful insight. Stopping it was a challenge that took time to sort out and closer observation showed him that pulling his head back was just a part of the incessant tension wave that went through his whole body to his legs and feet. Basically, he was pulling his whole body down and squashing himself. Learning not to do that was his next challenge. He also suffered from digestive problems and – as he improved the use of his whole body – his digestion improved as well.

What Alexander discovered wasn't unique to him – it was, and is, pertinent to human movement. Everyone can organise themselves well if they know how. When stressed, everyone will react physically in much the same way, pulling down, stiffening, tightening and generally squashing the life out of themselves. This can be so habitual it isn't noticed, until something goes wrong or you want to perform in a particular way. For an actor, unrecognised misuse is a barrier to good performance.

Always allow, don't push

Breathing is the mother of all rhythm – it is an ultimate expression of being. Breathing is about having clear, open passageways and letting the moving parts of your body move. You have no need to deliberately take enormous breaths in for speech – breathing is a demand led activity. If you need more breath, your whole body will respond to make it available, providing you keep the framework of yourself lengthened and widened. Poor breathing affects your movement, poise and balance, and it's

the other way round too – poor balance and poor Use makes for poor breathing.

One of the most curious things Alexander said about breathing was, "I see at last that if I don't breathe, I can breathe." This strange observation came after long periods of experimentation with his breathing, trying to solve all his voice difficulties and realising that every single thing he tried just got in the way; it interfered. The more he tried to 'do' his breathing, the more it all went wrong – no matter how 'well' he tried to 'do' it. It was only when he had the insight to stop interfering, to stop trying and to allow his own body to sort things out for him – in the knowledge of what he didn't want – that he saw something different happen. In particular he observed the strong desire to breathe in before speaking, to take a preparatory breath before opening his mouth. This was what he meant when he said, "If I don't breathe". The misuse pattern was so strongly associated with the preparatory in-breath that he had to give it up!

You can experiment with this concept in the workshop at the end of the chapter.

Good organisation for speech

Getting yourself well organised so that your voice can work freely requires you to make the most of your body as a resonance chamber. Think of yourself as one enormous concert hall with perfect acoustics. Every part of you is involved with the production of sound, not just your vocal mechanisms. Your muscles act as a web of support for your skeleton; your skeleton in its turn acts as a spacer for muscles to attach to and creates cavities for organs to occupy. If the muscles of your legs are very tight, it will have a dragging effect on your pelvis and lower back. Your back will most likely respond to this drag by stiffening and tightening, particularly in the lumbar area. This is the area that the diaphragm attaches to the inside of the spine, so already the drag on the back means a drag on the diaphragm attachment. Add to that the inevitable pulling effects further up in your body and you can start to see the problem.

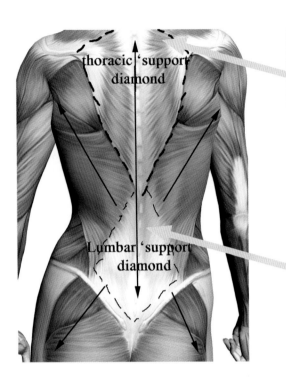

thoracic 'support' diamond

Lumbar 'support' diamond

Trapezius muscles
Strong diamond shaped pair of muscles that span the neck, reaching up to the back of the skull, out sideways to the shoulder blades and down the back. They meet and blend with the lumbar support diamond.

The thoracolumbar aponerosis
Strong facia that covers the base of the thoracic curve and the lumbar curve. Lattisimus dorsi muscles leading to the arms blend in here, as do gluteal muscles leading to the legs.

The diamonds of the back

Lengthening and widening really is important

Muscles, bones and facia all affect each other and in turn affect organs underneath them, including your lungs. The two diamond shapes of muscle and facia in your back act as both anchor points and suspension points for your spine. If your back is lengthening, up and down, then the lumbar diamond support will be firmly toned. It will support your spine and allow your arms and legs to work independently of your body. If you have ever injured your back, you'll know that pain avoidance makes you very careful how you walk and use your legs. You will avoid certain arm movements too, such as lifting your arms up high, because you instinctively know that the movement will pull on your back and hurt you. What you want is an ideal situation where your arms and legs are supported by your back muscles, and yet can move independently of each other and independently of your back. This scenario gives you an easy fluid movement through

your body, and you can only get this when your back is supporting you because it is lengthened. You want both your diamonds to be elastic and supportive so your voice isn't restricted by tension in your muscle suit. Even tight arms can weaken the power of your voice. If you want to test this out for yourself try the armpit experiment opposite.

When does tension begin?

Speaking, particularly in a dramatic situation, is a very strong stimulus to slip into tension patterns. Alexander himself found over and over again that he stiffened his neck and pulled his head back when he started to recite, which interfered with his voice to the point of making him hoarse if he persisted. It seemed almost impossible not to stiffen. After experimenting he found that the tension pattern was not confined to his neck and head, but was a body wide response and it began when he thought about

speaking, well before he opened his mouth. It was at that point that the neck stiffening crept in. He had traced a physical response back to a mental origin and discovered for himself the powerful link between mind and body. It was his intention to speak that set off the wave of shortening and tightening that so interfered with his voice. Discovering that he could change that deeply ingrained response by creating a mental pause before responding to his own desire to speak – a pause in which he actually could keep his neck free and send his head up – was one of his major discoveries about human movement and reaction. Life is full of stimuli, some pleasant, some not. Mostly we can't change the stimuli, but, thanks to F. M. Alexander, we can change the response.

Armpit echoes

▥ Put your right hand high up under your left armpit. You want your hand to cover the back and the front of your armpit. This is where the latissimus muscle that runs up from your lumbar diamond support meets your upper arm. The muscle attaches to the inside of your upper arm so there is a direct connection between your armpit and your lower back. Other muscles make up your armpit too, including the pectoral muscles that span from your breastbone over to your armpit. So you have your back and your front musculature meeting together under your armpit.

▥ Now make a strong fist with your left hand, and hold your arm tight against your body. As you do this you will feel the muscles of your armpit push down on your right hand. Occasionally people find these muscles difficult to locate and might need to further activate the upper arm muscles by squeezing them too.

▥ With your fist still clenched, speak your name out loud, or say your address. Notice the quality of your voice. You might like to do this with a friend and ask them to observe the quality of your voice for you.

▥ Now you are going to give yourself some Alexander directions. Ask the muscles of your neck to release and send your head up; you can use the image of the red dot if you like. Ask your back to lengthen. Then repeat the experiment, but as you do so make sure you keep lengthening. You can still grip your fist, but not your neck!

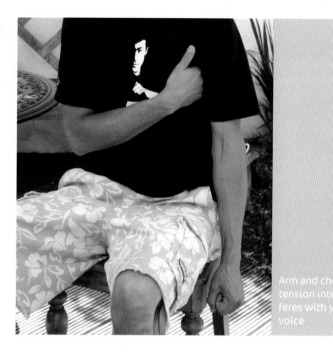

Arm and chest tension interferes with your voice

▥ Speak your name again and see if you (or your friend) notice the difference. For most people the difference is dramatic and a real taste of how tension affects the voice. You may notice that if you keep your neck free from tension, the muscles under your armpit don't activate as strongly and sometimes they don't activate at all, even though you are making a fist. A free neck is one of the keys to a free voice.

Ground your sound

What you do with your legs and feet will have an effect on your voice. Feet in particular show the tension of your whole body. Take off your shoes and socks and have a look at your feet. Are your toes distorted? Can you see all the tendons on the top of your foot sticking up? If so then your tense feet could be interfering with your voice. Don't confuse tension with tone, or release with relaxation. You don't need tension at any time, but you do need appropriate tone for the activity you are undertaking. If you are walking up a steep hill, or running, then your legs and feet will be working hard and your calves and thighs will be well

Dropping the heels is a direction, not a position

your mouth and your diaphragm restricted you will tend to repeat those habits every time you see that bit of text. If you get a memory block associated with a specific piece of text you will sense that bit of text coming up and begin to tense up in anticipation. This will actually encourage your memory to fail you. Not only that but you'll start to get tense earlier and earlier in the work you are doing till you dry up well before you get to your 'difficult' bit.

The swallowing experiment

If you think you don't pull your head back when you speak there is a simple experiment you can try, which will give you a sense of what a deeply ingrained habit it can be.

toned. Give yourself the direction to let your heels drop on to the ground as you're walking, and your toes to lengthen away from your heels. Remember this is a direction not a position. You can 'drop' your heels while standing up on the balls of your feet. It's a matter of intention, not a matter of position. Allowing your legs to release out of the diamond of your lower back will not only ground your sound, but keep your back 'staying back' so that you don't pull your lower back forward because of leg tension.

Lie in semi-supine, as in active rest, with your head resting on a small pile of paperback books and your knees bent and pointing up to the ceiling. Take a little time to get accustomed to where you are, then simply swallow a little of your own saliva. If you pull your head back you will probably feel your head dig in to the books or even slide down towards your shoulders as you swallow. You can be sure that if you can't swallow without pulling your head back, you won't speak without doing it either. Pulling your head back will put pressure on your larynx and constrict your voice.

Tension and memory

If you learn your lines, or rehearse your lines, without paying attention to your Use or your breathing, then you will struggle to get the sound you want. Our body quickly learns what we teach it and if we teach it tension – usually by default because we don't notice what we are doing – that is what our body learns and associates with a given piece of text. Paying attention to your Use when learning text is the best investment you can make. Taking time to keep your neck free while silently reading text for the first time pays dividends when it comes to speaking the lines. If you read with your neck and jaw locked, your tongue clamped on the roof of

Take a little time to get some 'up' directions through your back, neck and head and deny yourself the familiarity of dragging your head into your torso as you swallow.

Learning and preparing text

The Alexander Technique is very popular in the acting profession, and many drama schools employ full-time Alexander teachers. The technique will help everyone from professional actors to those of us who simply need to recite text, perhaps in preparation for a speech.

There are ways you can pay attention to your Use as you read text for the first time.

▥ First of all, get yourself organised in a good way so you can read easily.

▥ Sit on a flat-bottomed firm chair and pay attention to lengthening and allowing your ribs to move freely.

▥ Hold the text up so you don't have to pull down towards it as you read.

▥ Let your feet rest flat on the floor to give yourself the best chance of keeping your legs free from tension as you read.

▥ Let your back widen to support your arms as they hold the text.

▥ Read silently, speaking the words in your head. As you read, observe the small bit of white space between each word so that you see the words as separate entities.

▥ Imagine each word as a pearl in a necklace. The pearls are separate from each other, but they touch each other and they are strung together. When you speak, your breath is the 'string' connecting the pearls.

▥ Let your mind flow easily from one word to the next; you don't want to read in a stilted fashion, even inside your own head, but if you skim read at this point you will not get a good sense of the dynamics of breathing needed for the text.

▥ Use punctuation as a pause signal. If you have a lot of text to read, break it up into smaller sections.

Dan is sitting in balance reading Shakespeare. His feet and sitting bones make contact with the chair and floor; his lengthening back supports his arms and allows his ribs to move easily.

jaw. There is no need to activate your tongue at all to hum; let it lie quietly in your mouth. As you hum you will feel the vibrations in your mouth and possibly your nose and forehead.

▥ Keep observing the punctuation of your text and notice what your ribs are doing when you pause at the end of a sentence or a phrase. If your text has no punctuation you will need to find a natural phrasing rhythm to work with and let that dictate your breathing.

Humming

Having read through the text a few times, hum it as if you were speaking it.

▥ Keep your lips closed as you do this and observe any tendency you might have to pull down. Humming with your mouth closed makes an additional demand on your breathing and postural support.

▥ Keep plenty of space inside your mouth, with your tongue resting lightly between your upper and lower teeth and plenty of space between your upper and lower back teeth at the hinge of your

Walking and humming

Now it's time to get a little more active. Hum through the text again, still with your lips closed, but walk around as you do so. Pay particular attention to your legs and feet. You want a sense of contact with the ground as you walk and the direction of letting your legs lengthen. As you allow your feet to make a good contact, your body will respond to this by springing up away from the floor if you keep the sense of lengthening throughout your body as you walk. Remember, it is a thought, not an invitation to pull yourself upright with effort.

Speak with your body

The act of speaking is about involving your whole body. This doesn't mean wriggling everything, but being aware of more of you than just your face and mouth. Be aware of your back as you speak. To help this process you can experiment with reading aloud in different positions. Try reading aloud in semi-supine, which really lets you know if you pull your head back. Read on your hands and knees so you can give your muscles different learning scenarios.

Emotional clarity

Shades of emotion bring a text to life, and finding a way to portray emotions without the consequent over-tightening of muscles is partly a matter of practice and partly a matter of careful consideration of what is needed. A good starting point is to make a running order of emotions, or perhaps the archetypes of the character you are playing, and then let your body express them without the accompanying shortening and tightening of muscles. At first this will seem very odd because we associate tension and effort with results. But if you don't allow excessive tension to get

in the way you will find you portray a greater depth of emotion than you at first realise.

Having played with that idea for a while, deliberately exaggerate the emotions – make them really big. Express them with your body, with movement and with your voice. However, it is not essential to speak the text – you might find it helpful to make accompanying sounds for the actions rather than actually speaking at this point.

Make whatever movement you want, but keep the idea of your body as an open resonance chamber in whatever you do. When you are happy with your work then rein back the emotional tone to where you want to place it and add the text. Occasionally return to silent reading.

What about portraying anger on stage?

Strong emotions can easily take you over and pull you down. If you have lines to shout and are manically running around the stage in a rage don't forget you are acting for others to see. If you let yourself get swept away with emotional intensity you are more likely to embarrass your audience than engage them. Keeping a sense of space inside your body, particularly freeing your neck, despite storming about the stage allows you to get your message across very powerfully.

Going a little deeper

Text needs to be interpreted so that an audience can feel the emotions and colour of the work. Portraying strong emotions that are usually associated with tension, such as anger, hatred or fear can be a considerable challenge to vocal stamina. If you have to shout or scream your lines how can you do so without damaging yourself? Once again your Use – how you organise yourself is the crucial factor. It's easy to think that shouting means greater effort but it doesn't. Volume comes from intention, not pressure. Consider

A baby's lungs can make a lot of noise!

a screaming baby – the volume is certainly there! The baby wants to be noticed and attended to and can produce a phenomenal volume for such a tiny being. But no matter how much it cries it won't get a sore throat because its whole body is involved in the production of the noise. Its free body lets its lungs supply the vocal mechanism with the required fuel for the sound. When an adult wants to express an emotion they often do so by over-using throat muscles and thus straining the vocal cords. We associate emotions with the throat area. Common observations such as "my voice stuck in my throat," or "I had a lump in my throat," express this tendency to constrict. Keeping the throat open so that you always speak, or shout, or scream 'on breath', rather than without breath, will save your vocal mechanisms from over-strain. Put simply, speaking 'on breath' means you don't run out of air before you run out of words. If you do, you are most likely to force speech from your throat. This is a quick route to vocal damage. You haven't a hope of keeping your throat open in isolation from the rest of your body. Think of your voice as the messenger of your body. If you want the message to be open, clear, strong, round, gentle, powerful or a changing palette of all those qualities, then your body has to enable that, and the best way is to allow yourself to lengthen and widen.

Open shouting

Sight-reading.

If you are going for an audition, you may be given text to sight-read. With a short period of time available to you before you speak how can you prepare in the best way?

▨ Read through quietly, observing your Use and breathing.

▨ Notice full stops and punctuation, notice beginnings and endings of words you read.

Even when thinking (reading) the work in your head, let your own voice read them and make sure you read each word, phrase and shape it in your head as you read. This is how it will come out when you speak it, so pay attention to lengthening and widening as you read. If you sit in a slump, frowning and holding your breath to concentrate, you will associate that Use of yourself with speaking the text, so give yourself the maximum chance of a good delivery and use yourself well as you silently read.

Breathe into the available space

Intention creates a voice, and breathing and intention go together. To give yourself an experience of the space around you, practice breathing into it. You can do this in your own room, or you can fill the Albert Hall with one gentle breath. It's not about taking in the biggest breath you can manage and then squeezing it out as far as you can – it's about your intention or desire to fill the space you are in.

▨ You can stand or sit to experiment with this idea, either way, take the time to get your balance organised so you are lengthening and widening and you have a free neck so that your ribs can move.

▨ Breathe in and out through your nose, quite evenly and gently. As you do so become aware of the space in front of you and let your breath follow your intention from you to the opposite wall. Or if you are in an open space, such as a park, select a tree to aim your breath towards.

▨ Let your face, chest, belly, knees and toes direct into that space.

Breathe into the space around you

Now become aware of the space behind you, which you can't see but you know is there.

Let your intention take your breath out behind you.

Allow the back of your neck, your upper and lower back, legs and heels to direct into that space.

Bring your attention to your sides, breathe into the space on either side and allow your ribs to direct as you do so.

Let the space breathe back into you.

Now let your heels drop as you breathe into the floor or ground underneath your feet, and into the space above your head at the same time.

If you are in a high hall you want to breathe as far below your feet as the ceiling is above you. If you are outside then the sky is quite literally the limit and the core of the earth your foot destination.

Think of this as an allowing process and don't be tempted to take deep breaths; it is always about your intention to seek out space and to allow space to breathe back into you. Finally, breathe into the space above you, below you, and around you all at the same time. Play with this idea in as many different environments as you can and use it as a way of getting to know your performance space.

Sinéad Gillespie – actress and playwright

Before training as an actor, Sinéad was a lawyer and subsequently a teacher, so all her career choices have been voice led. Currently she is performing in a one-woman play, *From Within*, that she wrote drawing on her experience of parenting her autistic son. This is her story.

School teaching

"When I was teaching in schools I was prone to throat infections and voice problems. When you stand up in front of a class there is a wall of noise in front of you, coming from the children, and you somehow have to make yourself heard. What do you do? My response was to pull up, to push my voice out, to shout. In my head I thought I had to get over the noise. I knew there was physicality to my problems, not just confined to my voice, but I didn't know what or how to deal with it. The Alexander Technique provided me with many insights and ideas to work with.

Drama training

"I came across the Alexander Technique in my drama training. It was a real gem and one of the best parts of my training. I am a small woman and AT enabled me to inhabit my own body with confidence. It's as if I am saying to myself, 'I have these bones and this skeleton as my framework and I can project and own this space'. Holding the stage, owning the space and projecting my sound are an absolute priority; it's a must for me as an actor. The work is very physically demanding and I use the skill of direction to help me in difficult situations.

A speaking rock

"The first time I really felt the benefit of direction was when I was playing in a production of *Arabian Nights*.

One of my parts was a rock and I was huddled up on the floor, completely still for 10 minutes, which is a long time to hold a pose. Then I had to get up and move, so I couldn't risk having a dead leg or cramp. I directed round my body all the time and when it came to speaking my lines, which I did in this same pose so my mouth was facing the floor, I reminded myself that my whole body was my sound and I spoke the lines out of my back, using Alexander direction to help me.

My whole body speaks

"Understanding that there is plenty of internal space lets my whole body resonate to my voice. There is space between vertebrae, there is space inside my lungs, there is space inside of me and I use it. This idea helped me in two quite different situations. The first occurred when I was playing in one scene of *Mother Courage* and I was right at the back of the stage, standing completely still. The audience was miles away and I had one line to deliver. There were other actors upstage of me, moving around, whereas I was still. I used direction to send my line across the room, I didn't shout or push, I just used direction. In another role, Bone, I spent the first 10 minutes lying down on the floor whilst the audience came in and were either standing or sitting around quite close to us. The floor was cold and hard and my opening speech was delivered softly as it was a speech from dreams or nightmares. So I thought to myself, 'Well, here I am lying on this cold floor, eyes closed – but I'm speaking up above me and all around me and my direction will take my words all round this space'. The amazing thing is – it works. I can be heard, and I'm not killing myself in the process.

From within

"In my own work *From Within*, I play both the autistic child and the parent. As the child I distort my body considerably. As the parent I play a very intense scene where I am sitting sideways on a bed holding a pillow up. The audience doesn't know what I'm going to do with this pillow – maybe smother my autistic child. I hold this position for some while and then I slowly lean forward and put the pillow on the bed, lay my

Sinéad can now scream without hurting her voice

head on it and cry. Then I have to go immediately into the next scene, which is a softly spoken dream sequence. If it wasn't for the AT I just couldn't do it. I am twisted, my stomach is squashed, the 'bed' is an insecure prop and the intensity all has to be portrayed. I direct my legs to make contact with the floor and I speak my lines out of the back of my shoulders.

Sinéad adopts the body posture and facial expression of self-absorbed tension without damaging her body

"I have toured several venues with this work and played it at conferences of social workers and other groups connected with autism and caring for autistic children. These venues are not theatres and my audience are not in a play-going mood, they are in conference mode. Often my stage manager and I have driven up to the venue, dragged our equipment in ourselves and have very little time to set up before I perform. I have to deliver the play in that unknown space with no lighting, no stage and no curtains. I have to draw the audience in to this very poignant story in a space that has previously been used to deliver speeches via a microphone system. I have no mic system, it's just me. So I have to command the space very quickly. I walk into the corners of the room, directing myself to lengthen and widen, directing my feet to travel along the floor so that I can speak in that space. In these strange venues I have to do more than own the space, I have to be the space. That sounds a bit odd but I use direction to experience the air in the room, the height of it, the depth of it. I direct myself so that I am the space. Then I can speak."

Workshop 6

Snakes and kettles

This workshop is a breathing and postural support experiment. You are going to hiss, making a 'sssssss', sound. You can do it sitting, on your hands and knees or lying in semi-supine, as you wish. It offers an insight into how a controlled out-breath doesn't have to pull your body down. Before you start the exercise, notice what happens if you just let your breath 'fall' out of your body with no control. Everything falls down. When you speak, you do control your out-breath, intentionally or unintentionally, and if you are unaware of what you are doing, you are more likely to be breathing like a vertical concertina, collapsing down as you breathe out when you speak, and hauling yourself up again as you take the next breath in. That is going to change. This particular exercise creates a narrow passage for the air to get out from your body and so encourages your diaphragm, ribs and abdomen to adjust slowly, and retain tone as they do so. Take time to read the workshop

material. This workshop doesn't have an audio commentary, as individual timing will vary. Read through the material and try the procedure out in your own time.

You will need

▦ A sense of humour: you will make some strange noises!

Your approach to the procedure

Enjoy hissing like a snake or a kettle; enjoy the sensation of your ribs coming together and then opening out again with a rewarding ping.

Getting there

▦ Start your first experiment sitting, choose a firm chair and don't lean on the back. Get yourself organised with your feet resting on the floor and your back lengthening and widening.

▦ Put your hands on either side of your ribs so you can observe their movement. What you hope to feel is your ribs moving in and out sideways, not pulling down towards your pelvis as you hiss. If you do find you are imitating a leaking concertina rather than an indignant snake, you need more head direction and more lengthening.

▦ Remember direction is an intention, not a heaving upright of yourself, and remember too that this sort of change takes time but is worth doing.

Hissing is fun

You are going to hiss though a small gap between your upper and lower teeth, with your lips slightly parted and your tongue just behind your front teeth. Avoid tightening your mouth and cheeks up into a knot, and leave your neck and jaw free. What you are doing is expelling air against the resistance of your lips and tongue, so you are creating a back pressure by blocking out the free flow of air from your body. This can have a stimulating effect on your ribs, if you don't simply pull yourself down or rigidify your chest as you do so.

Directing

When you have chosen your position, ask your whole body to lengthen and widen, paying attention to

letting your neck stay free and not hunching your shoulders up. Adapt the directions if you are in semi-supine or on all fours.

- Let your head be going up toward the ceiling.
- Ask your sitting bones to rest on the surface you are on.
- Direct your thighs to lengthen away from your hip joints towards your knees; tight legs are not wanted for this experiment.
- Let your upper back lengthen and widen so that your armpits are free from tension.
- Allow your shoulder girdle to sit easily on your ribcage.
- Let your head sit easily on your neck.
- Breath gently in and out through your nose.

Let's hiss!

For the first hiss DON'T TAKE A BREATH IN TO START HISSING. If you do, you will almost inevitably pull your head back, lock your neck up and do all the things you normally do in order to speak. You probably think, "How can I hiss without any air?" but there is always air in your lungs. Your priority is not hissing, it's lengthening, which you usually forget about the instant you decide to hiss. The hissing part is easy, the lengthening part is not. So give 90% of your attention to lengthening and keeping a free neck and 10% to hissing.

How loud?

If you are lengthening as you hiss you will feel your ribs come towards each other under your hands, let them do so. Don't force the hiss out with great effort, just enough so the cat on the other side of the room can hear your hiss. On the other hand don't let it dribble out with no pressure; the cat actually wants to hear you hissing.

How long?

The length of time you can hiss will depend on how well organised you are, how fit you are to carry out this experiment. Over time, the length of your out-breath will increase without you deliberately attempting to do so. A good guide is to stop when you hear the pitch of your hissing start to fall; this is a sign that you are starting to pull down and is a good moment to stop that particular hiss and let your ribs ping out to fill your waiting hands.

At the end of the hiss

When you hear the pitch drop or you know it's time to allow breath in, take it in through your nose not your mouth. This continues the stimulating effect of the ribs, as once again there is a small opening for the passage of air into your body. Your first hiss, the one you DIDN'T deliberately breathe in for, will be shorter than subsequent hisses. When you have ALLOWED breath back in to you, hiss again, keeping lengthening and widening as you do so.

If you are new to this, you might find you want to stop after only one or two hisses. Don't make yourself dizzy! As you get 'fitter' you will be able to do this effortlessly for as long as you want. The golden rule is always KEEP YOUR LENGTH. If you can't do that, its time to stop.

Variations

You can play with expelling air making a 'ffffff' sound instead of hissing. This is produced by you making a small opening in your lips but letting your tongue lie quietly at the bottom of your mouth instead of bringing it forward to your teeth. It gives you a more open passageway for the air and so it's easier to pull down, particularly without noticing you are doing so, but it is a useful exercise in maintaining length with a more open airway. When you speak, you modulate the airway according to what you are saying so anything that encourages a flexible approach will help.

Play around with alternating between 'sssss' and 'ffffff' and notice the difference in internal pressure between the two. Keep your resonant self resonating throughout both sounds.

Benefits

A well-toned diaphragm, ribs, back and a better co-ordination of posture and breath support.

SUMMARY OF CHAPTER 6

- Your whole body is involved in sound production
- Consider your Use before you open your mouth
- Understanding intention can help project your voice

7

"SINCE SINGING IS SO GOOD A THING, I WISH ALL MEN WOULD LEARN TO SING."
William Byrd, 1588

CHAPTER:

The singing body

IN THIS CHAPTER

▥ Body use in singing

▥ What is abdominal support?

▥ A different approach

Passion

Nothing inspires people like singing. Of all my pupils, those who sing are dedicated, passionate and happy to spend time and energy pursuing their singing. Singing is a natural human expression. It communicates directly to the soul and from the soul and cuts across culture, race and time itself.

Early influences

In junior school I recall the class sitting in rows at their desks while the big wireless in the corner was tuned into BBC Singing for Schools. This was where I learnt such works as 'Hearts of Oak' and 'Cockles and Mussels'. In the playground large groups of us played skipping and singing games, learning far more skills than we were aware of. We skipped with a long rope, turned by two children who were called 'enders'. They turned the rope while the rest of us took turns in running into the rope and skipping, everyone singing or chanting as we did. We learnt about co-ordinating postural and respiratory mechanisms, being part of a group and taking turns. We learned to listen to other people and match our song and actions to theirs. We played ball games and clapping games, both of which required the co-ordination of sing-

ing and action. In this way we established rhythmic patterns in our bodies and minds. For us it was play; nobody organised us to do it – it just happened.

Body Rhythm

Today we know that music, and particularly singing, plays a very important role in the ability to learn almost any subject. Rhythm, an understanding of timing, co-ordination and awareness of other people all contribute towards good learning. Our playground games served us in more ways than we realised. Our bodies naturally contain many rhythms – the faster rhythms of our breath, our heartbeat, and slower, longer rhythms such as sleeping and waking. Singing allows us to understand these rhythms and enhance them.

At secondary school we tackled such works as 'The Messiah' and 'Hiawatha's Wedding'. The songs I learned as a child are still with me, embedded in my memory and retrievable almost instantly – even whole passages of 'The Messiah', which I first sang aged 13. When I sing it now – as I do every year with 500 other singers in the Royal Albert Hall – I am transported back to Stratford Grammar School and the smell of my friend Christine's peppermints, which she sneaked in to rehearsals (sucking sweets is not permitted in choir, girls!).

Vibration

When you sing, your whole body vibrates – you resonate. When you listen to singing, something of

the same experience occurs. It is an expansive, uplifting feeling. It embeds itself into your nervous system, releases happy hormones and carries memory across the span of your life. Songs my mother sang to me, I in turn sang to my own children. From babyhood upwards I sang them nursery rhymes and 'You Are My Sunshine', which I remember having been sung to me before I could walk. If I sing that now my grown-up son smiles and says, "I remember that". I hope he will sing it to his children one day.

Singing weaves you in to the fabric of your life and the lives of those before you. There is something very compelling about singing something that has been sung by generations before you, hundreds of years before. It speaks of survival and the enduring nature of the human spirit. Every year on the 1st of May, a group of singers ascend the Magdalen Tower in Oxford University just before dawn. As the first rays of light appear they sing 'Summer Is Icumen In', thought to have been written in 1260, as they and their predecessors have done for the past 500 years. It connects them both to the past and the future and marks the passage of the year as it turns through the seasons – another rhythm acknowledged and celebrated.

Indian singing

Padmini Menon is Indian and she loves to sing. It is part of her culture and her experience of her life – she has always sung. To be able to sing a raga, a singer has to undergo years of training and discipline and, although she has not reached the level of being able to sing ragas herself, she enjoys listening to them and trying to identify them from the nuances used by the musician. Ragas are very complex and studying to sing them requires years of dedication. Ragas are still sung, and played. The singer generally sits cross-legged, as do the instrumentalists. Chairs were not part of society and not in general use as they are today.

The sitting challenge

Padmini sits cross-legged as she sings. She had been dissatisfied with her singing for quite some time, because she knew it was not quite how she wanted it,

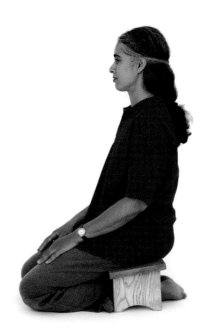

Easy, upright balanced flow of head, neck and back offers internal space to sing.

but couldn't identify exactly what was wrong, or how to address it. When she decided to train as a teacher of the Alexander Technique, she also made up her mind that she would stop singing for a while and just focus on the Technique in the hope that she would learn something which would help her to improve it.

Her first 'Alexander' discovery was how tight her hip joints were and how compressed her lower back was. This made sitting cross-legged a strain. Although at first Padmini didn't notice any problem, it did interfere with her breathing and make it more likely she would pull her head back as she opened her mouth. She raised the height of her sitting bones by sitting on a couple of telephone directories and alternated her position by sitting on a meditation stool. This enabled her to lengthen up as she sat and let her back support her. When your back starts to be able to support you in this way, it also starts to strengthen. You can then return to cross-legged sitting and progress to lowering the telephone directories until you are able to sit in comfort on the ground again. This is what Padmini did. Allowing her hips to widen and directing her thighs to lengthen

towards her knees gave her a stable base from which she could also lengthen and widen her back. This gave her the right framework to explore her singing. She started with Indian scales, which were so familiar to her that she could observe her Use while singing. She noticed the tendency to tighten and narrow her back as she ascended the scale and how she was tempted to push the sound out of her throat. Inhibiting both these interferences resulted in an opening out of her sound and an easy transition from note to note. She then added a hand movement to do with counting which involved turning her hand over at certain points. At first this caused her to narrow her shoulders, just slightly, as she turned her hand, and once again she interfered with the sound. Reminding herself to widen as she moved her hands helped remove that interference.

Consider the singer, not the song

What was different about this approach was the emphasis not on the sound she made, but entirely on the way she was using her body as she made it. To sing requires a particular state of being – a sense of openness and spiritual awareness that influences the sound. Padmini found that by using inhibition and direction she could allow the pure sound she wanted just to emerge from her. As soon as she became self-conscious, or tried to modulate the sound directly, she tightened up. Understanding Alexander's indirect approach to the voice brought her to a place she thought was only accessible after years of study.

The mysteries of abdominal support

If you can't get what you want by release, you certainly won't get it by force or misdirected effort. Singing is a very physical activity – it requires a particular kind of fitness. Much is said about the need for abdominal support – the idea being to support the breath, to support the sound. There is an assumption that you must have strong abdomi-nal muscles in order to sing well. In my experience of working with singers, *it's the other way round*. If you organise yourself to sing well then your whole body, including your abdominal muscles, responds to the demands you are making, and is being exercised by your act of singing. Inevitably, these muscles will tone up and become stronger because of the work they are doing. If you set about it the other way round – strengthening your abdominal muscles to help you sing – the most likely result is interference with your sound because you inevitably compromise your resonance with misplaced tension.

Concentrating on the abdomen often means singers ignore their backs, or have little concept of how their back works. Concepts of core musculature support only get half the body involved in the supporting act. Your entire body, from the tips of your toes, to the top of your head, is one big resonance chamber with many more precisely located resonance areas in between. Getting the whole body involved – by lengthening and widening – creates the tonal support you need to sing, or to speak.

Natural voice

The human voice is capable of singing an almost endless variety of styles, shades of tone and colour. Each voice is unique, with its own individual timbres, resonance and characteristics. Your voice is as individual as your fingerprint. So what is a natural voice? When it is possible to create so many different types of voices – rock, classical or pop – and as the voice is so mutable, how can you encourage a natural sound to emerge, if you want to? Many things influence your voice: your physical structure, the length of your neck, the size of your lungs and the state of your health. But the biggest influence of all comes from your own intention – from what is going on in your head. This is because what is going on in your head has a profound and immediate effect on your body and voice. Organising yourself so you have a free neck and can lengthen and widen offers the opportunity for your natural voice to emerge. Using the Alexander Technique you create a supportive

framework for your voice with your web of muscular support and your directed intention.

Colour and intention

A good conductor can change the sound of a choral group by asking them to create different stories for the work they are singing. Take the madrigal 'Weep, Oh Mine Eyes' by John Bennett (c 1570), which is a song about lost love. But what kind of loss? If the group is considering the yearning loss of young love, perhaps the first time your heart was broken, or unrequited love, they will produce a very different sound than if they were thinking of a different kind of loss, perhaps loss of a long-term love. Yet how do they do this? What makes these two sounds different from each other when it is the same work, the same notes and the same group singing it? It is the intention that creates subtle bodily changes that in turn create subtle but discernable changes in sound. Intention changes sound.

Glorious neutral and blank canvas

When you can leave your neck alone, so that it is free, and your head can go up so that your back can lengthen and widen and your feet connect properly to the ground, you bring yourself into a state of balance that could be described as glorious neutral. You are not making excessive effort to hold yourself up, you are not tightening your legs or your abdomen. You are not, in effect, doing anything – you are simply there. This happy state gives you a blank canvas on which you can paint your own voice. As intention and wish registers so effectively in your voice this is – to a certain extent – the easy part. The difficult bit is getting yourself to the point that your intention doesn't have to cut through layers of tension and unnecessary holding to make its mark in your sound. The best way you can get to a glorious neutral is to use the experience of the Alexander Technique to educate your awareness of your balance.

Alexander lessons for singers

Every summer I teach the Alexander Technique in a summer singing school at Ardingly in England. Sing-

ers come for their individual Alexander lessons to improve their Use and make the most of their voice. We usually start the lesson with some table work, lying in semi-supine, their head supported by books, their knees bent and their feet flat on the table. This is a neutral position, the arms and legs are at their mid point between flexion and extension and the back is resting. It's a good place to start removing the layers of tension that mask the natural balance mechanism. It's where you can rediscover what glorious neutral might mean, and experience internal space. Forming the intention to lengthen and widen while you are in this position lays the groundwork for lengthening and widening when you are upright. I use my hands to encourage singers to 'undo' holding patterns of which they may be unaware.

After the table work, the singers come up to their feet. Our teaching studio overlooks some playing fields and, at the very back of these, there are some wonderful oak trees. They make a good place to aim your head towards. I encourage the singers to let their feet open out on to the floor. Often this is interpreted as a request to put the feet further apart from each other and it takes a while to appreciate that we are after a different kind of opening. What we want is an internal opening of the feet, so that each foot is not scrunched up, but is resting properly on the floor – offering an upward impulse to the rest of the body. This, combined with sending the head forward and up over the oak trees, gives a lengthening tone to the whole body, particularly the back. It encourages the back to widen so there is no pulling in and narrowing. This is glorious neutral, but in an upright position. Glorious neutral creates internal space for free movement of your diaphragm.

Knees

Singers can get very concerned about their knees. They may have been told (quite correctly) that they don't want to brace their knees, but often they interpret this by letting their knees go soggy so they are slightly bent all the time. One young singer went so far as to alter the length of her performance dresses

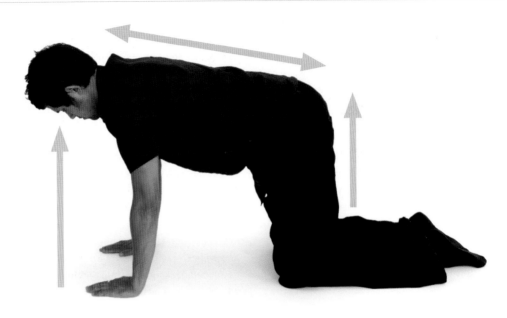

Try singing
or humming
on your
hands and
knees

so they wouldn't trail on the ground when she had her knees bent. Considering the knees in isolation from the legs and the back is a recipe for mis-use. The most likely result is a lack of unified muscle tone throughout the back, which translates into a smaller 'range' of good quality notes. A lengthened back has muscle tone from the neck right through to the buttocks, knees, heels and feet. If you let your knees go soggy, you interrupt that chain of tone and are likely to let the top of your pelvis tip forward and narrow your back. This will subtly pull on the back of your diaphragm and demand more compensatory tension from you. So consider the knees as part of your legs and your legs as a vital part of your whole muscle suit. Neither a soggy nor a stiff-kneed person be!

Painting the canvas

If things are going well, and the singer is well balanced, then we up the stakes a little and increase the stimulus by humming a scale. We start with humming because it stimulates the ribs nicely. It means your mouth stays closed so it's less tempting to pull your head back as you breathe in and its sound is very revealing. If your legs are tight, or you instantly forget your head direction the second you start hum-

ming, then the sound is very local to your throat and head and has a thin quality. On the other hand if you keep lengthening and widening, then the humming vibrates your whole body – you can feel it in your back and the sound is rounder and more open. You have started painting the canvas of your voice.

Intention and direction

Sometimes we play with singing while on hands and knees. This position demands a great deal of co-ordination from your back. It can also reveal to you any habit you might have of pulling your head back, or dropping your neck column when you open your mouth to take in a breath as you sing. You can experience the power of intention in this position. If you think of it being exactly like semi-supine, except that you are the other way up, then you can apply the same directions and intentions of lengthening and widening as when you are lying down. Using your limbs as pillars of support you can allow your back to be suspended between your arms and legs. You maintain an upward intention from your hands and knees and a lengthening intention from the crown of your head to your tailbone. These two directions/intentions let your back work really well to support you

and you'll be surprised at the sound that will emerge when you work in this way. In this position your arms and legs are sharing the weight load of your back so it's easier to get your back working well. Investigate the workshop 'Crawling for grown-ups' at the end of Chapter 9 to learn more about being on your hands and knees in a thoughtful way.

How do you land on your note?

When singers hum a scale they will either successfully stay free in their body or they will follow the pitch of the scale with their body. When they do this they pull themselves up as the scale goes up, often accompanying this by raising their eyebrows and clenching their toes in an effort to 'reach up' to the note. These notes become unsupported and the singer, sensing this, tightens more round their abdomen, or pushes their ribs out in an effort to recruit extra support for the notes. In our lessons we approach this from a different perspective, using inhibition and direction to help. We use the wonderful oak trees far away on the other side of the field as a reminder to let the neck stay free and the head to go forward and up, over the trees. Even when more effort seems needed, our key thought is 'allow'. The oak trees and the direction of the head are well above the envisaged 'height' of any note, so the note can be approached from above and the singer can land on the note from above rather than pinching up to it from below. When descending a scale, the tendency to follow the direction of the note with your body is the same, as the scale goes down, so you pull down. Meanwhile your poor diaphragm is attempting to go up inside you and you are making it hard work. Both types of interference take your balance away from glorious neutral. Taking this different approach helps significantly when the note is high and at the end of a phrase, or if you are singing a coloratura (fast) passage.

'e', and 'ah'

Working with a young soprano on Mozart's 'Alleluia', a Motet in F for soprano, from Exsultate Jubilate (K. 165, 1772), this temptation to 'pull'

up for notes became obvious. This is a work that demands superb breath control because it has long coloratura passages which follow on from each other almost immediately, leaving very little time for breath. The entire work consists only of the word 'Alleluia', and the syllable/sound 'e' was giving her particular problems. This was because the singer was unconsciously tightening her throat and chest to make this sound. Producing this sound requires the vocal folds to be closer together than producing the 'ah' sound at the end of the word, which is an open sound. However, the singer had overdone the tightening and added to her difficulty by pulling her entire body down and tightening her neck. The 'e' sound stuck out and sounded not only flat but also colourless, so she was unable to make any difference in her phrasing – every word sounding the same in the middle. She had created a vicious circle – the more it went wrong, the harder she tried to get it right and the more she tightened up, pinching herself and her sound. She had lost her length. In her lesson we looked at this problem purely from the perspective of lengthening and didn't think about the sound at all, so her end-gaining desire diminished. She could then consider how she was approaching the problem rather than looking directly for a solution.

A pair of sparkling eyes and a flexible soft palate

Encouraging her to let her feet make proper contact with the floor and her head to go up and out over the trees, we played with encouraging a lightness in the mask of her face by thinking of silly jokes. The sort of joke that makes you want to giggle, and brings a sparkle to your eyes. This has the effect of opening the throat and allowing the soft palate to lift up rather than be pulled down. All of this creates more space inside your mouth and throat and once more takes you to a place of glorious neutral that you can work with. She lightly taped her cheekbones and forehead with her fingertips to 'wake up' her face. This made her want to giggle too.

Popping bubbles

Having got a sense of lengthening working through the singer's body, we played with the idea of releasing just one note up over the trees as if it were a soap bubble popped out from a wand. This image amused us both and allowed her to keep her face light and animated and her soft palate gently lifted. She was amazed to find how easily the sound came out, and that it was rounder and richer than she thought possible. As soon as she took her attention away from lengthening and back to her sound she reverted to her old way of supporting herself and her old tight, thin sound returned. It is important to remember that change like this cannot occur instantly, but inhibition and patience will eventually reap their rewards. By the end of the lesson she could 'pop the bubbles' of a whole phrase from 'Alleluia', with ease, making a sound she had never made before. She went off to her singing session very excited. Later that day she came back to my studio and said she'd 'risked' lengthening in her lesson. She found the temptation to slip into the old habits very strong but she stayed calm and kept her attention on length. She said her tutor told her it was the best she had ever sung and her friend asked her where she had 'got' that smashing new voice from. She replied, "That's my real voice, I just didn't know it was there."

A gentle way with inhibition

Singers and musicians, by their very nature, tend to be dedicated 'end-gainers'. In a competitive environment, there is not much room for shrinking violets and lack of confidence. Some singers meet this challenge by bracing their entire bodies against the potential rejection they will experience in auditions. Having to undo the associated tension and bad habits of Use is quite a challenge. Inhibition is a hard discipline in this situation, where the focus is entirely on result. It's useful to remember that inhibition allows you to make a thoughtful response to the stimulus of the situation and that the stimulus is continuous and ongoing. What this implies is that you can usefully ask your neck to undo, just a bit, even when you are in the middle of singing, so you can change your response to the ongoing stimulus. The stimulus to tighten and pull down is always there, but you don't have to always respond to it in the same way – you can be gentle with your inhibition.

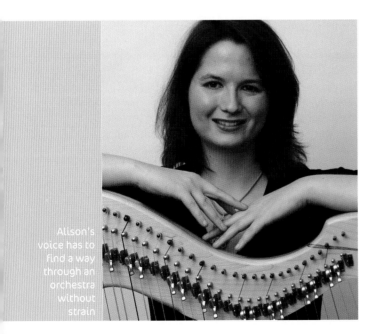

Alison's voice has to find a way through an orchestra without strain

Alison Nicholls: classical singer and harpist

Singing is Alison's passion, her profession, and her life. The development of a classical singing voice is a long slow process that is never complete – it's always work in progress. At the age of six, Alison saw a video of Mozart's *The Magic Flute*. Directed by Ingmar Bergman, the video was shot in Sweden at the famous Klungliga Teatern (Royal Opera House) and depicts the action of the opera on stage, with images of a young Swedish girl watching. Alison was totally captivated by the opera and watched the video over and over again, replaying it as soon as it had finished. This went on for some time. She then declared her intention of singing the famous 'firework' aria 'Der Holle Rache', sung by the Queen

of the Night, a character that above all fascinated Alison. She set about her intention by going into her garden, getting on the swing and working up to a good swinging rhythm. Then she started to sing, pitch perfect, note perfect, in rhythm and in Swedish or, more accurately, the sounds of the language she had heard. It was an astonishing performance. 16 years later she still wants to sing Queen of the Night and is working on her coloratura. This is her story.

Singing: it's up close and personal

"I have been singing for over 12 years now and I've always been very clear that singing is a very physical activity and your body is your instrument. However, unlike any other kind of musical instrument it is not a rigid structure and not any kind of intermediary between you and your audience. You don't translate your sound through anything other than your own self. Instrumentalists can use their instrument as a barrier between them and their audience, and as a channel for the emotional content of their sound. They have something to hold on to, something to carry on and off stage. I have only myself. As a singer, my own body is the medium I use to communicate directly with my audience, it's the palette for my sound, and it's very personal.

Bel Canto

"I am classically trained in the bel canto school of singing. Bel canto translates as 'beautiful singing'. It's a system that allows my voice to unfold. I am grateful that I have been taught by people who really understood the importance of never pushing my voice, never straining. I had my first singing lessons aged eight from Penny Jenkins, who took me through all my singing grades and taught me right up until I went to university. Penny always encouraged me, chose music that I enjoyed and which suited me, allowed my voice to unfold in its own fashion and never dictated what my voice should be. I remember one day Penny's husband Neil Jenkins (tenor) asking if he could look down my throat. He was pleased to see that I had a large open throat. Actually I have a double uvula, like a canary, and

perhaps that influences my sound. I also have big lungs, which I think I inherited from my grandfather who was a saxophone player. So I am lucky to have the bodily equipment. Learning to use it well is my journey and my responsibility now I am older. Without good teaching and a conservative approach I could easily have over-sung at a young age and given myself vocal problems.

Don't end-gain

"I have been helped by my knowledge of the Alexander Technique, particularly the concept of non end-gaining – not focusing directly on the result you want, instead paying attention to how you set about it. This is a very odd concept in some ways. Surely you want what you want and see to it that you get it, don't you? Well, in some ways you still do that, but you think of how you are doing things, not just the end result you're after."

What I want for my voice

"I'm always working for a good sound – I want good support and stamina. I will often have three or four rehearsals a day and I need stamina and an ability to use the right amount of energy and no more. I want a fluidity and seamlessness in my sound, so I have cohesion throughout my range. I don't want to sound like two different people singing, with a fluty sound at the top and a heavy sound at the bottom. When I use myself well, my body does this for me. I want to preserve my sound, so I think long term about my voice. I still want to be singing and have a good voice in one year, 10 years, 20 years... Eventually I want to sing Wagner. That's a very long slow process and I'm starting now. When you sing with an orchestra you have to find a way for your voice to cut through the instruments so you can be heard. It's not possible to do this with force, you have to find a different way.

The Alexander Technique influence

"Through my Alexander lessons I have become aware of all of my body, not just my diaphragm and abdominal muscles and the other bits that people

associate with singing. I know that I don't need to clench my toes to sing a high note. I am more aware of my legs and the thread of my breath filling every part of me, not just my voice. My breath enriches my body – it's a holistic concept, freeing my whole body, and it's not just about the phrase I am singing.

Support

"AT taught me the difference between support and holding. Holding sometimes feels like support, you can feel your ribs being held out and your stomach being held in, but it's not going to get what you want if you go about it with excessive effort. It is a tricky thing because if you watch your teacher singing, you can see their ribs going out and their stomach going in and so you think 'right, I'll do that too'. But it's not a simple case of sucking in your tummy and holding your ribs out. That is more likely to tighten your sound than support it. That's where I began to understand about inhibition. I had to literally say 'no' to the tension and the desire to do it right, before I could then say 'yes' to the new sensations and directions. It is a leap of faith because you have no idea what will happen, what kind of sound will come out of you, when you stop doing something so familiar. For me, I organise my breathing and lengthening first and then support and sound follow. Support comes naturally when you lengthen. When you get an idea in your head of what to 'do' then you hold on and get in your own way. I have confidence in my training and my body. I provide a lengthening structure and let my body sort things out for me.

"I sang the lead role of Emily in *Gravity and Light*, an opera about the Alexander Technique written by my mother [the author]. It was performed at an international congress of Alexander teachers in Oxford. For me the final chorus really sums it all up. This is the chorus:

To change the world first change yourself and let
your spirit breathe
To take your time just change your mind and all

things can begin.
If you want to lift up your heart
And sing
How will you do it?
Emily. First I say 'no' and then I say 'yes'
Hardiman. The 'no' still must linger on
Nicholas. You can't know a song by a singer
who's wrong
Chorus. It is your choice, it is your choice
Choose to say 'no'
And leap, and leap, into the unknown
Only by giving up the old ways and refusing to feel if
you're right
Will you find the freedom to cast the first spell
of gravity and light
gravity and light

Workshop 7:

Let's raise the roof (lifting the soft palate)

A flexible soft palate plays a vital role in the production of sound in both speaking and singing. If your soft palate is not flexible it is liable not to be able to rise and lift fully, and will tend to be slightly flattened. This will have a flattening effect on the sound you make, giving it a nasal quality. To encourage the soft palate to rise you need a sense of 'up' throughout your whole structure. This workshop offers some experiments designed to open up the space inside the mouth, encouraging the soft palate to rise and the throat to open.

Read the workshop material through first, and then listen to Track 7 on the CD. It contains thoughts and ideas to enlarge on the written explanations.

You will need
▪ Either a mirror so you can see what you're doing or a good friend who will join in with you and treat the whole experiment as a game.
▪ A sense of the ridiculous.

■ A few silly jokes to make you want to giggle (sorry not included!).

Experiment 1. A whispered 'ah'

Producing the whispered vowel sound 'ah' can help open the throat and raise the soft palate. First of all get yourself sitting in balance so that your back is lengthening and your feet are resting on the floor. Keep your neck free and remember that directing your head forward and up is the most important aspect of the experiment.

Can you open your mouth?

Put your hands up to your ears. Make sure you don't pull your head down towards your hands as you do this. Place one finger (probably your index finger) behind your ear lobe, and another finger (probably the second one) in front of your ear lobe.

Now you have your Atlanto-Occipital joint (A/OJ), where you nod your head, and your Tempro Mandibular Joint (TMJ), where your jaw hinges open, between the fingertips of your hands.

Play with slowly opening and closing your jaw several times. Watch out that you don't pull your head back and down as you do this. Do open your mouth to at least two finger widths wide, not just a tiny slit that a fly couldn't get through! You want your jaw to be free to move and it is a favourite place to hold a lot of tension.

Next time you open your mouth, gently make a whispered 'Ah' sound, paying attention to keeping your lengthening active throughout your body. Close your mouth after the 'Ah' to take air back in through your nose. Remember, you don't need to take a special in breath for this purpose, just simply open your mouth, there is always air in your lungs. When you close your mouth, air will come in easily through your nose and into your lungs.

Now have another go, directing your lower back teeth away from your upper back teeth, as well as your head forward and up. This will help to free your TMJ more and give you more space inside your mouth. Do several more whispered 'Ahs' like this.

It's easy to pull your head back without thinking (left)

Keeping your neck free and directing your head forward and up lets your back lengthen and makes inner space for free breathing. (right)

A sparkle in the eyes and a lightness in the mask of the face helps lift the soft palate

described in various ways as a secret smile, a smile or sparkle of the eyes or an inner smile.

The famous Mona Lisa portrait is said to display this smile. There is no point in approaching such a task seriously, hence the silly jokes. What you want is to get to the point before you laugh, that feeling of impending mirth lifts up everything in your mouth, throat and facial muscles. So tell each other silly jokes, or tell yourself a silly joke and allow yourself to sense the laughter coming and then do some more whispered 'ahs'.

Benefits

Good whispered 'ahs' help to extend your out-breath, tone up your respiratory mechanism, lift your soft palate and encourage a good reflex in-breath. It seems such an innocuous thing to do but it will pay dividends if you explore it.

All right, I do have one silly joke.
Q. Why do birds fly south for the winter (or north if you're in the southern hemisphere)
A. Because it's too far to walk…

Experiment 2: An inner smile

Having got some space inside your mouth you want even more! To encourage your soft palate to rise you need lightness in your face across your eyes, nose and forehead. This won't happen if you are pulling down in your body, but even when you are going up in yourself you need a little extra. This extra has been

SUMMARY OF CHAPTER 7

▓ Your legs and feet matter when you sing

▓ How to colour your voice

▓ How to use thinking to modulate your voice

CHAPTER: 8

Just play the music

IN THIS CHAPTER

- The challenge of playing
- Why understanding gravity can improve your playing
- Breathing and playing – it's not just for wind and brass players

Poise in playing

When a musician plays, she or he brings with them not only the knowledge of the music, but all the problems they may have encountered on the way to being able to play that music. They also bring with them something much more fundamental – their relationship with gravity.

The way a musician walks, talks, eats, sits and breathes will largely depend on the way their whole being deals with the downward pull of gravity. And the way she or he deals with gravity will affect the way they play.

This fundamental relationship with gravity is far removed from usual concerns about techniques required for playing, about strengthening weak fingers and interpreting music. Working with – and improving this relationship – can allow the ground to be cleared for a musician to achieve what she wants in the way she wants to, without dictating 'the right way'. Because this relationship is a fundamental that permeates life,

it doesn't have to be practised with an instrument but can be used anywhere, anytime. The best thing any musician can have, and work for – regardless of what instrument they play – is a good back.

Good Use builds stamina

When a human being is well organised, their response to gravity is one of springy flexibility. Uprightness without effort. Poise. For a musician this is particularly important as rehearsals and performances demand many hours of playing. If your Use is poor, then the longer you play, the worse it will get.

This is not to imply that good Use is only achievable by acquiring the perfect body shape in a nice straight configuration. It doesn't mean that the body parts need to stack up on top of each other like a tower of bricks. It is not that simple. Good Use implies you set about your daily life with the appropriate amount of effort and muscular tone required to do what you want. No more and no less. It is about you as an individual making the best possible use of what structure you have. Most instruments demand both strength and stamina and playing is an all-embracing activity – physical, mental and emotional. Good use encompasses all those elements.

Woodwind and brass

Any instrument that requires you to bring it up to your mouth brings with it the temptation to pull your face, head and neck down towards the instrument

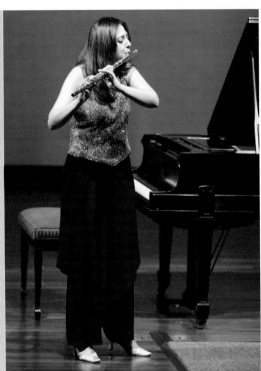

Pulling
down to
your flute
compresses
your ribs

Mouth to mouthpiece

Bringing your mouth to the flute so you can create a good embouchure is a delicate operation. If you reach forward for the flute with your face then you will simply stiffen your neck and tighten not only your mouth but also your neck and throat – the most likely result being a thin, somewhat breathy sound. Every time you take a breath in you will reinforce this pattern.

Let your head nod

Your head is heavier at the front than the back, so if you have no tone in your neck your head will nod right forward on to your chest. But if you have just sufficient tone in your neck, and an upward direction through your spine, then you can allow your head to nod on to your waiting flute. This action will stimulate a further lengthening of your back and get your ribs in a good condition to move freely as you play. Your shoulders can stay down away from your ears and your arms are not stiff, so fingers can move easily. This young girl demonstrates good use of her head, neck and arms as she plays.

Pianists

From the point of view of someone wanting to use their hands, arms and fingers in a complex and intricate way such as playing the piano, good support for the arms is vital. This support can only truly be effective when there is an understanding of how the Use of the whole body, and particularly the back, is involved in the process.

instead, which will only encourage you to stiffen your ribs and chest. The flute in particular can lure your chin out towards it, thus shortening your neck and dropping your whole neck column downwards. Playing like this encourages a downward pressure on your lungs and diaphragm throughout your breathing cycle. Even if you have learnt circular breathing, this use of your body will strain your neck, shoulders and back. As well as restricting your breathing, you actually make it harder to hold your arms up because you have disturbed your shoulder girdle so much. Your arms will tighten more than they need in order to stabilise themselves and this in turn will make your fingers a little stiffer, making playing a matter of tension. This young flautist has thrust her whole face down onto her flute and distorted her neck. She has pulled down through the front of her body and hunched her shoulders up. All of this will affect the quality of sound she makes as well as contributing to physical discomfort. Her relationship with her flute is uncomfortable.

Without useful support, the arms and hands can become both tense and heavy, resulting in a dead, literally heavy-handed sound, that no pianist wants. Attempts to improve this are often made by even more tension that almost holds the hands away from the keys in an attempt to lighten up. This double bind habit is a very difficult one to break. First, excessive tension makes the hands too heavy and then further tension appears to make them unable to produce a resonant enough sound. It's as if the pianist is snatching his hands away from the piano at the same time as putting them on the keys to play.

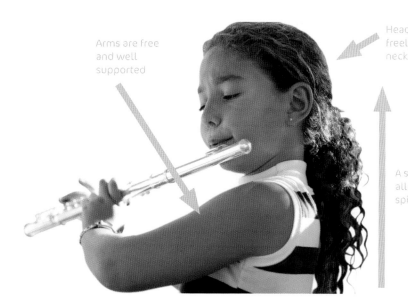

Arms are free and well supported

Head rocks freely on the neck

A sense of 'up' all through the spine

The right position?

It is easy to assume there is a 'correct' position for particular activities – such as playing the piano. Certainly in a broad outline sense this may be so. It is definitely easier to play the piano sitting down than standing up. However, playing the piano, like many other activities, requires a great deal of flexible movement to manoeuvre the arms and fingers around the keyboard and to use the feet for peddling. Ideas about position, such as 'keep your back straight', tend to be of limited use in this situation and can even contribute to tension problems by becoming too fixed.

Pianists tend to pay a great deal of attention to getting the height of the seat absolutely right, particularly if they are experiencing back problems. There is no doubt that getting these conditions 'right' is useful but, as this only tackles the externals of the problems that playing presents, it is only of limited value.

Seen from an Alexander perspective, it is not so much a question of whether you want your back straight or not, but how you achieve it.

Many pianists – having either no idea how the back should work, or partial concepts about muscle strength – will tend to sit at the piano with their

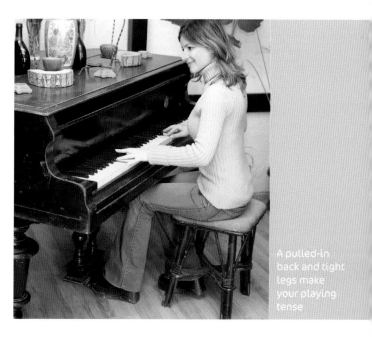

A pulled-in back and tight legs make your playing tense

whole body braced forward towards the keyboard. Often their lower back will be tightly pulled in towards the keyboard and narrowed. If the pianist is tall or has a long back, they may collapse the lower back into a curve and let their chest sink so as to get nearer the keyboard. Either way, these habits of body use will interfere with freedom of breathing and movement and will contribute to tiredness in a pianist who wishes to practise for extended periods of time. If a pianist has such poor habits of Use, they will be accentuated when playing, but they will also be apparent to a good Alexander teacher when the person is not playing, but simply sitting in a chair.

The Back and Ribs

When your lower back is not pulled in then your pelvis is neither tipped forward nor backwards, but instead acts as a container for all your abdominal organs – as well as a point of stability for your legs to connect to your back.

Your ribcage is then supported both by your spine and your stable pelvis underneath. Your springy, extending spine simply lets both parts, ribcage and pelvis, operate in a supported way.

Your ribcage, in its turn, acts as part of the web of support for your shoulder girdle. As most of the musculature that connects the arms to the torso does so

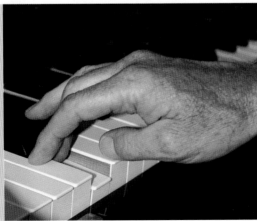

A free wrist and hand allows the fingers to pass over the thumb and take the next note down to the key bed without stiffening or collapsing the hand

via the ribcage – or is at least in that area – then your arms and hands are also supported naturally by your lengthening and widening back and free neck.

Where things go wrong, such as when the basic co-ordination and balance of your spine is disturbed, then one way or another there is not enough support for your arms. This is when excessive tension creeps in to provide the support that should come naturally.

Excessive tension creates stiffness and difficulty in movement. This usually tempts you into greater effort and more tension which, in its turn, prompts more stiffness and inflexibility. All of this tension is compounded by the stiffness of the ribcage interfering with your breathing. The weight of your arms and hands, when not properly supported, can drag on your whole shoulder girdle, which in turn drags on your neck. The single most useful thing any pianist can do to get a freer use of their hands and arms is to improve their breathing.

Breathing

Many pianists hold their breath when they play, often breathing very in a very shallow and spasmodic manner. When your breath is held in any way, then your ribcage is either fixed or – instead of gently expanding sideways as the breath comes in – is heaved up and down in one rigid block. This affects the flexibility of your spine and causes your back to narrow. In this way your arms are then robbed of their support and the cycle of tension builds up again. Often poor breathing goes with a fixed jaw, clenched teeth and, inevitably, a rigid neck and pulled-back head.

Problems in playing

Playing the piano requires your forearms to be held in a pronated (palm down) position for long periods of time. This is not a natural use of the hands and in itself this can contribute to forearm strain and tight tendons in the wrists and fingers.

Playing requires co-ordination of the two hands. When you play a scale with both hands together, you want

the notes to go down exactly at the same time with the same weight and value – and this demands a great deal of co-ordination. When you are playing a descending scale with your right hand, your fingers must cross over your right thumb to reach the next note. The thumb is a very strong digit. If it is stiff it will play the note heavily and act as a brace that pushes the fingers away from it. This makes it difficult for the fingers to cross over the thumb and more likely that you will push them heavily in to the notes to get the sound to balance between the thumb and the finger. This has the effect of tightening and narrowing the hand and makes playing tense. One of the reasons scales and arpeggios are practised so much by young pianists is to encourage co-ordination as a foundation for more complex playing. Unfortunately simply repeating a stiff use of the hand over and over again will simply entrench the stiffness rather than improve the evenness of tone.

Co-ordination problems can exist within one hand. Even a brief glance at the anatomy of the hand will show that the fingers and thumb are not all served by tendons and muscles in the same way. Your hand is primarily designed for grasping – with your thumb opposing the fingers – and your hand able to flex a great deal to achieve this. Different fingers require different uses if a pianist wants to produce an even sound. Playing rhythmic patterns, particularly if the patterns are different for each hand, highlights the problems of co-ordination. If a pianist can't get good co-ordination they often practise more, going through the passage over and over again, which usually results in the build up of more and more tension.

Slow Practice

Slow practice – cutting the speed of a piece right down – gives time to form the shape of the notes under your hand. From an Alexander point of view it allows a pianist time to inhibit automatic tension from dominating their playing. It's a useful way to learn new work too, as the initial practice of a work builds up a muscle memory association with the piece. If that association is one of tension then

you have to undo it before you can progress. Slow practice gives time to keep your neck free and your breathing uninterrupted and formulate the kind of movement through the arm and hand and fingers you need to play the passage faster. Simply slowing things down but doing them the same way won't help. Slow practice allows you the discipline to practise slowly in a helpful way.

Listening

The ability to listen to your own playing as you are doing it is vital. You need to hear what is happening. If you like what you are doing it makes it easier to carry on and achieve the kind of sound you want. It has a profound effect on how you feel throughout your whole body.

When you are changing the colour of something, your whole neuromuscular system has to respond to adapt to what you want. The amount of pressure you use on keys has to vary from moment to moment. The balance of chords, or melodic line, affects the colour of your sound, and how you listen for them and to them affects the way you play them. It's both an instantaneous and a continuous thing.

The piano is a percussion instrument. If you want to produce singing legato sounds from it you have to manoeuver the illusion with complete co-ordination of your playing mechanism (mind/body/emotions). Every melodic note in a phrase has a different weight and you want to create the illusion that you are singing it, because the moment you play the note the sound is diminishing. Therefore you have to really listen in order to match it with the following note.

Educating the ear to listen and hear accurately involves far more than just the ears themselves. There is also the question of when you can hear the subtle differences between what you are playing and what you would like to play; how do you change it? That is where the whole approach of the Alexander Technique comes in – the more you can leave yourself open in your body, the more likely it is that your

intention can initiate the change you want to make. Having clear concise intention in your mind and direction in your body is the most powerful combination for creating the sound you want.

Guy's story

Guy Richardson is a composer and piano teacher. He has been having Alexander lessons for 14 years. His initial interest was to help release tension in his arms and hands when playing the piano. This is his story.

"I started having lessons because I was developing RSI in my arms. They were particularly painful when I was playing the piano and they never felt right. I could feel my arms pulling up into my shoulders, away from the piano keys and it was such a strong habit that I didn't know how to deal with it or stop it.

At first

"From the very start of my lessons I was dedicated to practising active rest. I wanted to do it all 'properly',

Guy's arms no longer pull up into his neck

not realising at the time that this very strong desire of mine to get it right and do it properly actually got in the way of progress. I didn't feel anything much at first but just kept going. I had a deep feeling of something unresolved inside me and, whatever that something was, it affected both the way I wrote [composed] and the way I played the piano. I hoped the Alexander Technique might help.

"My first sensation of release came outside of lessons. I felt it in my neck and it was such a shock that it felt like a flash of intense pain. However it made me realise something was going on inside me – something was shifting. It marked a turning point. I was a very anxious person – I felt imprisoned by my own anxiety, and it almost stifled me. Having lessons helped me to understand what was going on. I had used my mind to try and control my anxiety and I did so by controlling my body – holding myself tight and rigid. At first I brought that controlling aspect into my response to the Alexander Technique and often I would give myself the directions, as I understood them, and would immediately try and do them. I'd often end up even stiffer than when I started. For me – with my mind running off in all sorts of directions – I found it helpful to allow my mind to be quiet and alert. By bringing myself to the here and now I was able to think about what I was actually doing when I was lying down in semi-supine.

Inhibition and anxiety

"I was too anxious to even think about inhibition in the early days of lessons. My mental activity, my mental life, had always been completely bound up with physical tension. Writing made me feel so emotionally anxious that I locked up and practically paralysed myself.

"One day when I was writing [composing] it dawned on me I was doing something I didn't need to be doing. The emotions of writing the music were being blocked because I was so tense. The movement of musical thought was getting trapped inside my physical body. In the past I would have stopped

what I was working on, out of sheer frustration, but this time I thought, 'I don't have to do this – to get myself into such a ridiculous state of tension. It's just not necessary.' Up to that point my tension had been so much a part of my writing that I didn't see the problem. When I was able to start inhibiting the truly stunning tension in my arms, I then became aware I was clamping my chest and holding my breath.

"For me it's been like an awakening to the potential of springiness, of the life inside me. I had led a smothered trapped life and I no longer needed to.

Playing and directing

"Directing has been important when I play the piano. I can give my directions and feel my whole being expand. I have actually felt my head go up, apparently of its own accord. Occasionally this happens when I wake up in the morning – I find myself directing and undoing. The most exciting part is feeling the very tips of my fingers and a wonderful 'ping' in my toes as they come to life. I now feel that everything in me is becoming connected, whereas before it was totally disjointed. If I think 'OK, let go, allow the spring to work', all the different parts of me come to life.

"After 14 years of lessons and working on myself with the Alexander Technique, applying the ideas to all aspects of my life, I feel as if a weight has been lifted off me. It's as if my life had been on hold with tension and is now flowing again. My ribs were so tight it felt as if I was trapped inside an iron lung. But now that I am free, the trapped feelings have almost gone and directions really help me release the pressure.

Psychological effects

"Release for me can be painful at times, but it also gives me confidence. I recognised that anger has been a huge interference in my life, showing itself in my breathing and use. Deep release sometimes let me feel emotions of anger and I saw how ingrained it was in me and now I can let it go. Sometimes it was as if I felt anger slipping into me, almost by the

back door, but it came with a strong physical contraction and I can release the physical side of it and the anger diminishes. I feel as if I've been asleep in a prison of anger and anxiety and am now awakening. My mind now has been absorbed into my body and my body into my mind as a result of the process. Without this work I think I would have given myself an ulcer by now, as my doctor warned me years ago.

Releasing

"I wrote a piece for piano which I called 'Releasing', based on what I feel when tension and unrest builds up inside me and then how that can release into a sense of calm, lightness, and a sense of widening. The work starts rhythmically and harmonically calm, but the rhythm soon becomes more complex, the harmony more dissonant, and the tempo faster and wilder. Then it abruptly stops with a very loud chord, and the rhythm calms down. The chordal texture widens and the harmony becomes more consonant, the tempo gentler and the texture of the piece

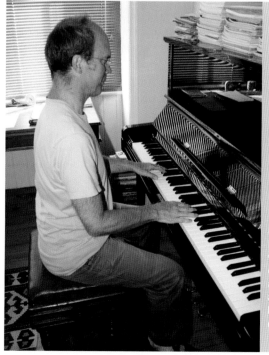

Guy lengthening naturally as he plays, his head is well balanced on his neck and his arms and legs are lengthening out of his back

becomes lighter. The piece ends with a great sense of space and a mood of serenity and calm.

Composing

"Before I had lessons I was so tense that I would just feel the music inside me stop. Now I can let it flow. My music has become more flexible and elastic. The structure of my pieces has opened up – they flow and develop more because I no longer try and control them and I can cope with the anxiety when it arises. Rhythmically my writing is freer too. A fellow composer recently commented that he thought my music had opened up. I now allow my music to breathe – I don't trap it inside me.

"I started lessons to help my arm problems, but it has expanded into much more than that. I hate to think of the state I'd be in without this work."

Loose the tension, keep the verve

For string players, a strong flexible back is a vital component in playing. Violin and viola players support their instrument between their shoulder and head, and the temptation to clamp down on the instrument is very strong. To play forte requires strength, so there is a firm contact between the instrument and the bow. In effect the bowing arm puts a downward pressure on the strings and the pressure has to be met by the instrument being supported by the other arm. Both arms are held out away from the body, so if your back is braced or collapsed your options for supporting your arms and your instrument are limited to tension. Your whole body acts as a resonance chamber for your sound. From this perspective you, as a human instrument, require as much attention to your technique of postural support as your violin technique. A tight body results in a tight, thin sound, lacking resonance and tonal qualities. Most players are taught and practice standing up, but when they perform in concerts they sit, often with very little information about how to sit in a supported way. Understanding how the diamond-

shaped muscle and fascia structures of your back support your arms and legs – and the role of the lengthening back in maintaining a good tone in the diamonds – allows a player to use their arms freely. Tight back and arms make it more likely that you will experience problems with technical aspects of playing. Your bowing arm may judder as a result of tension in your arm and shoulder, giving an uneven jumpy sound. The temptation is to respond to this problem by playing more firmly which, if you don't change the way you use your body, simply increases the tension in your arms and can make the sound worse. Problems with vibrato are also often tension-related. Your fingers need to be very strong, but also flexible and elastic. With your hand and wrist being

Playing with your back narrowed and tight and your legs braced will not give you a full sound

used in this extremely strange position you need all the support you can get from the rest of your body. Understanding how your back, arms and legs relate to each other, helps give you a good foundation for the intricate use of the hands.

Lengthen your fingers

All musicians need open flexible hands to play. String players especially need free wrists, palms that can form flexible dome shapes without tension and articulate fingers. Letting your fingers lengthen around the curved shapes they make on either your bow or the neck of your violin can facilitate freedom in the wrists. Allowing the inside of your hands to remain open will help too. Practising releasing your arms and fingers away from your instrument changes your use pattern and gives you the opportunity to observe your temptation of falling into old tension habits. The more you focus on getting your playing 'right', the more likely you are to repeat your tension patterns over and over again. Each time you play like this you reinforce the tension message to your nervous system and make it harder to change things. It's not until you are brave enough simply to stop trying to get things right in your playing that you have a chance to focus on the first relationship which needs your attention. Not your relationship with your instrument or your music, but your relationship with gravity.

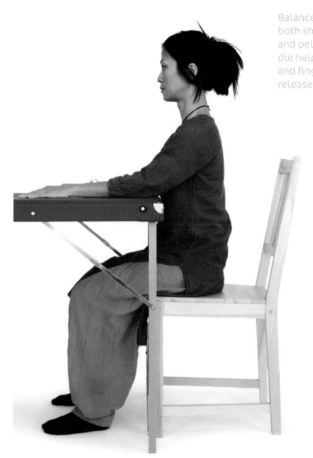

Balance in both shoulder and pelvic girdle helps arms and fingers release

Workshop 8

Directing your arms and fingers

This is an invaluable practice for musicians (and computer users, which obviously includes just about everybody). It allows you to build up a new sense of awareness about how your shoulder girdle can be properly supported by your back and thus give you freedom in your arms. We all waste effort in tension. We could redirect this effort to where we wanted it, if we knew how to stop it going down the wrong channel. This procedure builds that skill.

Take time to read the workshop material before you listen to the CD track. This will greatly improve your understanding and enjoyment of the audio instructions. When you are ready, select Track 6 on the 'Workshops CD'. The CD will describe directions and thought pathways to aid this practice.

You will need

▥ A level chair.
▥ A table to sit at where you can easily rest your forearms on, right up to your elbows; a dinning table is often perfect for this experiment.
▥ Patience.

Your approach to the procedure

Arm tension is very misleading as you often feel pain rather than tension, so efforts to stretch your fingers out to relieve pain don't address the tension issue. Be prepared to have a period of time where you really can't tell what is happening in your arms. If you persist and give your self the new directions to work with, you will get your reward – in time.

Directing your arms on a table

You are going to direct around a six-sided shape made by the pattern of your arms resting on the table.

■ Sit on your nice level chair. Pay attention to your neck and head direction so you are asking for length from your sitting bones resting on the chair seat, right up to the crown of your head. Let your feet rest flat on the floor under the table.

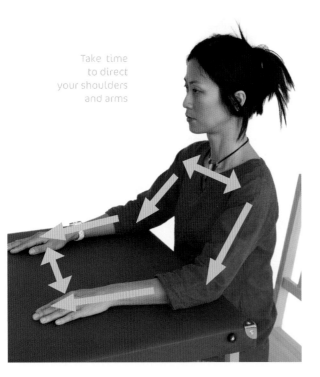

Take time to direct your shoulders and arms

■ Sit close enough to the table so you can easily rest the entire length of your forearms on the table, palm down, *including your elbows*.

■ Direct your armpits and shoulder tips to widen away from each other, from the clavicles at the front of your body, and from the C7ish area at the base of the back of your neck. This is *side 1* of your six-sided shape.

■ Continue your basic 'up' directions and your widening and add directing both of your upper arms to lengthen from the tips of your shoulders down to the outside of your elbows and from your arm pits to the inside 'crock' of your elbows. This is *sides 2 & 3* of the shape.

■ Now ask to direct both forearms to lengthen from the whole elbow along both sides of your forearm to the wrists and then on out through to your finger tips This is *sides 4 & 5* of the shape.

■ Finally direct across the space between your two hands, across the table top, asking that space to widen. Remember all directions are thoughts rather than actions. This is *side 6* of the shape.

■ Put it all together and direct round the six sides of your shape, still breathing, still keeping your neck free and your sense of 'up'.

Taking it further

If your back isn't well co-ordinated, you are likely to find that by the time you have been through all the thinking, you have lost your head direction and slumped down a little. Gradually that will improve, not just because you practise this procedure, but because your general levels of awareness improve and your use improves. It becomes easier to be supported and more likely to be your choice. Then you can play around with moving your fingers. Try the following out but do invent your own games. There are simple questions you can ask, which are:

■ How is my breathing?
■ Is my neck stiff?
■ Hello legs feet and toes, what are you up to?
■ Am I going up?

Keep these as background considerations and try the following.

▓ Lift the index finger of one hand, taking care to lift by release and lengthening rather than effort.

▓ Play about with fingers lifting in pairs and patterns.

▓ Can you push the tip of your finger into the table without over activating all the tendons of your forearm?

▓ Can you make your fingers curved and tap them on the table without scrunching your armpit?

Experiment with any ideas for finger and hand movement that occur to you, but monitor the tendency for the arms to start contracting upwards into the shoulders. If your elbows lift off the table, you can be sure you are pulling your arms up. When it comes to playing an instrument, of course you can't rest your elbows on a table top, but you can give yourself the direction to let your elbows lengthen away from your shoulders. These experiments will let you know how successful you are.

SUMMARY OF CHAPTER 8

▓ What you do when you are not playing affects how you play

▓ A lengthened and widened torso helps open the arms and fingers

▓ The shoulder girdle and its importance in playing

being:

When you inhabit your own life, you are truly a human being

> "IT'S NOT GETTING IN AND OUT OF CHAIRS EVEN UNDER THE BEST OF CONDITIONS THAT IS OF ANY VALUE: THAT IS SIMPLY PHYSICAL CULTURE. IT IS WHAT YOU HAVE BEEN DOING IN PREPARATION THAT COUNTS WHEN IT COMES TO MAKING MOVEMENTS."
> F. M. Alexander (1930s)

Take a seat

IN THIS CHAPTER

▥ Aspects of sitting

▥ Sitting and pregnancy

▥ What about chairs?

Why sit?

One of the most common requests made to an Alexander teacher is, "Show me how to sit properly." Clearly people are aware that sitting is something that causes problems and there is an expectation that learning to sit properly will solve whatever the problems are.

Today's life style is a sedentary one for many people. In Dickens' time, the ledger clerk stood all day at his desk – which had a sloping surface – writing with his quill, dipping said quill in and out of an ink well and making the equivalent of data entry in a neat copperplate hand that could not be rushed. This is naturally a very different affair – in terms of the use of the body – from today's equivalent who is likely to sit all day in an office chair that probably isn't comfortable, typing away on a small keyboard, eyes fixed on a computer screen.

We do a lot of sitting, and for many different reasons. We sit at our desks to work, we sit in our cars to drive and perhaps we sit to play a cello or some other musical instrument. We sit in a variety of cross-legged positions

on the floor when we are young or when we are practising yoga. We sit on bar stools without backs, car seats that envelop us, kitchen chairs, meditation stools, piano stools, sofas, armchairs, wheelchairs, pushchairs; the list is endless. We sit in a kneeling position as in the Japanese tea ceremony; we sit astride horses and motorbikes.

One thing that all these different sitting scenarios have in common is we are required to bend our hip joints; our weight is then taken not by our feet, but by other parts of us. It brings into play a different demand of support involving the pelvis, hip joints, lower back and sitting bones. Most of the weight bearing we do on our feet is done in motion of some sort or another. Unless you are a guard, it is unlikely that you will spend hours standing completely still. Even if you work in a shop you will move around quite often, but it is likely you will spend hours sitting. For some people sitting is practically all they do. They get up in the morning, sit to have breakfast, sit to drive to work, sit at a desk till lunchtime, sit to have a snack, sit through the afternoon's work and then drive home to sit again to eat and sit yet again in a collapsed heap on the sofa. No wonder things go wrong!

Sitting in an Alexander lesson

During a lesson, your Alexander teacher will guide you in the transition of movement from sitting in a chair to standing up in front of it, and visa versa. We use firm,

upright chairs for this, similar to old-fashioned dining chairs. The firmness enables you to experience the contact your sitting bones make with the seat of the chair.

Your sitting bones are at the base of your pelvis, in the middle of your buttocks and – as you can see from the picture – they are rounded so that you can rock back and forth on them. Halfway up the sides of your pelvis are your hip joints – ball and socket joints that allow your legs to bend and rotate so you can sit down. If your hip joints are stiff, you will have problems with flexibility all through your lower back area. The base of your spine, your sacrum, is securely wedged into your pelvis and there is little movement at the sacroiliac joints. Immediately above your sacrum is your lumbar spine and this is much more flexible and therefore easily abused!

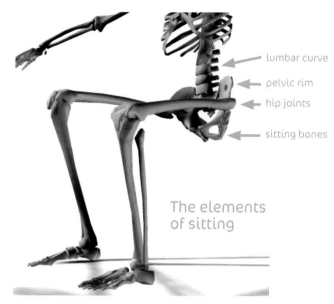

lumbar curve
pelvic rim
hip joints
sitting bones

The elements of sitting

If you sit without adequate support from your sitting bones you are likely to let the top rim of your pelvis collapse backward. This will encourage your flexible lumber curve to round out so you sit in a slumped C-shape. You can see people sitting like this all the time on trains, on buses and in offices. They are nearly balanced on their sacrum rather than on their sitting bones. As with all positions, to sit like this for a short time will not harm you, but to do it habitually will. If you sit like this at your desk typing on your computer, you create compression in your lumbar spine and cause your intervertebral discs to distort under pressure. The misuse doesn't stop with the lower back either. Your chest is likely to be collapsed on top of your pelvis, restricting your breathing. This drooping will encourage you to collapse your neck forward as you gaze at your screen and consequently you will pull your head back. Every part of your body is pulling down.

The consequences

If you habitually sit in a slumped manner you put great strain on your muscular and skeletal systems and may well end up with back or shoulder pain. If you sit like this to type, you don't support your arms and hands properly and so you are likely to end up with sore wrists and fingers. Adding an external support

such as a wrist support when you are typing doesn't go far enough to sort that particular problem out. It's not the external environment that will properly support your wrists – it's the internal environment you create for yourself with the web of muscle support running through your body.

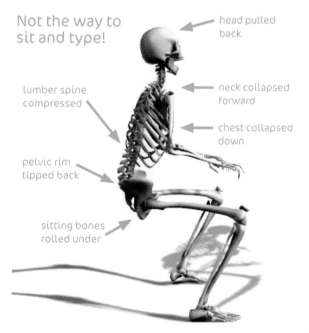

Not the way to sit and type!

head pulled back
neck collapsed forward
chest collapsed down
lumber spine compressed
pelvic rim tipped back
sitting bones rolled under

117

Can't stomach sitting?

It's not just your muscles that can suffer from slumping – your internal organs will complain too. Your gut, lungs, heart and liver are all made up of soft material, which relies on the protection of your ribcage and pelvis to prevent damage. Being soft means you can easily squash them with the general downward pressure of your body. Just imagine squeezing a full hot water bottle. It's obvious that some areas of the bottle come under greater pressure when you do this and the same happens inside you. So, if you have poor digestion, you should ask yourself if you are contributing to it by the way you sit and generally use yourself during the day.

Is sitting natural?

People speculate that sitting isn't natural. They point to earlier societies when people either squatted or sat cross-legged on the floor. Only two generations ago, most Indian families sat on the floor to eat and cooking was done on the floor too.

More of a collapse than a rest

Chairs were simply not around. The Japanese tucked their feet underneath them and ate in a kneeling position – unlike today's sushi chains where everyone is perched on a high stool, slumping as they strive for balance and snatching their lunch as it slips past on a conveyor belt.

It would be easy to think that sitting isn't natural, but it is certainly a part of a baby's journey to upright posture and chairs are not going to go away. Babies sit in order to free their hands to pick things up and to get themselves a little higher so they can see what's going on. Left to its own devices, the baby sits on the floor, with its legs out in front. As back muscles gain strength, the baby gains a greater degree of control over head balance. Desire for a toy encourages the baby to reach forward with its hands and arms. In doing so its whole body moves that way and the legs fold up underneath the baby's body and gradually get it into a crawling posture. Sitting is a part of the 'lets get up and walk' plan.

Sitting as an adult is something we must contend with and something that would repay some thought on our part. We are so careless of how we sit, what part of ourselves we sit on, that sitting in upright balance as an adult is likely to be unusual rather than normal. The rounded C-shaped back is so common that sculptor Immanuel Giel represented it in his work of a dedicated hiker taking a rest.

Room for one more?

If you are inclined to slump when you are pregnant you make things harder for yourself and your baby. Your abdominal muscles are very elastic but when you slump you shorten your whole body. This makes it more difficult for your baby to get into an optimal foetal position: head down, facing your backbone, ready for its journey into the world. If you sit like this, you will probably stand and walk with your lower back very tight and pulled in. Your neck will droop forward to compensate. This habitual posture will not encourage your growing baby to present

well. The more space you can make inside yourself, the easier it will be for your baby. Your digestion will suffer too. It's bad enough having a pair of feet under your stomach without adding to the pressure yourself. It's important to keep a sense of lengthening throughout your pregnancy, not just towards the end. The more the baby can move around – before it grows so large that only small movements are possible – the more likely it is to select the greatest space for itself when it is restricted. Many women have found using the Alexander Technique very useful in both pregnancy and birth. Keeping the ribs free so that breathing is easy is more important than ever when you are breathing for two.

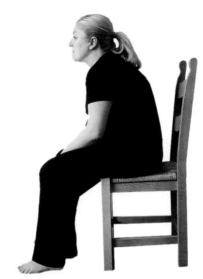

Slumping when you are pregnant squashes the baby and your breathing

Astrid's story

"When I became pregnant with my first child I was already involved in the Alexander Technique. In fact I was training to teach it myself, having had enormous benefit from my own lessons. Pregnancy was a challenge to my balance and my back. As my weight increased and my shape changed I was very conscious of how easy it would be to let myself just sag down. Sometimes when I was tired it seemed so tempting just to collapse. What that taught me was I needed to rest more rather than grit my teeth and keep going.

"I wanted to do all I could to stack the odds in favour of a natural birth, but I didn't get obsessed about it. This was just as well as both my pregnancies ended up with quite a lot of intervention. I was aware that poor posture made pregnancy harder work for both me and the baby. It made perfect sense to me. If I wasn't able to give my baby enough room, then the chances of her settling in a good position for birth were diminished. I could see pregnant friends quite quickly getting into slumping habits with their lower backs really pulled out of shape. They complained of backache and sacroiliac pain and indigestion.

"I tend to have large babies and ended up having a venteuse delivery with my daughter, and an elective

caesarean with my 10lb son, who had decided to lie transverse and stay there. I think that childbirth tends to be a bit 'luck of the draw' biologically and I certainly don't worry about being an Alexander teacher and not managing to have 'perfect' natural births.

"Where Alexander Technique really benefited me was

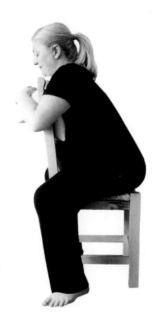

A great resting position that keeps you lengthening and widening

during the pregnancies. Even towards the end I still felt as if there was space for my ribs to move and was able to breathe reasonably easily. I had a little bit of sciatica, but was able to manage that by releasing and directing my legs out of my pelvis. I can also still remember the blissful relief I felt when Carolyn gently guided my bump 'back into my back', so that the baby was better supported and pressure was taken off my back. I was aware of the need to maintain space in the body so that the baby had 'optimal foetal positioning'. This is where the baby is head down with the spine at the front, facing towards the mother's pelvis.

"It was vital for me to keep a sense of my primary control, my 'upness'. Pregnancy places extra demands on the body and this makes it easier to do things badly. By returning to the awareness of the fact that I shouldn't slump or arch my back, I was able to maintain a sense of space and freedom in my body during both my pregnancies.

Beautifully balanced sitting

"When the baby is born, the real fun starts! I hadn't realised that carrying baby car seats is really awkward, as they pull you down on one side. Bending down to lift my baby out of her cot was challenging too. I found breast-feeding a real trigger to pull down towards my baby and took care that I didn't do so or I would end up with a sore back and with my shoulders round my ears. Just noticing what I was doing – and staying aware that there could be a better way of sitting, and positioning the baby – was extremely valuable for me at that time. AT gave me strategies during pregnancy to cope physically with my body, and to enjoy the changes happening to me."

Sitting is about lengthening

The learning point of the movement in and out of a chair during your Alexander lesson is less to do with sitting and more to do with co-ordination and lengthening. The movement from sitting to standing requires you to move upwards against the force of gravity. Your legs, back, neck and head must all co-ordinate to let you stand up. If you set about that movement by stiffening, then you remain tight in your muscles, and the feeling of tightness will seem normal. And if you are pulling down as you are sitting comparatively still, then you will pull down more as you start to move. The way you sit is only a part of the way you support yourself generally, so if you want to sit better, you need to move better. During a lesson this cycle of stiffness, compression and pulling down becomes highlighted and you have an opportunity to change it. When you are sitting, ask your body to lengthen up away from your sitting bones towards the crown of your head. Keep your neck free as you do so and you will further enhance the tendency for your muscles to do what you ask, which is to support you without effort.

When you reverse the movement, so that you sit down, you may think this is easier on your ability to co-ordinate. It isn't. The shortening habit is just as dominant when moving towards gravity as when

moving away from it. The power of habit is so strong that you are likely to set off the increased pulling down habit before you actually start to move. That is the point where things have to change and that is why in your lessons an Alexander teacher will spend a lot of time working with this co-ordination.

Balance is about ease

Easy balanced sitting is natural. Small children do it without thought. This two-year-old girl (see previous page) is sitting upright without effort. Her sitting bones, thighs and feet are supporting the weight of her body and her arms are resting quietly on her legs. Her head is freely poised on her neck and she doesn't need to use the back of her chair to support herself. Such effortless sitting is possible because she has no excessive tightening in any of the muscles throughout her muscle suit. She is quite naturally making the minimum muscular effort required to let her sit as she wants to sit. It's not a simple case of her being flexible because she is young. She is flexible and upright because she is free from excessive effort. She has naturally chosen a good arrangement of her limbs too – her thighs are parallel to the floor and the chair seat is the height of her lower leg. Her feet rest easily on the floor. Her attention is outward, and she is able to leave her body alone to sort out her balance without her tensing up. For an adult, this ability to simply leave things alone to sort themselves out is not so easy to achieve. Sometimes we need to re-learn how to let our body support us and what that involves. The guided movement from sitting to standing and standing to sitting in an Alexander lesson offers endless scope for understanding this skill.

Cross-legged sitting

Sitting cross-legged is an ancient posture represented in many religions and mythologies. It is an attitude adopted for meditation as well as to encourage flexibility. It uses the ability of the hip joints to both rotate and flex and the balance of the sitting bones. All the elements of what we need for sitting in a chair

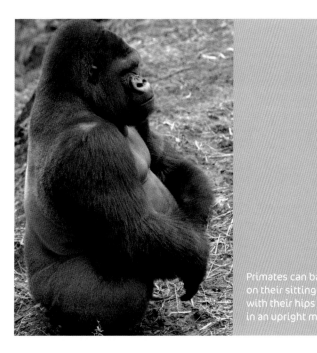

Primates can balance on their sitting bones, with their hips flexed, in an upright manner

are here in cross-legged sitting. Primates regularly sit in variations of squats with their feet facing towards each other. Not completely cross-legged because their lower limbs are shorter than our human legs, but the basic ingredients are there as demonstrated by this silver-backed gorilla. Just as for humans, sitting frees the hands to hold young or food. The problem for many of us is that we are shortened in our muscles and this shortening encourages us to collapse when we sit cross-legged just as it does when we are sitting in a chair. But it offers scope for improvement because more of our body is in contact with the floor in this situation. Even if you can't get your legs into the perfect lotus you can still allow your legs and sitting bones to rest on the floor and lengthen up from that contact. If you find you are uncomfortable and your pelvis is tipped backwards then raise the relative height of your sitting bones to your feet by sitting on a couple of telephone books. (See workshop at the end of this chapter.) Sitting cross-legged gives you a triangular base from which to balance. It also offers a wide base which increases the security of the position. It encourages release and opening in the hip joints.

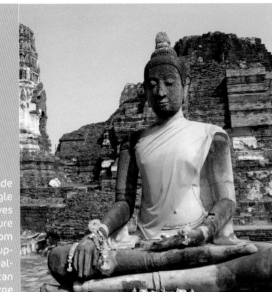

A wide triangle base gives a secure pose from which upright balance can emerge

compensations and the compensations for the compensations, what you are left with is an easy upright posture reflecting the good use of the mind and body.

Don't sit still

Sitting is a matter of constantly renewing your balance. Now and then check where you are on your sitting bones. Have you let your pelvis collapse back? Have you wrapped your feet round the chair legs or pulled your heels up off the floor? When you set yourself up to work, pause for a moment and consider how you are organising yourself in your chair. Take time to get things as easy as possible, with your computer screen at the right angle so you don't have to strain your neck to see it. Create an image of a magic magnetic red dot that floats in the air about two or three feet above your computer screen. Let this be where you direct the crown of your head. If your computer faces a wall then get yourself a red sticker and attach it to your wall at the appropriate height. The idea is to help you stop automatically tightening your neck and pulling your head down onto your spine. This is the beginning of the compression wave that gets set up in your body. A magic red dot helps to prevent it and undo it if you start to sink.

Looking at the gorilla in the natural world and the statue of the deity sitting cross-legged, we can see that they both have an upright upper body and a well-balanced head sitting on the top of their spines. The way our human head balances on our neck is different from the gorilla but, nevertheless, the posture demonstrates a minimum of effort expended to sustain the desired position. From the statue's point of view the position is also one of meditation or worship and – like the statue of the head of Jesus in Chapter 3 – the head is slightly nodding on the top of the spine with a sense of lengthening extending up through the crown of the head. The statue's headdress reinforces the attitude of the head. Like all practices, it is the consideration of the whole body that lets you sit cross-legged easily, and doing so further encourages more release and mobility. As well as paying attention to the lower back, the upper back must maintain a lengthened tone too. If the upper back is over-rounded then the neck curve will drop forward and the head will be pulled back. This will increase compressive forces in the upper back and restrict the breathing. What the statue depicts is an absence of interference with the whole body. When you take out the tensions, the

Don't still sit

If you do have a desk-bound life and spend a lot of time sitting, take every opportunity you can to get up and move around. Don't get fixed into one position and sink further and further down into your hips. If you work from home then make yourself get up every half hour. Fetch yourself a glass of water, go and stroke the cat – do something to make yourself move. If you have a big project on and you need to work intensively, break it up by doing some semi-supine. Even five or ten minutes spent undoing all the shortening of your muscles will enable you to manage your Use better. If you sit in a slouched position you are likely

to injure your back and interfere with your digestion. Compression affects your spine and your intestines. Because your abdominal area is relatively soft, it is easy to squash your organs without realising you are doing so. The way you use your body affects the way it works.

The best chair could be the one you are sitting in

When it comes to chairs, we are confronted with endless choice. The most useful approach you can take is to first of all ask yourself what you want the chair for. If it's for watching the television then you will make a different choice from a chair to sit at your computer. Remember, you are an individual and what suits another person might not suit you. This is especially true of ergonomically designed chairs. Who was it made for? What height are they? How long are their legs and their back? All these things make a difference. As I sit here typing this book I am sitting in an old Victorian dining chair that I picked up in a second-hand shop. It has a straight, deep seat that is firmly stuffed with horsehair and a small pad in the upright back. It encourages me to sit in an easy, upright way. It doesn't swivel or go up and down and it's heavy so I can't tip it easily. If I want to move, I actually have to move, rather than let the chair do it for me. The way you sit in your chair is just as important as the chair itself. If you pull down – stiffening your muscles and restricting your breathing – then it doesn't matter how expensive your chair is, it will not help you. If, on the other hand, you take the time to think about how you are sitting then you are more likely to find a natural balance between you and your chair.

These statues – found at Ramses the Great's Abou Simbel temple along the Aswaan lake in Egypt – show Ramses and his queen. They are seated in a very similar way to the two-year-old girl. Their thrones are arranged so the seat is flat and extends most of the length of their thighs; it is the same height as their lower legs. They sit with their feet flat on the ground and their hands resting

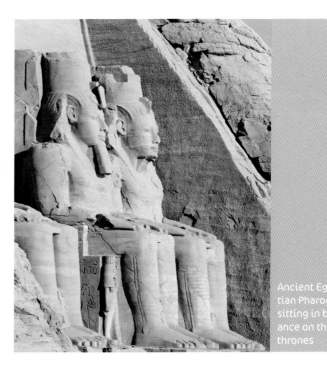

Ancient Egyptian Pharoes sitting in balance on their thrones

on their thighs, just like the little girl. The backs of their thrones extend up to the top of their headdresses but they are not leaning on them, rather they are balanced upright on their sitting bones.

They demonstrate a harmonious balance in their bodies and an easy relationship with their chairs, even if their chairs are thrones.

Workshop 4

Cross-legged sitting

Take time to read the workshop material before you listen to the CD track. This will greatly improve your understanding and enjoyment of the audio instructions. When you are ready, select Track 7 on the 'Workshops CD'. The CD will describe directions and thought pathways to aid this practice. The idea of this procedure is to give you a chance to experience upright poise and balance in a different way.

You will need

■ Somewhere quiet you can practise; an empty beach would be wonderful, but your front room will do!
■ Loose clothes.

Your approach to the procedure

Sitting cross-legged is traditionally linked to a meditative attitude, but you can use it to sit and read or just to rest quietly. Do start out with telephone books if you need them rather than making yourself sit there in difficulties. The idea is to balance in an easy way, not to see if you can push your knees into the floor.

Getting there

You can follow the process for getting onto your knees in a kneeling position as described in Workshop 1, and then move easily into cross-legged sitting. It doesn't matter which leg is 'on top'. When you have practised a few times, deliberately cross your legs the other way.

Height of the books

If you need books to sit on make sure they are the right height. They need to be high enough to enable you to avoid tipping the top rim of your pelvis back and so encourage you to lengthen the upper back too. If you notice your upper back is over rounded then add more books. You want to support your whole body at the point you can lengthen rather than make it a struggle. In this way you will be able to let things go and release. If you try and force things you are liable to tighten up even more. So if it feels too much of a strain that's probably because it is too much of a strain. It requires considerable co-ordination to sit upright and this is your chance to improve your co-ordination.

Directing

When you are reasonably secure in your position, ask your whole body to lengthen and widen, paying attention to letting your neck stay free and not hunching your shoulders up.
■ Let your head be going up toward the ceiling, or the sky if you are lucky enough to be outside.
■ Ask your sitting bones to rest on the surface you are on, including the books if you are sitting on them.
■ Ask your hip joints to move away from each other, to widen out.
■ Direct your thighs to lengthen away from your hip joints.
■ Direct your lower legs to lengthen away from your knees.
■ Allow all the parts of your legs and feet that are in contact with the floor or with each other to rest on the surface they are in touch with, making sure you are not pulling yourself upwards.
■ Ask your lower back to breathe and widen.
■ Let your upper back lengthen and widen so that your armpits are free from tension.
■ Allow your shoulder girdle to sit easily on your ribcage.
■ Let your head rest easily on your neck.
■ Breath gently in and out through your nose.

How long?

You can sit like this for as long as you can maintain the upright support. This may be only a few minutes at first and gradually work up to half an hour or more.

Benefits

Sitting like this can help your whole back to co-ordinate better and thus enable you to sit more easily at your computer and in meetings.

You will slump without adequate release in your lower back and hips

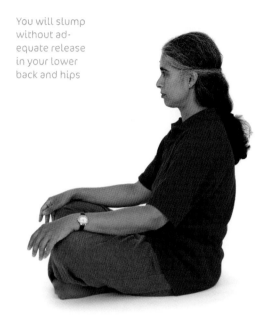

Sitting on books will help free your hips

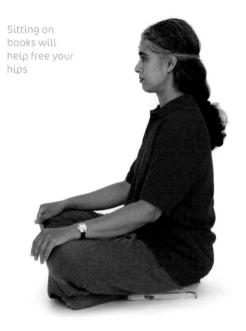

SUMMARY OF CHAPTER 9

▨ Finding balance in sitting

▨ You can create internal space for your growing baby

▨ Re-learning how to let your body support you

CHAPTER: 10

"LINK UP YOUR MESSAGE [DIRECTION] AND THE FEELING OF IT NOW. WHEN YOU HAVE LEARNT THAT, YOU WILL HAVE LEARNT THE THING BY MEANS OF WHICH YOU CAN DO ANY EXERCISE."

F. M. Alexander (1930s)

Feel free to move

IN THIS CHAPTER

▦ Bodies are made to move

▦ Good movement starts with stillness

▦ Applying the Alexander Technique to different activities

The joy of movement

Whatever your chosen form of exercise, the most important thing to ask yourself is "Where's the joy?" If you don't enjoy what you do, or your attitude is one

of counting the miles or the repetitions or the lengths of the pool, then perhaps it's time to rethink. Whatever you do, using yourself freely will make things easier and more pleasurable.

All motion arises out of stillness

The way you deal with gravity when you are not in motion will be amplified when you are moving. The faster you move, and the more complex the activity, the more your individual pattern of Use will impact on you. It's not what you do, it's the way you set about doing it.

When you are relatively still, perhaps lying down, then the general level of stimulus you are dealing with is fairly low. While lying down you can't fall over, so fear of falling is removed, or at least reduced. You need do very little to maintain your position, so activity is less likely to cause you to tighten up. It is at this level that thoughtful change can be incorporated into your awareness, because although you may think and feel you are inactive, you are in fact responding to gravity in your own unique way. This will most probably be by tightening your neck muscles and pulling your head back. If you think this unlikely then look around the park on a summer day when everyone is lying on the grass and look at the angle of the back of their heads on their necks as they lie there apparently relaxing!

Lying down can reveal poor running habits

Practising active rest is a great way to prepare for any more strenuous activity. Running coach Malcolm Balk often starts his workshops with people lying down. Looking round the room at runners lying down on their backs with their knees bent, Malcolm has a good idea of how they will run. Problems such as knees pulling inwards when you run will reveal themselves when you lie down. Patterns of Use that include the unfortunate runner's head being jammed back in to the books underneath their skull will escalate. This will result in the head being pulled back as the person runs, and a disturbance of the smooth relationship between the head, the neck and the back, acting as an effective brake on the whole movement. If you can't lie down, or sit in a chair, without misuse making your life difficult, you certainly won't run freely.

The human habit of up and down flow

There are always lucky individuals who seem to be able to get away with any amount of abuse! They have a natural talent that allows them to speed along despite their appalling co-ordination and bad habits. If you are one of those lucky people, congratulations, but even you will benefit from improving your Use. The rest of us mere mortals have to make the best of what we've got and that means learning to move in a free, upwards-flowing manner that creates little tension in our necks, shoulders and backs and lets our ribs move easily, adjusting to the rhythm of our breathing as we run.

Running with an upward direction in your body means you put less pressure on hips, knees and feet as you land, so you are less likely to injure yourself. Malcolm points out that "what you can't hear won't hurt you." So the sound of your feet slapping heavily on the ground as you run is the sound of injury coming your way.

Malcolm poses the question, "What do you think is the engine that powers your running?". Answers always include "my legs", occasionally "my back", sometimes "feet".

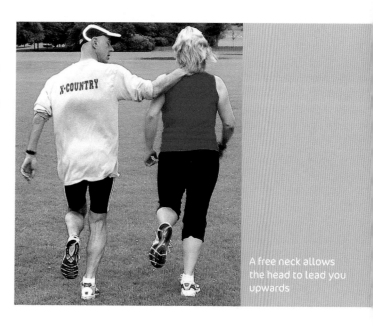

A free neck allows the head to lead you upwards

"No," says Malcolm, "it's gravity. Fall forwards and upwards into gravity and pick your feet up – that's running."

Climbing

Kevin Barber is a schoolteacher, but his twin passions are rock climbing and playing the guitar, accompanying himself to songs he has written. This is his story.

"The discovery of the Alexander Technique was the beginning of a new chapter in my life – almost a rebirth. From a life of constant discomfort, and often pain, I am now – at 56 years of age – pain free and active. I am free to pursue my sporting passions with a degree of confidence that, for many years, was denied me.

Sports

"As a young man I participated in a number of sports: football, rugby, basketball and athletics. Skiing became a passion and I would holiday in the Alps as often as I could. I also ran to keep fit and this, combined with an old rugby injury, eventually led to the beginning of a recurrent knee

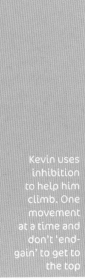

Kevin uses inhibition to help him climb. One movement at a time and don't 'end-gain' to get to the top

problem which forced me to give up skiing and running when I was in my late thirties. This was a bitter blow but at least I was able to find a new passion: rock-climbing. My knee stood up to this new sport rather better and, as I had already been forced to give up all other sports, was an enjoyable way to keep fit and active.

Back pain

"Worse was to come, however, as in my early forties I developed a recurrent lower back problem which rapidly became a chronic condition. I soon reached the position of being in discomfort all of my waking hours and this deteriorated into pain for most of that time. I had sciatica giving pain in the leg and my back would frequently go into spasm and force me to become completely immobile. I couldn't even stand still without having to shift constantly in an attempt to relieve the pain. I don't like to take drugs and would only resort to pain relief when it became unbearable. Fortunately for me I was able to sleep quite well without too much discomfort and at least I was able to still climb!

"I tried osteopaths, chiropractors, conventional medicine and acupuncture – all to no avail. I resigned myself to a life of pain.

"About this time I met a climber who was training to become an Alexander teacher. She was looking for subjects on whom to practise and she invited a few of her climber friends, me included, to come along to the training course with her. This was the start of my new life!

"At that first meeting I met Carolyn Nicholls, now my Alexander teacher. The information I received at that first meeting immediately caused me to realise that the Alexander Technique offered me a lifeline. I was already aware of many of my bad postural habits but never realised the possibility for change existed. I began one-to-one lessons with John Nicholls. The first lesson was a revelation. I left the lesson more upright, relaxed and balanced than I had felt for years but even better news was just around the corner. Within three months of starting lessons I could feel an improvement in my knee. I tried a cautious visit to the dry ski slope. No pain. No swelling. I gradually increased the frequency of my visits and I was back on the slopes that same year. I have been skiing every winter since. Sometimes I go two or three times a year with no adverse effects. My knowledge of the Alexander Technique even allowed me to improve my skiing technique.

"This was, of course, unbelievable news for me but I still had the back pain. Checking in the mirror each day I could see the characteristic imbalance in the pelvic bones and this persisted even after two years of lessons. I could manage my pain better but I resigned myself to never being entirely free of discomfort.

"After two years of lessons I found myself on holiday in Spain one summer. I was standing by the swimming pool watching my two daughters swimming when I became aware that I was not having to shift my weight from foot to foot in order to relieve my discomfort. I was standing, balanced equally on both feet and free of pain. I went inside and looked in the mirror. My pelvic bones were level. At that moment I genuinely felt as if I had been reborn. The freedom to stand and walk in a balanced, pain-free manner is something I have tried never to take for granted since then.

Singing

"I have found the Alexander Technique a great help with my other passion – singing. I play the guitar and sing in clubs and pubs and the skills I have learnt through the technique have allowed me to manage my voice, posture and playing position effectively as well as helping me to manage the contradictory effects of rock-climbing and guitar-playing on my hands.

"I now have lessons with Carolyn Nicholls about once a month and I lie in the semi-supine position usually three or four times a week. I use the technique when I am climbing, skiing, playing music and in my everyday life. It is now part of who I am."

Swimming: don't make a splash!

Swimming and the Alexander Technique make a happy combination – with the effect of gravity reduced you can allow the water to support you without making excessive effort. For many people, a fear of water, of the possibility of accidentally inhaling or swallowing water, is something that makes them tighten up. Inevitably this tightening includes your neck muscles stiffening and your head pulling back, making it more likely than not that you will swallow water, which in its turn, makes you more apprehensive and causes more tension and makes you even more fearful.

Water phobia

Ulla Pedersen is an AT teacher, a swimming coach and former member of Denmark's swimming team. She combined her swimming, coaching and Alexander skills to help Simon – an eight-year-old boy with a water pho- bia – to overcome his fears and to take him on a gentle journey towards swimming.

First, she got him just to sit on the side of the pool and swish his feet in the water. Having survived that, she pro- gressed to helping him allow the water to support him. Taking his head gently in an Alexander fashion while he floated on his back, so that he could release the muscles

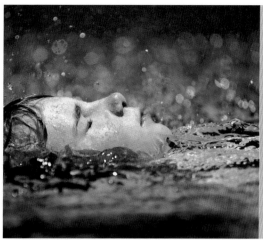

Simon learnt to let his neck stay free in water so he could float easily

running all the way down his back and could lengthen out his whole body. She introduced him to goggles so he could look underwater easily, without the fear of water hurting his eyes. Being able to see both over and under water helps reduce fear levels in general. Once he was happy with the goggles he could put his face and head underwater. Ulla knew that people can learn reason- ably quickly to have their head under water. However, it is the change between having your head under the water and then taking it out, or having it out and then putting it under, that is the problem: it seems impossible to breathe. Ulla and Simon played lots of bobbing up and down games in her step-by-step approach to water confidence, so that Simon always felt safe, both because he was with Ulla and because he felt in control of what was happening.

Breathing out underwater

The next step was getting him to breath out gently under water, blowing out a stream of bubbles from mouth and nose. This was mostly done by playing a game – giving each other underwater messages and making faces. Fear makes you feel as if you want to take a breath in, when in fact you already have too much air in your lungs and need to breathe out. Bubbling out air is one way round this problem. Splashing games further decreased his fear that water was an enemy possibly containing sharks. He allowed Ulla to literally tow him round and round the pool, supporting him under his

129

head and sometimes under his back so he could simply lengthen out. It was then time for Simon to turn over on to his front and allow Ulla to tow him around by his outstretched fingertips. This meant breathing out under water and then learning to turn his head to the side so he could breathe in without gulping down water. He learned to do this without pulling his head back and, although for him this was a game, it was a skill Ulla was able to build on when eventually she taught him crawl.

Gliding

After the towing games, Ulla got Simon to glide through the water by pushing himself away from the side of the pool, arms out in front, fingertips lengthening and his neck so free that he could rest his forehead in the water and easily open his eyes to see the bottom of the pool floating past. Simon himself played with variations of this game, sometimes gliding on his back with his arms above his head, sometimes on his front with his arms by his sides. With Ulla's encouragement he made wriggling fishy-type movements of his body, in any way that seemed fun to him. Ulla's way of helping Simon was to make whatever he did fun so he did not worry about 'learning to swim', but through enjoyment was acquiring the skills of confidence and release that underpin the movements of the various swimming strokes. This indirect approach is in line with F. M. Alexander's ideas

about not going directly for your goal, but instead thinking about how you might get there. Ulla and Simon spent many happy Sunday mornings playing in this way. Simon would think up things he wanted to do to show Ulla, and she was always close by in case fear crept in, ready to literally support him and, if necessary, act as a buffer between him and more boisterous swimmers. They explored the middle of the pool and the deep end – two particularly fearful spots for a nervous would-be swimmer. Sometimes Simon's sister Charlotte would come and they would play underwater charades and Ulla had to guess what they were doing.

This approach is radically different from the one Simon had experienced at school (where he rapidly refused to go). There the children stood in lines at the edges of the pool practising arm strokes or leg strokes. Breathing wasn't even mentioned and free play was seen as something to be allowed for the last five minutes of the lesson. It was not a recipe for happy swimming.

Arms and legs

Through gliding and wriggling, Simon began to swim using his arms and legs as a natural extension of his body, and in co-ordination with each other. Ulla didn't have to teach him to swim, he discovered how to do it himself. At this stage he became interested in the strokes and wanted Ulla to teach him the overarm crawl stroke. He soon realised he already knew how to roll his body so that he could breathe when needed. He didn't fight to push air out of his lungs in a big rush, but was able to let it out gently and gradually. The rolling motion of his body naturally extended his arms forward over his head and he was able to finish each stroke easily and completely. His legs moved freely at his hip joint in response to his arm movements. Without having to mention it, Ulla had taught Simon the principle of Alexander's primary control where a free neck and a lengthening and widening back will allow the whole body a natural upwards movement. Through playing, Simon learnt to stop the fear responses that were holding him rigid and making things worse. Best of all he didn't even know he was doing so. For him, it was fun and he loved it. Swimming became a natural consequence of playing.

Gliding helps lengthening the whole body and encourages a gentle out-breath

Don't fight the water

For many swimmers, the water is something they fight. If they want to swim faster, they fight more, make extra effort, and try harder. This usually results in a great deal of splashing and not sufficient forward motion for the amount of effort extended. If you are a splashy swimmer and want to improve, you would benefit from Alexander lessons to learn how to release your neck and lengthen and widen your back. Alexander skills learnt on land are directly transferable to water and you can improve a lot on your own, applying what you learn in your lessons to what you do in the pool. You will find Alexander and swimming teachers who specialise in combining these skills. Think about your attitude to swimming too. If it has become a question of ploughing your way through a certain number of lengths in order to get your exercise done you might like to re-think and ask yourself if you enjoy what you do.This young swimmer in a school race, is trying so hard that he has pulled much of his body out of the water as he lifts his arm over his head with tension, so of course he splashed back down into the water. His neck is very held and his hips are pulled up towards his shoulders. He is fighting the water and he is not winning the race. Compare this with the photo of another young swimmer. His head and body and are resting in the water, allowing it to support him, his arm is coming over in an easy relaxed curve and there is no excessive splashing. He is utilising a natural gliding motion to propel him through the water. When his top hand and arm enters the water he is nicely placed to push the water away from him and use the water resistance in that action to increase his forward motion. He is swimming with the water, not against it.

Horse riding

When you ride, you seek a balance for yourself and you are in direct contact with another live creature, another nervous system and muscle suit. Your Use when you are riding will affect your horse for better or worse. In the

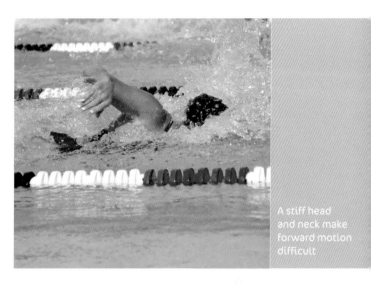

A stiff head and neck make forward motion difficult

past, horses were a vital form of transport; people rode as a matter of course to get around. Horses were working animals and sometimes fighting animals. Cavalry horses were taught to fight for their riders. Armies were mounted and precision riding, with complete control of your horse, was a matter of survival.

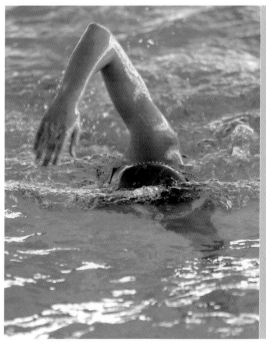

No need to splash

A strong back is a flexible back

Richard Weis is an Alexander teacher and a dressage coach/trainer living in the Macedon Ranges outside Melbourne, Australia. Richard numbers among his clients the German Equestrian Federation and many international and Olympic dressage competition riders and national federations. Richard uses his extensive knowledge of both human and horse locomotion in action and describes the rider's posture as a dynamic interaction with the horse.

For a horse to perform well, particularly in dressage, it needs superb balance and co-ordination. The elements of this balance are similar to the balance the Alexander Technique seeks to offer humans. For the horse, a free neck allows it to flex easily at the poll – the horse equivalent of the atlanto-occipital joint where the skull joins the spine. If this joint is stiff in either horse or human it effectively locks up the rest of the body. The horse needs to be able to breathe freely and in response to the gait it is performing. This necessitates having a mobile ribcage. In Alexander terms this is a lengthened and widened back. Both horse and rider benefit from this concept. If your back – or your horse's back – is lengthening and widening then it is both springy, flexible and strong. In this way it is able to support limbs that extend from the back, whether all four limbs touch the ground or not. Richard comments that a good rider's back is like a good swimmer's back: long, strong muscles with well-connected limbs that have both independent and integrated movement with the back and with each other.

The meeting of two backs

The interaction between the horse's back and the rider's backs is unique to riding. The rider's vertical upright spine meets the horizontal spine of his horse where his sitting bones rest on the saddle. The rider – by organising his own spine as a springy structure – seeks to organise and influence the horizontal spine of his horse. The horse too can act as a springy, elastic creature, qualities that

make movement easier, fluid and free from tension. For both rider and horse, the limbs act as extensions of the well-organised back and are also springy, so the contact of the rider's hands on the reins (and the horse's mouth) is subtle and supple, while his legs lie on the horse's flanks like sprung weights. The horse's back, when working well, also influences its own legs and four feet, which make contact with the ground in a natural, effortless way.

When an Alexander teacher uses their hands on a client, the nature of the contact of their hands is springy and it offers an organising stimulus to the client's nervous system – encouraging them to become light and spring in response. It's a subtle but powerful transaction. To do this, the Alexander teacher has to organise their whole body well and not just their hands.

When a well-sprung rider sits on his horse, he has a substantial contact area with the horse – much bigger than his hands. Through this contact he can offer lengthening directions to the horse with his whole body.

Dressage has often been likened to a dance – the elegance and poise of both horse and rider being admired both for its grace and skill. The sense of élan and lightness comes as the rider relates to the ground for his own organisation and balance. In doing so he makes himself like a spring, and convinces his horse that it is trapped between his body weight and the ground. The horse responds to this by springing up from the ground to his rider, always seeking the balance that the rider subtly shifts around. The rider signals to his horse using small spring impulses to bounce his horse around on the dressage arena.

You affect your horse and your horse affects you

If you watch a top quality dressage rider, they appear to do almost nothing. You don't see them move in the saddle or use their legs in any obvious way. Their hands are still and their body upright and poised. So how do they guide the horse? How do they ask it to turn left, right, or do some of the highly intricate dressage movements?

The answer is a subtle combination of weight shift and, most importantly, intention. If the rider intends to turn left, and has their own body in good balance, then that intension will set up shifts of weight that transfer through the rider's body to the horse. The freer the rider is of interference with his or her own Use, the more easily they can let the horse know what is wanted.

A young horse or a horse that is stiff in its own movement is not in good balance and this will transmit to the rider. When training riders, an experienced, well-trained horse is a great teacher. When training horses, a mature, experienced rider is the teacher. An experienced rider can give clear directions to a green horse because he is thoroughly familiar with the patterns of each movement: the up and down, the forward and back, the sideways and the wave-like oscillations which must be molded by the seat and legs of the rider and directed in a lengthening manner through the back of the horse. An established horse can guide a young rider by giving him a good experience of motion.

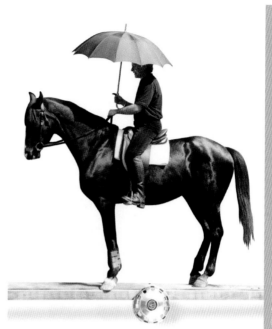

Richard and Ming experiment with equilibrium, balancing on a see-saw. Photo by George Weis

Direct your Horse

Richard writes, "Good riders lead; they don't follow. Directing the horse is a whole-body experience. The rider dynamically adopts the attitude in his own body that suggests what is required of the horse, including the vigour or impulsion. He takes the horse with him by doing with himself what he would like the horse to do and convinces the horse to conform. Eventually the horse learns to follow the rider by keeping his centre of gravity back under the rider's weight. He becomes efficient at carrying the rider, sensitive to where the rider has placed his centre of gravity and eager to follow every suggestion." Maintaining balance and equilibrium is a matter of ongoing patient work with attention to both horse and rider's Use. By the natural lengthened use of his own body, Richard enhances the balance of his horse Ming. Ming in turn supports Richard in the saddle and the resulting harmony allows Ming and Richard to balance on a seasaw.

Off the horse

Your Use on your horse will reflect your Use off your horse. Working with novice riders sitting on a wooden horse rather than a real one allows you to experience balance in this unusual position. You are upright but have very little support from your feet so most of your body weight is carried by your sitting bones and thighs. Thus what you are doing with your head, neck and back above the area of contact with the saddle will influence how well you can balance. Likewise what you are doing with your hips, knees, ankles and feet will affect your balance. The Alexander Technique can offer a way of improving your Use making any activity you undertake more pleasurable.

Stretching or lengthening?

Whatever your chosen activity, you will benefit from stretching. Bodies are made to move and stretching your body is not only useful but also pleasurable. Malcolm Balk reminds his students that stretching is like flossing your teeth – something you can't do too much.

Working on balance away from the horse

are concerned with lengthening the whole muscle suit, not individual muscles or muscle groups. The lengthening takes place as a result of undoing restrictive tension, combined with an intention to lengthen the whole muscle suit, rather than actively pushing or pulling muscles into a particular shape or position.

It is certainly possible to stretch muscles without lengthening them but stretching alone will not change your Use pattern, it will simply entrench the pattern you have. Many an enthusiastic student of 'hot yoga', who initially enjoyed the feeling of stretching their bodies into yoga poses in a hot atmosphere that encouraged them to stretch a little more, subsequently found they had injured themselves when everything cooled off after the class, and their muscles seemed tighter than ever. Once again it comes back to not what you are doing, but the way you set about doing it.

Workshop 10

Crawling for grown-ups

Read through the workshop material first before you listen to the CD. When you are ready, select Track 8 on the 'Workshops CD'. The CD will talk you through different ways of crawling and rocking on your hand and knees in detail while you are doing it. It contains directions and thought pathways for you to follow. The idea of this procedure is to give you a chance to experience yourself bearing weight through both sets of limbs. This has a different effect on your back from walking upright and can stimulate a beneficial reorganisation of your back muscles. There are many different ways you could practise crawling; this variation gives your arms a chance to act as weight bearing limbs and can help sort out arms that are painful from too much computer work.

The first thing my dog does when she wakes up is stretch. She starts by extending her front legs and lowering her chest onto them, with her rump held high, giving a luxurious stretch all down her back and front paws. Then she lifts herself up on her front legs and stretches forward, lowering her rump and stretching her back legs out one at a time with a little shake. All the time she is wagging her tail and looking very happy. That done she is just as likely to fall asleep again as she is to run around.

Many a person who suddenly is overcome with an urge to get fit, ends up injured because they haven't properly warmed up. Stretching warms the muscles up by increasing circulation to them. Movement increases blood flow, blood flow brings oxygen into the muscles – literally increasing their temperature making movement freer and easier. Good blood flow also keeps things moving – constantly bringing rich red blood to muscles.

But stretching is not the same as lengthening, at least as we consider lengthening. In the Alexander Technique we

You will need

■ A floor area without any furniture in the way. Either a carpeted floor or perhaps outside on the lawn!

 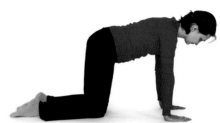

▓ Loose comfortable clothes you don't mind getting dirty knees in.

▓ Time.

Your approach to the procedure

All of these workshops are for you to experiment with ideas of thought and movement. It doesn't matter if you think you are 'getting it wrong'. What counts is your willingness to try something different, even when you have no idea what you are hoping for and what the result might be.

As a baby, you crawl with your large head held upwards so you can see where you are going. Crawling for a baby is about locomotion, getting to where the action is and gaining experience in navigating the world. As a grown-up, you have quite different body proportions to think about and your reasons for crawling are hopefully not about the need for locomotion!

As adults, most of us lead rather sedentary lives and do very little weight bearing through our hands and arms, unless we do press-ups in the gym. Weight bearing is different from lifting; it stimulates our shoulders arms, back and neck to tone up to support us. If we approach it in a lengthening way rather than an effortful way it will help us reorganise tense musculature round the shoulders and upper back.

Benefits

This procedure can help with arms and wrists that are sore from overuse of a computer or some other kind of repetitive action. It may at first seem an odd idea to weight bear through injured arms, but when done in springy lengthening way as described here it helps the whole muscle suit reorganise how it supports you, including how it supports your arms. Most people with over-use problems in their arms and hands have developed a stiff rigid upper thorax and tight ribs and shoulders. The arms are consequently held rigid when activity is undertaken.

Getting on your hands and knees

You can follow the procedure outlined in Workshop 1 (active rest) to get on to your hands and knees, or devise your own way down. However you get there, the important considerations are:

▓ Allow your breathing to be uninterrupted. Keep your mouth lightly closed and breathe in and out through your nose.

▓ Keep a sense of lengthening throughout your body as you come onto your hands and knees. Pay attention to keeping your neck muscles free and ensuring you are still thinking about that wonderful magic red dot about 3 feet above you, that helps you avoid pulling your head back.

When you are there

Before you begin to crawl, take a little time to review your position and your directions. Have your hands under your shoulders and your knees under your hips so that you are in a square position. This gives you the best chance of getting length because it's mechanically easier with your arms and legs acting like pillars of support underneath your shoulders and hips. You want to be springing up off your hands and knees, so ask for length up your forearms, upper arms and thighs, but don't let that thought make you surreptitiously press your palms or knees in to the floor. Your back wants to lengthen from your tailbone right through to the top of your head. Again, you don't want to push or pull your back about, you simply ask it to lengthen. Keep your neck in line with your spine, don't let your neck drop or droop towards the floor, and don't let your lower back hollow out like a sagging elderly donkey! Just as when you are upright, its useful to know what you want and then stop doing the things that interfere with it. Simple. At this point the CD starts with directions and ideas for you to follow, but do read through to the end of the workshop first so you know what ideas you are going to play with.

Let's Rock

Begin by gently rocking back and forwards. This is a challenge to your head, neck and back, and to your shoulders, wrists and hips. In fact, it's a challenge to your co-ordination. Keep gently breathing in and out through your nose and as you rock forward, make sure your neck is free but

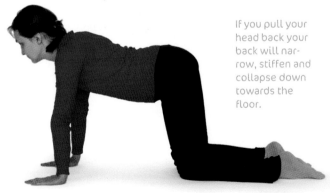

If you pull your head back your back will narrow, stiffen and collapse down towards the floor.

Let your head and tailbone direct away from each other as you rock, so you keep a lengthening back; don't grip your legs to do this.

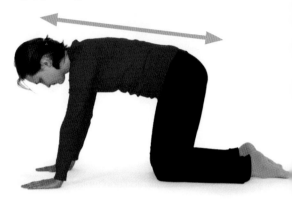

not dropped downwards. A free neck does not necessarily mean a relaxed floppy neck. It means a neck that is free to let you make what ever movement you want, but nevertheless has enough tone to support your head. When you are on your hands and knees, you need a little more tone in your neck to stop your head falling towards the floor. But you generate that tone by lengthening your entire muscle suit, not by tightening any individual bit of yourself.

Play with rocking until you are confident that you can keep breathing and maintain a sense of lengthening as your rock. Don't rush over this; treat it as an experiment rather than something you want desperately to 'do'.

Which way to go?

You can crawl backwards or forwards. Either way will benefit your support musculature if you do it freely. If you want to start by going forwards do so by sliding a leg forward on the floor so that it is closer to your hand. You can choose which leg to start with, and notice what happens when you make that decision. Do you tighten up on that side of your body? The most likely answer is 'Yes' and it's something to observe so that you have a chance of dispensing with the tightening and simply allowing the leg to slide forwards a little on the floor. As you slide the leg, make sure it goes directly forward and doesn't track inwards. Just move one limb at a time.

Hand

You can pick up the hand on the same side of your body as the leg you just moved. When you do this you are taking away one of your supporting pillars, leaving only three. Your whole muscular suit will respond to this, either by tightening or by lengthening. Choose to lengthen to generate the amount of tone you need, it's a lot less than you think. Place your hand directly in front of you. Check that you are still gently breathing in and out through your nose.

Lengthening lets you move

Now slide the other leg forward, with all the same considerations as before, keeping your neck free so that your head can lead your lengthening body forward just like other four-legged creatures. Bring your other hand forward.

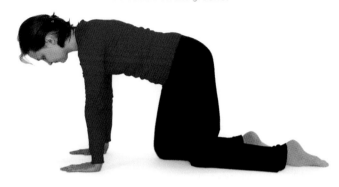

Slide a leg forward; don't lift it up, let it slide on the ground.

pling of muscular support through your body. You need the same support when you walk, so crawling can help you walk better as well as helping your hands and arms.

Crawling patterns

The pattern described above, where you move one limb at a time, on one side of the body at a time, is called homolateral. It's the way a dog or a horse walks, a pattern of four steps. It only happens when you do it slowly. If you speed up a little you will naturally move into a cross pattern where limbs on opposites sides of you move at the same time. Your left leg slides forward as your right hand reaches out, your right leg moves as your left hand moves. It's the pattern that dogs and horses trot in and it's the same pattern you naturally walk in if you are not carrying shopping. As your left leg goes forward, your right arm swings forward a little too. This happens as your torso naturally rotates as you move. If you hold your arms stiffly, or have them full of things to carry, you restrict this naturally rotation as you walk and help create tension and stiffness in your back.

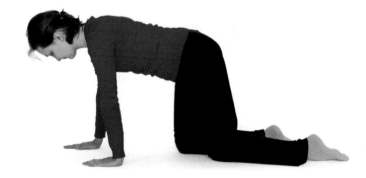

Keep directing upwards off your hands and knees as you move your hand forward, it will help maintain tone in your back.

Benefits

Playing with crawling helps you reconnect with the natural fluidly of forward motion. As you crawl your pelvis will rotate a little from side to side and there will be a rip-

SUMMARY OF CHAPTER 10

▧ **Run with an upward flow in your body**

▧ **Ease is the key in swimming**

▧ **Strength and flexibility go together**

CHAPTER: 11
Training and teaching

IN THIS CHAPTER

- **The subtle skill of teaching the Alexander Technique**
- **How to work on your own Use**
- **Supple, elastic hands**

A deceptive skill

Watching an Alexander teacher giving a lesson doesn't reveal much to the uninitiated eye. It looks as if the teacher doesn't do very much. It looks easy. Don't be deceived; it's not easy. Our teaching requires a subtle and very specific use of our hands that lets us make an elastic, stimulating contact with our clients. That contact is the result of many hours of study on the teacher's part and consists of many different aspects of understanding. It's not about where you put your hands on another person, or even what you do with your hands once you have them in place – it's about the quality of contact you make. That quality can best be described as elastic – almost magnetic – and comes about because the teacher's whole body is involved in creating it. The teacher's own Use is their main teaching instrument and the hands are a reflection of that Use – an extension of the teacher's whole body. Naturally, however, the skills needed for teaching go further than that. We want to explain to clients what is going on, teach them the skills they need to carry on changing their own Use outside of lessons and listen to their unique stories and adapt the teaching so it makes sense to them. For someone wanting to teach the Alexander Technique to others, that requires three years of training.

Small training courses

Training is a very personal journey and training courses are usually small. The Alexander Technique College trains no more than 15 students at any one time and there are at least three teachers working to ensure that each student gets a great deal of individual work and attention. Every day students will work with a teacher in a similar way to having an Alexander lesson. They work on a table, exploring the subtle elasticity of limbs and torso in a semi-supine position; they work with understanding balance in sitting in a chair, exploring the transition of movement from sitting to standing and vice-versa. To an outside observer this can look strange, but the situation offers endless scope for exploring Use and reaction, so that it becomes less about activity and more about how activity is approached, understood and experienced.

Who trains?

Most people train because they have found the technique helpful for their problem or interest; the motiva-

tion for lessons becomes the motivation for training. To be free from pain after years of back problems can be a very liberating experience and the desire to fully explore all the nuances of the Alexander Technique and to teach others is a strong one. For some people, like Jeanie Wood in Chapter 5, it is the embracing of a new way of being.

Experiential learning

Just as in lessons you learn the Alexander Technique by experiencing it, so on the training course you continue to learn in an experiential environment. There are many aspects to teaching, and one of the more significant is improving your own Use to a very high standard, as it is a valuable teaching tool. This in itself is a strange and rewarding journey. Part of improving your own Use is understanding how to work thoughtfully on your Use by yourself. Throughout the three years of training, this skill develops and deepens. If you visit an Alexander training course you will not see people sitting at desks constantly taking notes – you are more likely to see them lying down in active rest. This procedure becomes an opportunity to explore new directions and balance, to 'check in' with your own perceptions of your Use and how it is evolving. Your Use becomes your experimental playground and scientific laboratory where you explore different ways of thinking, different approaches to movement and to your own mental processes. It looks rather passive, but is very exciting when properly understood.

Working on your Use

There are other ways of working on your Use. Almost any activity can be approached in this way but there are classic procedures that generations of Alexander students have practised to enhance their understanding of their Use and that most mysterious of equations – your Use equals your teaching. Lying in semi-supine is one such procedure, variations on monkey is another and a strange practice of placing your hands in

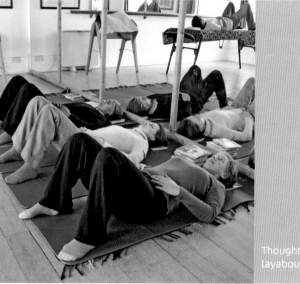

Thoughtful layabouts!

a particular fashion on the back rail of an upright chair is yet another. This practice, known (for want of a better term) as 'hands on the back of the chair', forms an important part of the training process.

This is a good example of the interaction of equipment and Use. The stool is a useful aid to posture only if you can use yourself well while you sit on it. If you are pulled down in your body, as in this picture, it will reduce the effectiveness of the stool and reflect in your face, chest and back. This is poor use of the body.

Lengthening is a subtle business; in a photograph it looks as if the difference between good Use and poor Use is simply one of posture and that in this picture Padmini is sitting upright whereas she was simply slumping in the previous picture. The interesting part of her transformation is the journey she took from one point to the other. It was not that she pulled herself up, it was that she stopped pulling herself down. Notice the difference in her facial expression and the way her whole body has responded to the lengthening impulse she has given herself.

A deeper understanding of your own Use requires a deeper understanding of inhibition and direction. The nature of that development is a key component of the training. It is a spiral learning path rather than a linear one. The practices that allow for development are similar to the practices first encountered in individual lessons, but the understanding of what is signified by such activities as 'monkey' and 'hands on the back of the chair' grows as the senses of proprioception, awareness and observation are refined.

Teaching and learning

Learning to improve your own Use is only part of a teacher's skill. Using your hands well is another aspect of skill, but the subtlety comes when a teacher can use their hands appropriately to guide a new person in the way that will help them the most, explain what is happening and offer directions that the person can use themselves. Teaching is a different skill from learning. As well as being very practical, training includes studying Alexander's own writings and researching aspects of application of the Technique to specific situations, such as pregnancy or osteoporosis.

Early training

When F. M. Alexander began to train other people to teach his work, he set about it in a very practical manner, giving them the experiences he himself had gained from developing his own Use to such a high standard. He did not leave much in the way of direct information about how a potential teacher could acquire the subtle Use of the hands necessary to teach other people, but one thing he did say was that everything you needed to know about teaching was contained in 'monkey with the hands on the back of the chair'. This procedure is a challenge to Use and is not something that is fully understood easily. It still offers insights into Use and teaching to teachers of many years standing.

Thought and movement

As your Use improves, so the boundary between thought and action seems to shift. When you experience the conjoined skills of inhibition and direction at a deeper level, you realise they are not just the precursor to movement, but the initiator of movement and the sustainers of movement. In the experience of working with an activity such as hands on the back of the chair, you find yourself exploring the place between thought and movement using direction as a bridge. Direction then becomes the motive power for movement.

Grasping and weight-bearing

We use our hands primarily to hold things, or to pick things up. Most of the time we hold things by grasping

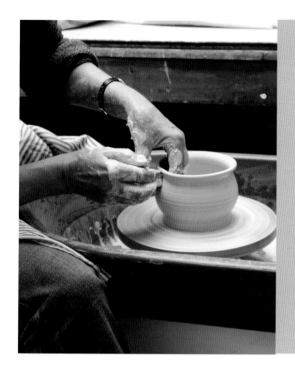

Using the hands and wrists freely is an important aspect of many crafts and skills. Potters must have a delicate but firm touch if they are to encourage the pot to form in the way they want it successfully, at the thickness they want and keep the whole design balanced so it's not lopsided.

The thumb and fingers of one hand are used in the same position as 'hands on the back of the chair' and the same criteria apply: if your thumb is stiff it will disturb your pot's balance. If you teach the Alexander Technique with stiff thumbs it will disturb your pupil's balance.

The wrists must be free and flexible to respond to the turning of the pot as it forms. If the wrists are stiff that too will influence the pot. Hands on the back of the chair helps potters as well as Alexander teachers.

with our fingers opposing our thumbs. This way of using our hands can encourage us to become short and tight in the muscles of the hands, wrists, forearms and upper arms. The other way we use our hands is in weight-bearing, although once we are past the crawling stage of our lives, we use this activity less and less. Supporting some or all of our own body weight with our hands tends to occur when we engage in activities such as press-ups or gymnastics, otherwise we lean on our hands from time to time but rarely weight-bear with our hands. Both hands and feet are very sensitive to external pressure – such as contact with a surface underneath them – and respond by stimulating a straightening response in the whole limb. So when your foot hits the ground as you walk, your leg will tend to straighten at the knee and hip to stabilise your body weight as it transfers to the other foot. If you lean on your hands on a table, your elbows will tend to straighten so that you don't fall flat on your face. This natural up-thrust reaction of your limbs is part of your body's support mechanisms – you don't have to think about it, it simply occurs, it is hard-wired into your nervous system.

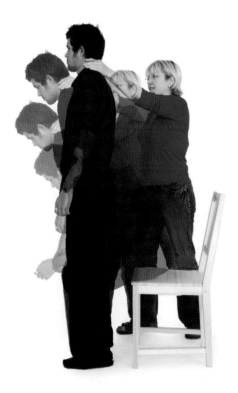

The teacher guides you both with her hands and verbally. She keeps her own body in balance as she does so

141

When we use our hands as Alexander teachers we bring with us some of the qualities of a weight-bearing reaction to holding our pupils. As we support and lift their arms and legs, and guide them through a variety of movements, we do so with hands that are springy, light, firm but free from excessive tension. We support our own bodies by allowing gravity to give us that 'up-thrust' that is a natural weight-bearing response. We take the weight of the pupil's arm or leg through our own bodies and transfer it to the ground where we can access support. Our hands become part of that up-thrust response, even though we are holding rather than directly weight-bearing. We need a balance of action between our flexor muscular that helps us bend our limbs, and our extensor musculature that helps us straighten our limbs. Ultimately this is a balancing act that now encompasses two people, not one.

Telic and paratelic States

Many states of mind have been identified by psychologists, amongst them telic and paratelic states. These terms were coined by Michael Apter (2003). Simply explained, when you are in a paratelic state you are more concerned with your process than your destination. A telic state, however, is more orientated towards a goal – is more end-orientated. Suppose you are riding your bicycle to work. If you are in a hurry, your destination is foremost in your mind, not the enjoyment of the ride. This is a telic state of mind. If, on the other hand, you are not in a hurry, but enjoying the view and the sensation of cycling, you are in a paratelic frame of mind. A key principle of the Alexander Technique is the distinction between ends and means and the importance of inhibiting or avoiding end-gaining – a paratelic perspective.

Telic states are goal-directed and future-orientated. Paratelic states are process-directed and present-orientated. In the process of learning the tools that enable someone to teach the Alexander Technique, the whole training experience seeks to avoid end-gaining (goal-orientated states) and remained focused on the process (what's going on now). For a would-be teacher, this understanding is vital to the success of teaching pupils who want something specific from their lessons which is, of course, entirely natural and appropriate. If, however, as a teacher you attempt to respond to that need directly, things will go wrong! For example, if a pupil comes for lessons because they wish to improve their playing of a musical instrument then, clearly, their goal is to improve that skill. During the lessons they would not be playing their instrument at all – at least not at first. Instead they would be learning to observe their balance and co-ordination. They are taught the tools to work with their own balance: breathing, co-ordination, movement and posture. It is these tools that offer them good Use which, in turn, will enable them to play better. By remaining focused on means (learning to improve their Use), rather than ends (playing better), they find, often to their surprise, that their playing has improved without them practising their instrument directly. The challenge that faces both the musical pupil and the Alexander teacher is to remain focused on means, as musicians are mostly very concerned with results and performance because that is their 'product'. Being able to transmit that kind of learning to another person requires a high standard of Use and awareness from the teacher. Keeping the pupil engaged in this indirect approach requires an

Students experimenting with different Use of the arms and hands

ability to explain clearly why this approach works.

Historically, there is little written about training Alexander teachers. Goodard Binkley had regular lessons with Alexander in the mid 1950s – towards the end of Alexander's life. He kept a diary of his experiences and often quoted what Alexander said and did. Interested in the possibility of learning to teach, Binkley questioned Alexander about how he achieved such powerful effects on him. Alexander's reply made it clear that he did so by making sure that he [Alexander] used himself appropriately while teaching.

> "Why, Mr Binkley, when I am teaching you, as I do now, I am able to convey to you what I want to convey, because as I touch you, and guide you with my hands in carrying out my instructions, I, myself, am going up! up! up!"

In the beginning

Novice students often feel very disorientated at the beginning of their training. They have had experience of the Alexander Technique in their own lessons, and are often confident that they know what the Alexander Technique is. Most Alexander students are professional people with high levels of skill in other areas, but those skills are not easily transferable to studying the Alexander Technique. This feeling of being de-skilled can be quite a challenge. When students start training, they are thrown back into a state of confusion, where they feel completely incompetent and at a loss to know how to proceed. One student, previously a lawyer, describes her experience.

> "I keep an open mind now because I am fully aware that I know nothing and I've realised that everything I thought I knew about myself..., the way I do things and use my body is completely wrong."

Advanced student

By the time students are approaching qualification, their awareness and Use are much more highly tuned. They fully understand that their Use lets them use their hands well, and that what they do in their own bodies has an effect on their pupil. One student comments:

> "If I tense in myself it translates into my pupil. The pupil's nervous system sort of picks it up and tenses. If my hands are stiff and tensing, then the pupil will pick it up but, on the contrary, if I release and lengthen and really let my hands be open, this stimulates the pupil to widen and lengthen. Again the nervous system of the pupil will pick it up."

Complex hands

The understanding that the hands are the operative aspect of a teacher's entire postural mechanism is one that comes slowly to students. Hands are subtle and complex organs. In context of the Alexander Technique, the hands are transmitters and receivers of stimuli relating to Use. You can tell a lot about someone from the contact of your hand on them, and likewise they can tell a lot about you. Children like to hold their parents' hands and friends and lovers hold hands. The hand is a medium through which we explore the world. Touching something offers us a more direct way of understanding it, which is why we love to pick things up and feel them. This urge is universal and is probably why museums have 'please do not touch' notices near their more fragile exhibits, or put them out of reach of inquisitive hands. As well as the physical qualities of openness, there is a sense that a teacher's hands make no judgement of the pupil, so it never feels as if the teacher is trying to push or pull the pupil into some kind of shape or make them do

anything – rather the hands offer the pupil a stimulus to lengthen, to go up and to release.

Reflective practice

An Alexander teacher is a reflective practitioner – subtly adapting their work to the situation they find themselves in with their pupil. Their aim is to teach the individual, not to make the individual learn the Technique in an abstract manner. Responding in this way while still teaching the principles of the Technique requires maturity on the part of the teacher. Our approach to reflective practice isn't head-orientated, or purely cognitive, it is experientially led. The interplay of body and mind offers enormous scope for observation and reflection, and part of the training process is to highlight that from all perspectives so it can be thoroughly understood. Classic procedures such as the semi-supine, which offer new opportunities to explore balance, can also offer reflective comparison. If this is something you have done over an extended period of time, you will find it changes and develops. Looking back to how it was can further highlight your learning path.

Look forward, look back

Raymond Dart is an Australian-born South African physical anthropologist and paleontologist whose discoveries of fossil hominids (members of the human lineage) led to significant insights into human evolution. He is also a devotee of the Alexander Technique which had helped him with his 'scholar's stoop' and both his children with their different problems. His interest in Alexander's work came because of its practical value to him and his family and his belief that Alexander had really discovered a step in human evolution – a new stage of upright carriage of the body, its link with consciousness, and all the implications of this. His own study of anatomy and movement from an evolutionary perspective had drawn him to this conclusion. Alexander's observations about

the primary control of the manner of our Use being orientated around the balance of the head, neck and back made perfect sense to Dart. His own studies led him to say:

> "Man can only look forward as far as he can look back"

Dart meant this in terms of the study of human origins, but he also acknowledged its absolute truth on an individual basis. If your neck is stiff then you can't turn your head easily. If this is the case you can't look over your shoulder (looking back), nor can you look forward properly as the stiffness will restrict both forward and peripheral vision. Such restrictions make balance a precarious business and the available range of movement shrinks.

Dart went on to develop a series of movements based on the evolution of the human species. The approach to these procedures is rooted in Alexander's work and Dart's procedures form a part of the study on the training course as they offer each person an opportunity to explore how their limb buds developed and evolved, and how their spine and head is segmental and all that this implies. The practical result of this is a considerable amount of wriggling around on the floor, an experience which is both informative and enjoyable.

Mature career choice

Many people who train to teach do so as a second or even third career and the average age of a student reflects this. We have no upper age limit on our training course, but we don't take people under 23. We have trained doctors, lawyers, musicians, school teachers, waiters, singers, physiotherapists, osteopaths, dressage instructors and IT experts. In fact anyone who has the desire to spend the time and energy involved in training can make an excellent teacher. No previous experience gives an advantage over another. Initially you might think that if you were an osteopath or a doctor, your knowledge of anatomy would be an advantage, but it's

not like that. Knowledge doesn't equate to Use. In fact it can even be a hindrance because it brings with it a whole series of beliefs and 'givens' that are constantly challenged by the new experience of your own changing balance. Our physical balance is totally bound up with our belief systems and sense of what is right and what isn't right. Training challenges that balance and this can be disconcerting.

Teaching others, a teachers life

Once qualified, teachers begin another kind of Alexander journey, where they teach others good Use. For most teachers this is a very rewarding job. Because you can only teach when you are using yourself properly, your work actually makes you feel better, rather than drained of energy. You have the joint satisfaction of helping others as you help yourself. Teachers work in many different situations, some from their own homes, others in music and drama academies or clinics. There are large thriving communities of Alexander teachers in the UK, USA and most countries. Every four years we hold international congresses where knowledge and experiences are presented, exchanged, discussed and above all practical work is exchanged.

Opening other doors

Training is a very revealing process and enables people to experience aspects of their character they may not have developed. It allows people to tap into their creativity in a new way and gives people confidence to try things they might otherwise have thought too difficult. Applying the skills of awareness to activities is very rewarding and many teachers find themselves embracing the challenge of creative writing, silk painting, stained glass studies – all sorts of things. Others discover they can sing after years of thinking they couldn't and join choirs. The experience of exploring your own awareness has many delightful and unforeseen consequences. Inhibition and direction can be applied to any discipline, art or craft and used to ex-

plore previously unrecognised talents. When embracing a new skill the normal desire to achieve a result creates an end-gaining attitude. If this can be avoided then new experiences can come about. This attitude can be found in other art forms where an explorative approach is considered not only valuable, but the path to a more developed art form. The whole concept of 'wrong' is challenged in this way and 'mistakes' can be incorporated in design and become a feature rather than an error.

Developmental teaching stages

Teachers improve their practice the more they teach. This is because the basic equation of your Use equals your teaching is still in evidence. Reading, research and experience all add to development. There seem to be key points in shifts of understanding that occur at roughly five-year intervals. In the first five years of teaching everything is new and teachers may see their skills as being in competition with other forms of body work and look for similarities and differences. Occasionally teachers feel the need to work out just where pupils are pulling down or twisting themselves, just how they are distorting their bodies.

After five years the ability to make a good contact with an individual's musculature deepens and the need to make comparisons drops away. Our work is practical and isn't like anything else – its fundamental nature becomes more apparent the more you teach it. Its relevance to individuals becomes more obvious.

After ten years of teaching, most teachers' hands are very open and soft but strong. Their palms look flat, as there is no tension in their wrists and fingers. The contact they offer invites an irresistible upward response from the pupil. At this point teachers are generally not concerned with unravelling twist or distortions because they understand deeply that the lengthening impulse unravels the Use according to how it wants and needs to unravel. In other words, teachers don't end-gain on behalf of their pupils.

Change and development still takes place in teachers and occasionally a big shift in Use can happen even after many years of teaching. Life always brings opportunities and challenges and sometimes the path we tread has to be reviewed in a new light. This makes the work exciting and intriguing. Alexander teachers never simply churn out lesson after lesson, according to some basic guidelines. Each lesson and each pupil is different and so boredom is not a problem.

A career for life

Like good cheese or wine, teachers mature with the passage of time. Most teachers do not retire but carry on teaching all their lives and their skill is highly prized by those lucky enough to be able to work with them. There are teachers alive today in their eighties and even nineties who still work because they want to. Being seventy is considered young in our profession!

Workshop 11

The Use energiser: hands on the back of a chair

This workshop describes an experiment for you to try out in your own time. It does not have an accompanying track on the CD.

Students experimenting with different Use of the arms and hands

Variations and application.

There are many variations of this procedure and this is a simple version that can benefit a wide range of people. Like active rest, it is a procedure than can be helpful to new pupils, trainee teachers, newly qualified teachers and senior teachers. Many teachers use it as a way of preparing for their teaching day, or a way to refresh them halfway through the day. Pupils who use their hands strongly such as musicians and potters use it to remind them to keep their hands working in relation to their back. Computer users find it helps counteract early tendencies that could lead to RSI. The procedure promotes balance of the muscular action of the hands, wrists and arms. It encourages freedom in the wrists and a release throughout the shoulder girdle and back.

You will need
■ A chair with an upright back that has a straight top rail. A dining or kitchen chair should be suitable.
■ An understanding of the workshop on flexion without tears, as you are going to use monkey to lower your height so you can put your hands easily on the rail of the chair.
■ The willingness to be baffled!

This initial awareness and lengthening and widening lay the foundation for the whole procedure. Savour each stage and don't rush yourself through to the next one.

Flexing
Still keeping your length, ask the big joints of your ankles, knees and hips to release without going at all soft or soggy in the joints (see the workshop on flexion for more information on this).

Let the joints of your legs bend, knees forwards, hips back, so you are flexed with your upper body leaning forwards. Don't reach for the chair!

More direction
Although it seems a simple thing to do, supporting yourself without excessive tightening is part of the challenge

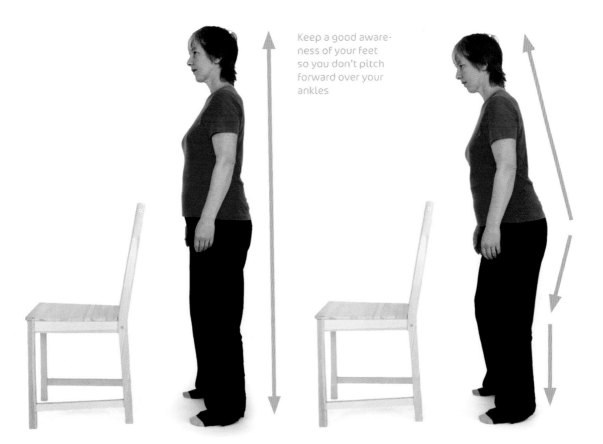

Keep a good aware-
ness of your feet
so you don't pitch
forward over your
ankles

Stand a little way behind your chair and take some time to be aware of your balance. It is important not to rush this procedure and get involved with the hands before you actually have them in place. Ask your whole body to lengthen from your feet right up to the crown of your head and simply let your arms rest happily by your sides. Have your feet about a foot apart from each other but don't be over concerned to point your toes directly forward; if your feet naturally turn out little, let them. It's important to work with how you are, not an idealised perception of what you think you should be.

of this procedure. Your back will be elastically toned if you have keep your directions going. If you haven't then your back will have stiffened up. Indications that you have stiffened will be found in your breathing and your jaw; if you have held your breath or clenched your jaw then the chances are you have simply forgotten about lengthening and got too involved with flexing!

Don't give up! Either start again or calmly take yourself though the directing procedure of freeing your neck, sending your head forward and up and asking your back to lengthen and widen again.

Lifting an arm

You are now going to lift one arm up, flexing at the elbow, and bring the back of your hand to rest on the rail of the chair. Lifting an arm in this way requires a small amount of additional tone in your body to counterbalance the extended limb. You are aiming to minimise that tone so that you neither stiffen up as you lift your arm, nor let your arm be floppy and unsupported. It's helpful to direct your arm out of your lower back rather than lifting it up from your shoulder. What this implies is that you avoid pulling your back forward as you lift. You counterbalance the weight of your arm by your widening back.

Don't disturb your
balance as you lift
your arm

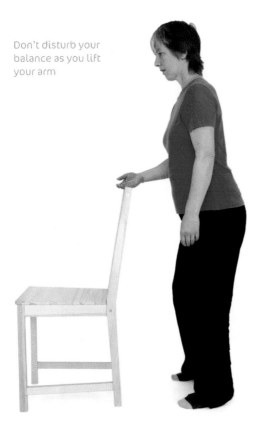

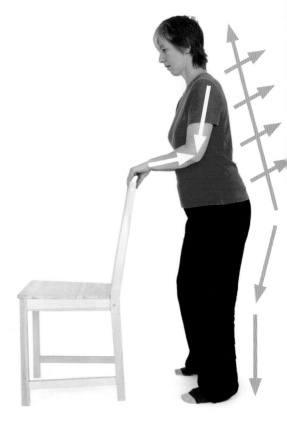

When you are ready, lift the other arm in the same way and bring it to rest on the back rail of the chair. Your hands should be about shoulder width apart. Take a moment to repeat your mental directions to yourself and check you have left your legs nice and free. When you do something like this, which focuses on the hands, it is easy to lose sight of the legs and feet. But they have a role to play in your balance, and tight feet will require a compensatory tightening in your arms. Let your arms rest on the chair, making sure you are not surreptitiously pulling your arms back up into your shoulders and neck. On the other hand you don't want your arms to drag you down to the chair and cause you to collapse in the chest and shoulders, so keep your shoulders widening away from each other and get a sense of 'magnetic' repulsion between your hands and your face and chest. It's always a question of balance and it is the acquiring of awareness that makes this such a long lasting study;you

A well-toned back is not only lengthening and widening, but there is a sense that it is supporting you as if it were being lifted in the direction of the arrows. We have an odd expression 'let your back stay back', which describes this. The pelvis and legs oppose the head and thus set up a stretch through the body and the widening shoulders also support the arms. The upper arms are lengthening from the shoulder tips to the elbows and the forearms are lengthening from the fingertips to the elbows. All of these directions are internal stimulation of muscle activity rather than external movements.

The wrists are directed towards each other so that the hands are deviated away from the ulna bones (little finger side of the wrist). The fingers are bent only at the first knuckles and are otherwise straight. The thumb rotates round so the ball of the thumb opposes the fingers.

can't expect to get it working all at once, but you can continue to explore the subtleties of balancing direc-

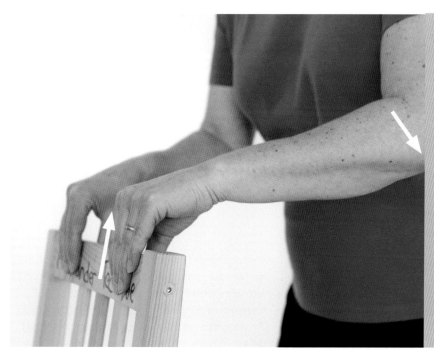

Jenny's hands hold the rail of the chair lightly and firmly. There is a 'lift' in the arch of her palm, her fingers are straight and so is her thumb. Her palm remains wide and free even though it is folded by the position of her thumb. The thumb itself is lengthening out of her armpit and neck and directing down towards the floor, opposing the 'lift' of the arch of the palm. Her elbows are directing out away from her body and slightly down towards the floor. Her wrists are curved towards each other. Her upper arms are not clenched and her hands and arms are both supporting her upper body and being supported by her upper body. It is a reciprocal support mechanism she has called into play. She breathes freely and easily.

tion, movement, action, reaction, intention and effort over a very long period. Don't be discouraged by all the subtleties – any increased awareness you can bring to the use of your hands will benefit you.

Turning the hands over

You are going to turn your hands over one at a time, and grasp the rail of the chair between your thumb on the back and your straight fingers on the front. As you turn one hand, keep an awareness of the other hand and leave it resting nicely where it is.

Problems

When most people first try this out, they will not be able to keep the fingers upright and straight, with the wrist bent and the thumb joint rolled round. Often the fingers are crocked and the thumb not able to rotate so that it's the side of the thumb that touches the chair, not the ball. There is absolutely no point in forcing your hand into this strange configuration because it can only be acheived when your whole muscle suit is ready to 'let go' enough to allow the movement to be easy. What appears to be a difficulty in achieving the required position,

reflects a shortening and tightening through the muscles of the whole shoulder girdle, tight biceps and triceps, tight trapesius mucles, tight latissimus mucles – in short – tight muscles! Patience is required to undo these and it only happens over a period of time.

There are many other subtleties of direction that can be called into play with hands on the back of the chair. It is a wonderful procedure because it offers endless scope for improvement and exploration. Every bit of your body has a role to play in this procedure. The precision of the hands can't be forced or hurried, but reflects your changing and improving Use. That is why it is such a good foundation for using your hands actively in almost any situation, including teaching other people the Alexander Technique.

SUMMARY OF CHAPTER 11

▦ Training is a journey of self discovery

▦ Reflective practice skills

▦ A teacher's career

CHAPTER: 12

"WHEN WE LEARN TO INHIBIT UNCONSCIOUS BEHAVIOUR, THEN WE UNCOVER OUR AWARENESS, IT ISN'T SOMETHING WE HAVE TO DO OR SOMETHING WE HAVE TO CREATE. IT'S ALREADY THERE, WAITING IN THE WINGS."

Mindfulness and creativity

IN THIS CHAPTER

▥ Physical balance opens the doors of creativity

▥ Alexander Technique improves your awareness

▥ Breathing, mindfulness and awareness are linked

Not just physical

Although the Alexander Technique is well known as a way of helping people with all kinds of pain, and with performance, it has a broader and subtler application to other aspects of the human experience, in particular mindfulness and creativity – two states that feed each other and often go hand in hand.

Mindfulness

Until fairly recently, concepts of mindfulness or meditation were things that were associated with other disciplines. This includes Eastern disciplines of Tai Chi, Qiyong, Zen or aspects of yoga, where the attitude of mind was as important as the movements or postures. Meditation, although widely practised, was seen almost entirely as a spiritual discipline, and although it was recognised that it offered health benefits, it was nevertheless a specialist interest. The recent rise in the use of mindfulness as management tool for chronic pain, anxiety and depres-

sion has changed that perception. In the UK mindfulness has been taken into a clinical framework and approaches such as mindfulness-based cognitive therapy (MBCT) are successfully used to help prevent relapses of depression. The recognition of the interplay of body and mind and the role of habitual thought and action finds many parallels in the Alexander Technique.

The journey starts without a map

The idea of not knowing how you are going to get to where you are going is a strange one. You could possibly end up somewhere other than your original intention. In an end-gaining society, much of what we strive to achieve is done in a very direct way. Concepts of 'allowing' or 'unfolding' are undervalued in favour of 'result' and 'achievement'. However this attitude devalues development of any internally orientated skills and the interconnectedness of different aspects of our lives. For a person suffering from stress or anxiety, or in pain, this driven approach allows no time for an exploration of the present moment. It is completely future-orientated. Valuing the here and now is an alien concept in the context of reaching a goal or a destination.

The here and now

Most of us find it almost impossible to be 'here and now'. We niggle at past problems and grievances, we anticipate

problems before they arrive. We fall into the habit/pattern trap. When we constantly rehash our past events, which are usually painful or stressful, we revisit them both in mind and body. Remembering, or rather going over situations again and again, we entrench the original response more deeply into our nervous system. Whatever the situation was, the physical response will have included a pattern of shortening and tightening throughout your whole body. So, as you worry about it, your neck stiffens and your breastbone sinks as you restrict your rib movement and clench your hip muscles. This tension becomes a part of the 'memory' and the more you go back to the past event, the more familiar the tension feels. Eventually the point comes when you may have forgotten the event, but you still have the tension – your body is not in the present, it is in the past. It is not in the 'here and now' it is in the 'there and then', or the 'will be and maybe'. To come to a point where you can acknowledge this enables you to recognise that your 'here and now' contains a lot 'there and then' – and it is not needed. Inhibition can be of enormous help in this situation. Inhibiting that ongoing response of tension – which drags you back into the 'there and then' or forward into an unseen fearful future – allows you to genuinely get in touch with your mind and body in the present moment.

This isn't always a pleasant experience. We layer our bodies and minds with veils of tension that we hide behind and becoming more mindful and aware of your present self can be challenging. However, awareness is often a precursor of change and release – a transformational state that allows a different perspective to come about.

Perception of pain

When someone starts having Alexander lessons because of a painful back, the initial change is often a change of habits of thought that comes about before the physical pain levels start to diminish. Pain is an immensely strong and unpleasant stimulus, from which most people want to get away. This is completely understandable, but often the response is to look entirely for ways of getting rid of the pain. However, this is a future state, not a present state. In

that attempt to escape to the future, tension continues to escalate and, in particular, breathing suffers. In early lessons it's not easy for someone to understand why it's helpful to simply be aware of where they are – probably lying on a teaching table in semi-supine position – and to work with that. However this is the way that hidden habits of thought and action can gradually both reveal themselves and diminish and that often leads to pain reduction, or it leads to a change of attitude that allows better management of pain. Simply cultivating the ability to stop and 'come to quiet' as we sometimes express it, offers something new and helpful to someone suffering from pain.

What is there for me here?

Part of the Alexander experience is the cultivation of a lengthening and widening musculature – an expansion of the body that can only come about when linked with an expansion of the mind. The ability to inhibit and direct are the tools used to access this expansion. Realising that expansion and upright support is a natural response to gravity is enormously valuable, because then it becomes clear that this is an allowing process not a doing process. The question "what is there here for me now?" is an individual one that can have many answers, but part of that answer will be "gravity, my own mind and my Use". This attitude allows an inner stillness to emerge from a chaotic mind.

States of mind and creative flow

How you approach a task, be it mental or physical, affects how flexible your thinking is, and a flexible mind is more open to creative thinking.

Psychological experiments that offered participants two versions of the same problem had different effects on creativity depending on which version the participant followed. In the experiment their task was to help a cartoon mouse out of a maze – a simple task that took only a minute or two. In one version, participants helped the mouse towards a nice piece of cheese, in the other version participants helped the mouse avoid a predator.

After completing the maze, participants then took a creativity test and the results were quite startling. Those who helped their mouse get cheese scored up to 50% higher than those who were in 'avoidance' mode. Even a cartoon mouse's predicament and how you tackle it can create different frames of mind. If your frame of mind is one of caution, this makes you less flexible when it comes to creative thinking.

There is a value that can be gained from having a non-endgaining attitude to your own process. As you inhibit excessive tension and effort and allow a natural releasing process to happen, you understand more fully that you cannot force change. This lets you sidestep trying too hard to achieve your goal and once again be with yourself in the present. This state of mind is also linked to creativity. It's not the task you perform – it's the state of mind you use to perform it.

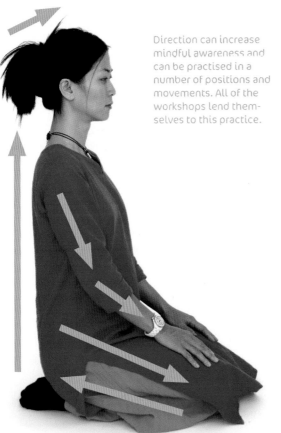

Direction can increase mindful awareness and can be practised in a number of positions and movements. All of the workshops lend themselves to this practice.

Mind and body in dialogue

Much is spoken about the mind and body being indivisible and one, but not much is written about exactly how that is experienced or how such a knowledge can benefit us. Attempts to use the mind to dominate the body usually end in disharmony of some sort, although it is clear that extreme willpower to complete arduous tasks comes from the determination of the mind to succeed in whatever the task is. Most people tend to ignore their bodies in favour of their mind, even pain can be viewed as an annoyance – something that gets in the way of what we want to do, rather than our body's way of telling us something. Awareness helps form a non-verbal language between mind and body so that we can establish a dialogue that allows us to listen to more of our inner workings and be less driven into constant action, reaction and motion. When we learn to inhibit unconscious behaviour then we uncover our awareness. It isn't something we have to do or something we have to create – it's already there, waiting in the wings. Becoming aware, becoming conscious, is a natural response to releasing the interferences that dull our perceptions.

Mindfulness in company

One of the most useful things the Alexander Technique can offer an individual is the ability to retain an awareness of self when in the company of others. This doesn't mean being egocentric or self-obsessed or ignoring other people. It means that you have the ability to stay mindful of your ongoing shifting reactions to the interplay between yourself and a group of people and not let tension build up in you. Simply being able to keep your neck free is a help. Noticing your shoulders migrating upwards and inwards and then inhibiting that migration lets you stay calm and focused. It isn't a matter of a religious or spiritual belief system – it is a matter of practical physical response to any situation.

Riding two horses

Non-endgaining doesn't mean being unfocused and it doesn't mean you can never have a goal in mind. If you

want to do something – such as write your first novel – then, clearly, that is your goal and you want to achieve it. The value of non-endgaining is it allows you to stay focused on the present rather than always being ahead of yourself in the future. If you want to write a novel, you are likely to think about the finished book, perhaps see its cover and visualise it in a bookshop. While this may motivate you in some ways, in others it will take you away from the journey you need to undertake to write the book. I equate this with the imaginary learning experience of riding two horses. Incidentally you ride them both at the same time! One horse is taking you towards your destination – in this case your first novel. The other horse is a different kind of animal. It doesn't go directly towards the goal; it takes unexpected turns and helps you explore previously unvisited landscapes. It is a non-endgaining horse that refuses to rush off after any stimulus that comes your way but instead whispers 'just a minute' in your ear as you ride. Somehow you start to enjoy the ride, the feel of your project, the taste of it, not just the completion of it. Somehow you still ride both horses, but the non-end-gaining horse may well take you to a very different book than you first anticipated. If you start any project solely focused on your anticipated achievement you narrow your own creative options and limit your experience.

Finding your inner voice

Accessing your own creativity is more likely to happen when a non-judgemental and open frame of mind is allowed to be present. Exercises such as free writing – where you simply pick your pen up and write anything regardless of whether it makes sense or not – are designed to let creativity out. But this approach treats creativity as if it were some kind of shy beast lurking in a cave that had to be tricked or enticed into coming out – and it might or it might not. This is ultimately an endgaining approach, which tends to have varying degrees of success. Paying quiet attention to your physical poise and balance, how you are sitting, how you are holding your pen, how you are breathing takes you into a different state of being; from here doors open into other inner landscapes.

Non-engaining in painting

In the process of this silk painting, hot wax spilled on to the silk. Paying close attention to 'use' allowed the artist not to view this as a 'mistake' but to incorporate the wax into the design. The 'spill' was deliberately repeated, building a background of trees and branch-like shapes. A non-engaining attitude towards the process allowed the design to build organically.

Jane's story

Jane described herself as 'an ordinary person'. She worked as a secretary, which she quite enjoyed but always felt she had somehow missed out on developing talents. She came for lessons because she was suffering from a frozen shoulder and had heard the Alexander Technique might help. Lessons helped her shoulder a great deal, but it went much further than that.

A different approach

A non-endgaining step-by-step approach can be applied to almost any creative task. Jane had always wanted to paint but believed she had no talent or colour sense. She found the sight of a blank sheet of paper intimidating. She asked if we could tackle this in one of her Alexander lessons and, although it was an unusual request, I agreed. Setting up an easel and paints, the first bit of 'inhibition' we practised was to restrict the number of colours. Jane wanted to try watercolour painting and had been given a magnificent box of paints for her birthday, but she couldn't bring herself to mar the perfection of the pristine box and just didn't know where to start. As she handled

the box and showed it to me, she was unconsciously stiffening her neck and holding her breath. That was where we started, simply opening the box and looking at it without allowing the stiffening pattern to take over.

The power of habit

Becoming aware of that pattern and all the associations that went with it really helped. She remembered being discouraged in her art classes at school and realised that the tension reminded her of that time and made her think she was going to fail yet again.

Jane took just three colours out of the box so as not to be distracted by too much choice. She happily dipped a brush in water and then froze. Once again habit jumped in, awareness jumped out and Jane felt overwhelmed.

By paying attention to her neck, her lengthening back and her rising and falling ribcage, Jane was able to bring her hand (plus loaded brush) to the paper and let a mark be made. She paid attention entirely to her Use, not to her painting. To her enormous surprise she found the action very enjoyable – she liked the feel of the brush as it met the paper and she enjoyed the feeling of the brush being an extension of her hand and back. Finally she noticed the marks she made were very free and expressive.

Slow creativity

Jane carried on in her own time and played with various ideas, all following Alexander thinking. She inhibited making a choice of which colour paint to dip her brush into, instead paying attention to her hand as it was holding the brush. If she found her fingers tightening round the brush or her jaw clenching, she simply stopped and freed her neck and let her spine lengthen. Then she allowed her hand to go where it seemed to what to go. That way a colour choice happened.

She paid a great deal of attention to her own Use, taking time, breathing freely and exploring the movement of her hands and wrists. Gradually Jane widened the range of colours and found that images seemed to be emerg-

ing from her paintings. At this point Jane realised that she could actually paint! A non-endgaining attitude had allowed her to acknowledge habits of tension in both mind and body that had caused her to freeze up. Staying present, giving her directions and paying attention to her Use had allowed her latent creativity to reveal itself.

Zen thinking and Alexander's genius

Many people find parallels between the Alexander Technique and Zen thinking. The idea of attending to a process rather than being attached to an outcome is not unique to the Alexander Technique. Paying attention to breathing and bodily posture is a component of several Eastern spiritual disciplines and Alexander students have explored these links ever since Alexander first taught his technique in the early 1900s. Alexander's genius lay in his practical approach to the problems of human balance. His discovery of an organising principle that recognised the core of ourselves – our head, neck and back – as fundamental to all of life's expression; his observations of the act of breathing being so deeply linked to our balance; and our balance and activity being something we could improve by improving our awareness. These then are the fundamental facts about functional human movement that Alexander discovered and that made him one of the "200 people who made Australia great". For us today the interpretation of his ideas has grown and expanded. A great deal is known about human physiology – about the brain, the nervous system and the role of thought in our lives. But the fundamental question "How do I balance?" is one that the Alexander Technique can go a long way towards answering.

SUMMARY OF CHAPTER 12

- Mind, body, breath and spirit form a dance together
- Knowing what you don't want allows you to know what you do want
- Creativity is our natural state

Glossary

I have been at pains not to overwhelm the reader with specialist Alexander Technique terms, nevertheless these concepts are explored in the book and readers will come across these terms in other literature on the Alexander Technique. These definitions reflect my current thinking and understanding.

Awareness	In this context, your ability to perceive your own body, and to register sensory messages from within yourself and from your surrounding environment. Awareness can be enhanced with practice.
Conscious control	Using your human faculties of awareness and consciousness to make informed decisions about your actions and reaction.
Directing and directions	Forming mental links between your mind and your muscles, asking your body to release in a particular way. This is a natural neurological function we can take advantage of if we think it out.
	Specifically asking your neck to be free so that your head can go forward and up and your back lengthen and widen and your legs unravel out of your pelvis so your knees can go forward from the hips and away from each other. Directing improves your balance and helps you organise your body in a useful way.
End-gaining	Trying too hard to achieve something so that you blind yourself to what you are doing on the way. Being totally goal-orientated at the expense of process. End-gaining usually ends in tears.
Faulty sensory appreciation	When your body tells you porkies (lies)! For example you think you are evenly balanced on your feet because your body tells you so but in fact you habitually stand with most of your weight on one leg. If this is your habit it will feel both normal and right to you. Changing it will make you feel unbalanced and wrong.
Habit/habitual movement pattern	Repeated activities or thought patterns that can become automatic and unrecognised. Habits can be good or bad.
Inhibition	A decision not to rush into reaction: a conscious pause between receiving a stimulus and reacting to it. An opportunity to stop. Inhibition is a skill built into our nervous system. For you to hold a fragile flower you have to inhibit extraneous movement of your hand that might crush it. We can take advantage of this phenomenon and use it consciously.
	Specifically an ongoing decision not to tense the muscles of your neck, or to pull your head back, or to shorten and narrow your back, or to pull your legs up into your pelvis or to pull your arms up into your shoulders.
Introception	Information from your body to your mind, arising from deeper internal structure such as organs. Mostly unconscious and unrecognised.
Means whereby	Thinking through a path to your desired goal so you can avoid the pitfalls of tension and excessive effort. Working out the 'how' of doing things.
Misuse	A way of moving that causes interference with natural functioning. An inefficient use of yourself in both mind and body. Misuse is usually habitual and unconscious.
Non end-gaining	Not fixing on a specific goal or outcome.
Primary control	A harmonious co-ordination of the head, neck and back that influences the rest of the body. Co-ordinate your head, neck and back well and everything else will be easy; interrupt that co-ordination by stiffening your neck and you muck things up.
Proprioception	Sensory messages from muscle, tendons and joints, telling the brain where the body is in space. Proprioception can be rather blunted or ignored. (Do you know where your ankles are? can you actually tell?) Used here in a general sense.
Psychophysical unity	Understanding that mental process and movement are linked, the mind influences the body and the body influences the mind.
Thinking in activity	The ability to continue to direct yourself well in movement. For example directing your neck to be free and your head to go forward and up and playing chess or the piano at the same time. A skill that takes time to develop.
Use	How you respond to the pull of gravity, how you use your body in movement and at rest. Your basic state of being.

Useful contacts

Alexander Teacher Training
The Brighton Alexander Technique College

Unit 3 Hove Business Centre, Hove BN3 6HA
www.alexander-technique-college.com
info@alexander-technique-college.com
Tel: 0 44 0(1)273 562595

For three-year professional teacher training, one-year course in personal development and short taster courses in the Alexander Technique. Offers postgraduate training to teachers. Head of training Carolyn Nicholls BA (Hons), MA, MSTAT.

Find a qualified teacher near you
The Society of Teachers of the Alexander Technique (STAT)

Oldest established professional body listing all STAT trained teachers, and teachers in affiliated societies overseas. Maintains CPD programme for members. All teachers abide by a code of conduct and carry professional insurance.
www.stat.org.uk

Richard Weis

International dressage coach and Alexander teacher
www.richardweis.com

Matthew Andrews, photographer

www.matthewandrews.co.uk

Patrick Bartlett, sound record

www.partrickbartlett.com

Alison Nicholls, classical singer and harpist

www.myspace.com/alisonsinger

Further reading

The Use of the Self
by F. M. Alexander
Pub. Gollancz

Master the Art of Running
By Malcolm Balk and Andrew Shields
Pub. Collins and Brown

Index